THE MUSEUM OF ILLUSIONS

OPTICAL
TRICKS IN ART

THE MUSEUM OF ILLUSIONS

OPTICAL TRICKS IN ART

Céline Delavaux

PRESTEL Munich · London · New York

Optical illusions, impossible perspectives, double and hidden images, insoluble enigmas: works of art are sometimes tantamount to fantastic fabrications. Looking at art in terms of its ability to conjure up illusions allows us to get to the very heart of what art is about. This is because illusionism in art reveals artists' technical skills and scientific knowledge as much as their imagination. It constitutes a material reflection of a painter's concept of representation, and, above all, it compels viewers to engage actively with it, luring them in with the promise of beguiling sensations.

Works of art that depend on illusion generate an uncertain pleasure because they make us their victims. They mislead us and make us doubt our senses. From classical antiquity onwards, artists have been drawn to explore the inexhaustible potential of illusion. According to a well-known tradition, the grapes painted by the Greek artist Zeuxis were so convincing that birds came to peck them. Wall paintings in trompe l'oeil lent not only decorative richness to the interiors of houses in Pompeii, but also drama, while during the Renaissance masters of illusion turned ceilings into painted skies. Today, the spray-painted murals of street art bring unbridled anti-establishment humor into our public spaces.

Sixteenth-century Europe became fascinated with anamorphoses (distorted images that appear normal when viewed from a particular point) and visual riddles—Mannerist oddities to which the Surrealists later turned for inspiration when seeking to suffuse their pictures a sense of the fantastic. There was also a vogue for composite heads and anthropomorphic landscapes during this period that reflected a distinctly human-centered view of the world. From

this point on, artists began to play with the whole idea of figuration, accurately representing or distorting the human form as it suited their purposes, as contemporary artists are still doing with great imagination and verve.

The invention of photography brought both a challenge and an aid to painting. The developments in optical science in the mid-nineteenth century offered a fertile ground for artistic experiment, especially to the Impressionists. The following century saw the birth of the Op Art movement with its mesmerizing pictures that appeal to every sense. The hyperrealists, for their part, painstakingly explored another perception of reality, as inevitably conditioned by, and filtered through, the ever-present media images surrounding us.

Illusion allows the most banal reality to be endowed with mystery, as the work of René Magritte so clearly demonstrates. Illusion allows art to go beyond the real, to question the visible, and to invent new worlds—impossible worlds, perhaps, but ones that function as effective critiques of our own.

Whatever their individual concerns—to exploit technique in order to trick, seduce, or educate, to reduce the meaning that can be given to any one form, to transform the human figure and inanimate nature to the point where they become confused, to explore the artist's perception and question that of the viewer, to transcend the real by creating fictions—illusion has preoccupied artists throughout the history of art and continues to fascinate artists, critics, and art lovers alike.

TROMPE L'OEIL

TROMPE L'OEIL IN ANTIQUITY
12

JAN VAN EYCK
16

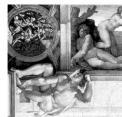

MICHELANGELO
20

CORNELIS NORBERTUS GIJSBRECHTS
22

PERE BORRELL DEL CASO
24

RICHARD ESTES
26

JOHN DE ANDREA
30

DUANE HANSON
32

GERHARD RICHTER
36

JEFF KOONS
40

RENÉ WIRTHS
42

DAN WITZ
46

EDGAR MÜLLER
50

BANKSY
54

CAYETANO FERRER
58

HIDDEN MEANINGS

VENUS OF MILANDES
62

ANDREA MANTEGNA
64

ERHARD SCHÖN
66

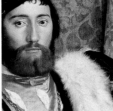
**HANS HOLBEIN
THE YOUNGER**
68

WILLIAM SCROTS
70

MUGHAL SCHOOL
72

UTAGAWA KUNIYOSHI
74

WILLIAM ELY HILL
76

SALVADOR DALÍ
78

MARKUS RAETZ
82

TONY CRAGG
84

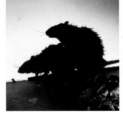
**TIM NOBLE AND
SUE WEBSTER**
86

THE (IN)HUMAN BODY

 GIUSEPPE
ARCIMBOLDO
92

 MATTHÄUS MERIAN
96

OPTICAL CHALLENGES

PIETER BRUEGEL
THE ELDER
122

 CINDY SHERMAN
98

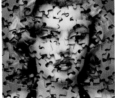 VIK MUNIZ
100

 BERNARD PRAS
104

 EVAN PENNY
108

BRIDGET RILEY
132

 TONY OURSLER
110

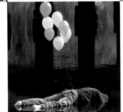 MARK JENKINS
112

EMMA HACK
114

 KIMIKO YOSHIDA
116

 MICHAEL KALISH
148

 LIU BOLIN
118

BEYOND REALITY

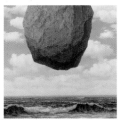

RENÉ MAGRITTE
158

GEORGES SEURAT
124

PHILIPPE HALSMAN
162

GIACOMO BALLA
126

VICTOR VASARELY
128

MAURITS CORNELIS ESCHER
164

JOAN FONTCUBERTA
166

CHUCK CLOSE
136

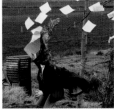

JEFF WALL
168

GEORGES ROUSSE
140

FELICE VARINI
144

MAURIZIO CATTELAN
170

EIJA-LIISA AHTILA
174

YAYOI KUSAMA
150

GILLES BARBIER
176

ANISH KAPOOR
154

PHILIPPE RAMETTE
180

RON MUECK
182

LI WEI
186

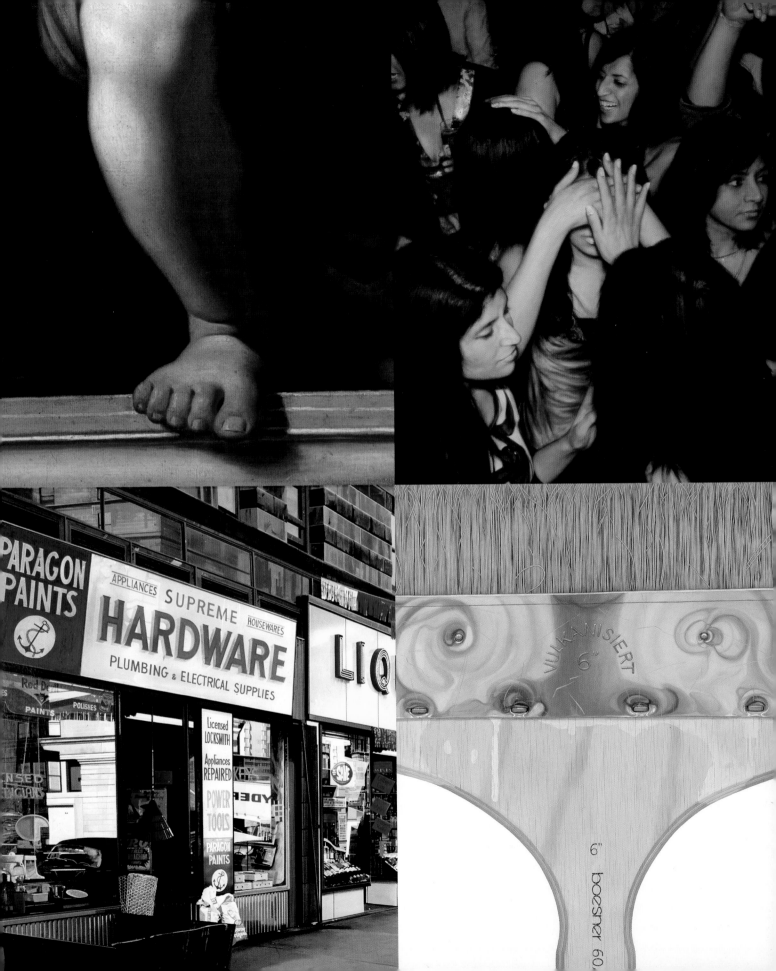

TROMPE L'OEIL

TROMPE L'OEIL IN ANTIQUITY
Greek and Roman Antiquity

In classical antiquity, illusion in painting was used for more than purely decorative effects. Trompe l'oeil could certainly create an impression of interior spaces larger and richer than those in reality. But it was also a way of bringing narratives and symbols vividly into everyday life.

The earliest examples of trompe l'oeil were discovered in Etruscan tombs dating from the seventh century BC. The insides of burial chambers were painted with ceremonial scenes, embellished with decorative elements painted to look like sumptuous materials in relief. Greek tombs incorporated painted false doorways suggesting passages to the next world. Trompe l'oeil thus lent painting a symbolic capacity.

Greek theatre also had an impact on the development of pictorial illusion. The trompe l'oeil treatment of backdrops influenced the decoration of private interiors, as is shown by the painted theatrical masks discovered on the walls of Roman villas. The art of trompe l'oeil became firmly established in Greece by the fifth century BC and developed throughout classical antiquity through mosaics and frescoes. The Romans copied the Greek masters of illusion, such as the mosaicist Sosos of Pergamon, copies of whose designs can be seen in Hadrian's Villa near Tivoli. Excavations of houses in Pompeii have revealed wall paintings that conjure up the sense of a complex space, artificially enriched with sumptuous materials through the imitation of precious woods, marble, and stucco. False windows and doors open onto gardens and imaginary land-scapes. The art of trompe l'oeil could thus transform a modest villa into an imperial palace. It could also create a gallery in the confines of a home: walls would often be divided into a number of painted panels, each with a single picture set on its own, apart from the rest of the decorative scheme. In fact, these pictures, which were mostly of mythological scenes usually borrowed from Greek art, were separated simply by frames that were themselves painted in trompe l'oeil. Some wall paintings acquired a theatrical quality by depicting entire narratives. A famous cycle in the Villa dei Misteri (Villa of Mysteries) in Pompeii depicts the cult of Dionysus. The various episodes are cleverly separated one from the other by painted columns that appear to belong to both the real and the narrative space. Lastly, trompe l'oeil brought with it the very first still lifes: wall paintings of food inside a house attested to its owner's wealth and hospitality.

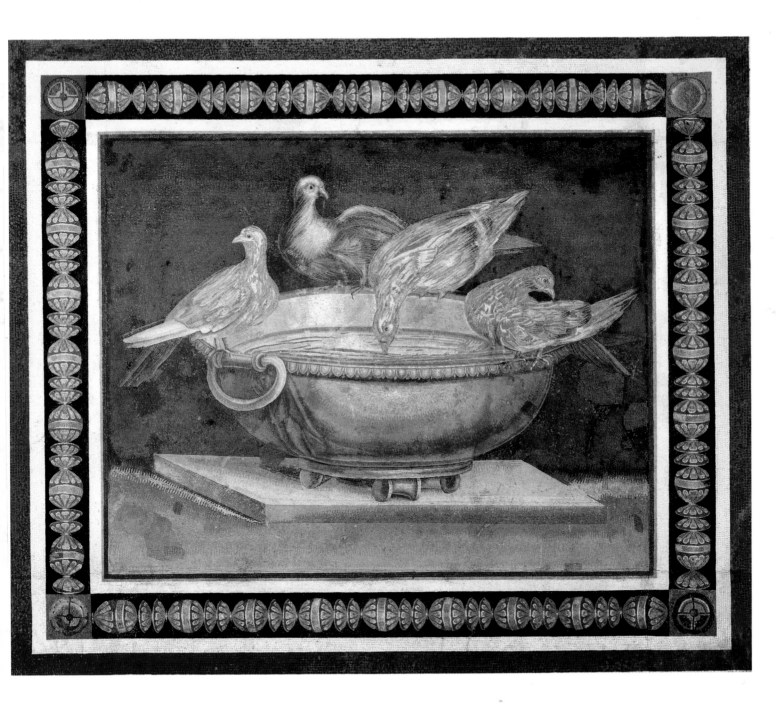

Four Doves Drinking at a Fountain, 2nd century AD,
mosaic from Hadrian's Villa at Tivoli, Capitoline Museums, Rome

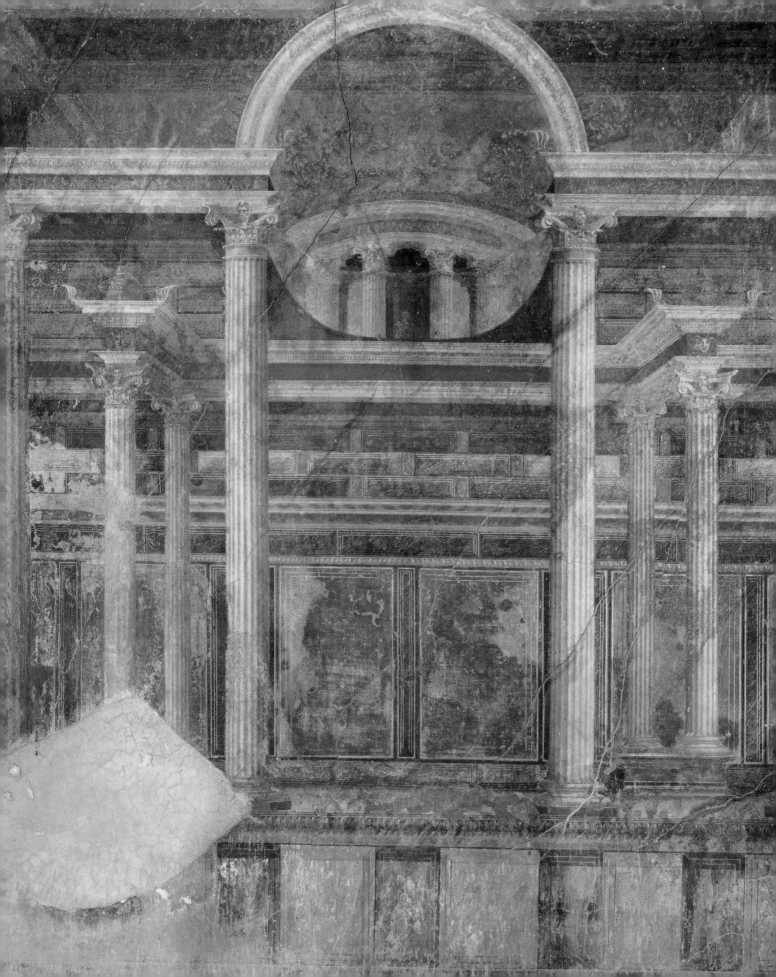

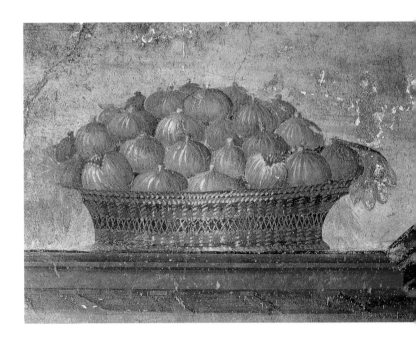

A basket of figs, detail of a wall painting, 1st century AD, Poppea's Villa at Oplontis, near Naples

Cubiculum 16 (detail), c. 60–50 BC, wall painting, Villa dei Misteri, Pompeii, Italy

JAN VAN EYCK

c. 1390–1441

During the Renaissance, the spectacular trompe l'oeil effects achieved by painters brought greater recognition to their trade and so enhanced their status. The technique of grisaille in particular, prized by master glaziers for stained glass windows and also by painters of miniatures, allowed them to show off their illusionist skills to perfection.

It takes only a glance at his famous painting in the National Gallery in London to realize what a passion Van Eyck had for demonstrating his artistry. In the Arnolfini portrait he not only clearly exhibited his command of the rules of perspective, which were then becoming required learning for artists, he also illustrated the very mechanics of painting. Reflected in the small convex mirror in the background of the picture are witnesses to the scene—and perhaps even the figure of Van Eyck himself, urging viewers to get closer in order to appreciate the minute detail of his work. Such was his mastery of oil paint, his ability to depict the finest physical details and the subtlest effects of light, that he was credited with inventing the medium. What is being championed in this picture is painting itself: in its perfect verisimilitude and attention to detail, it underscores the dignity of the discipline. The inclusion of the tiny reflection of the scene is designed to illustrate that nothing is beyond the scope of painting: it can even depict things from behind, comprehensively. In the fifteenth century a painter's trade was founded on skill and it was vital for Van Eyck, who was employed at court, to demonstrate his. Painters continued to seek recognition for their trade and between the fourteenth and sixteenth centuries their status was elevated from that of craftsman to that of artist.

It is clear therefore that it was here that the primary value of subtle pieces of illusion lay. But illusion was also used in works designed to promote devotion, as in the case of Van Eyck's works in grisaille. This technique, used by Giotto in his frescoes in the fourteenth century, was refined to perfection with the advent of oils. Like other Flemish painters of the period, Van Eyck used this trompe l'oeil technique in paintings of religious subjects. Grisaille involves painting in a range of grays and allows artists to imitate sculptures made of stone, often in combination with small projecting architectural elements such as niches. This creates an illusion of depth and volume: viewers have the sense that the statues are coming out towards them. Trompe l'oeil bridges the gap between the space in the painting and that inhabited by the viewer. The aim was for the viewer to be stirred to devotion by the quality of the illusion. The technique lent itself particularly well to religious subjects because it offered an imitation that is at once perfect but deferential. Grisaille creates images that border on the real, and yet at the same time present themselves humbly as imitations.

The Arnolfini Portrait, 1434, oil on wood panel, 82 x 62 cm, National Gallery, London

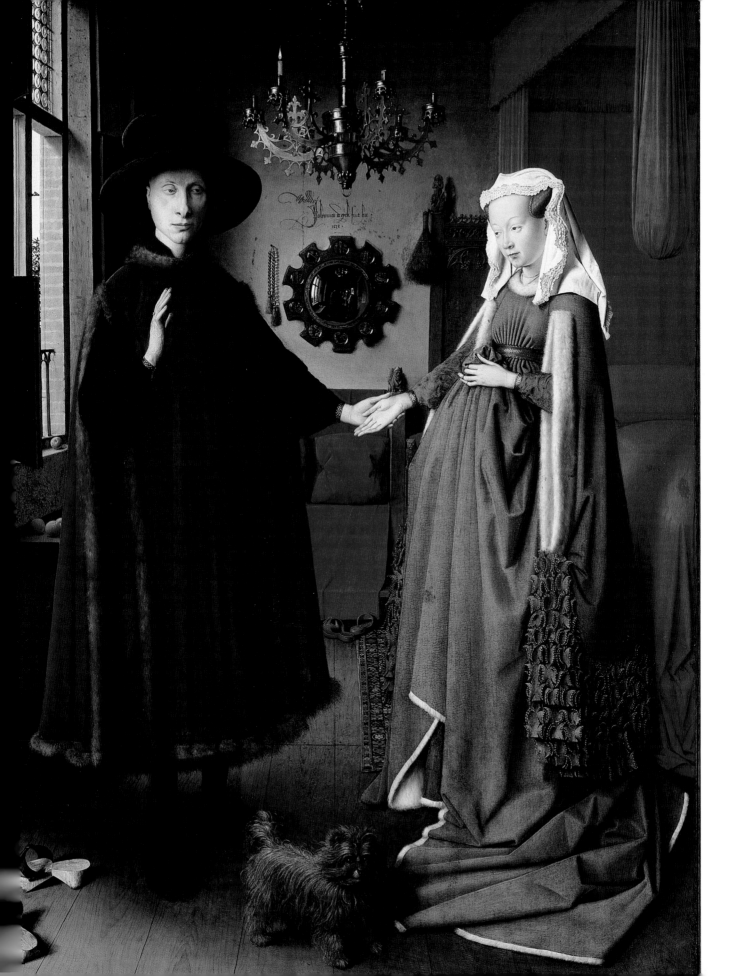

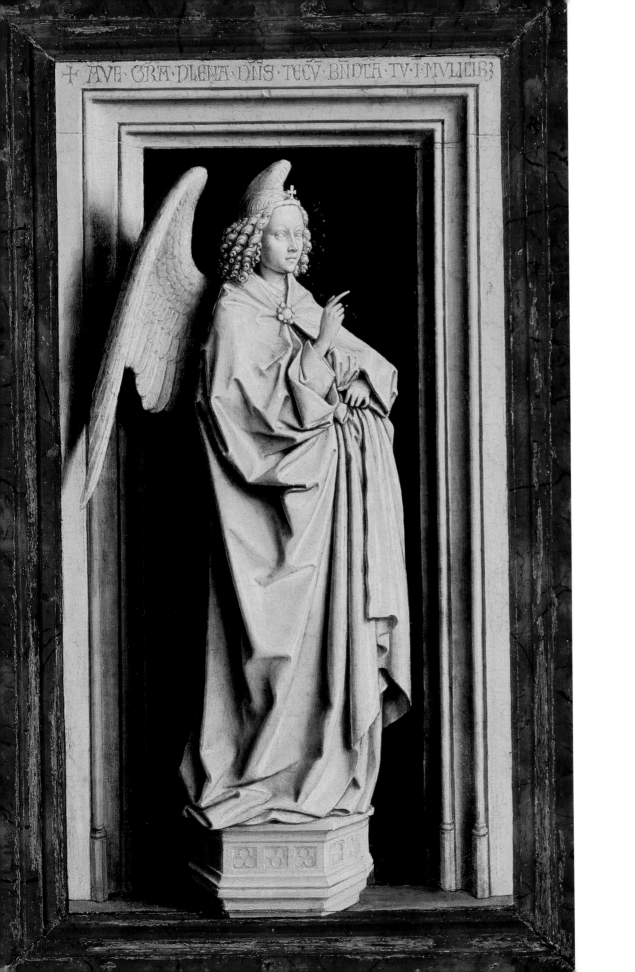

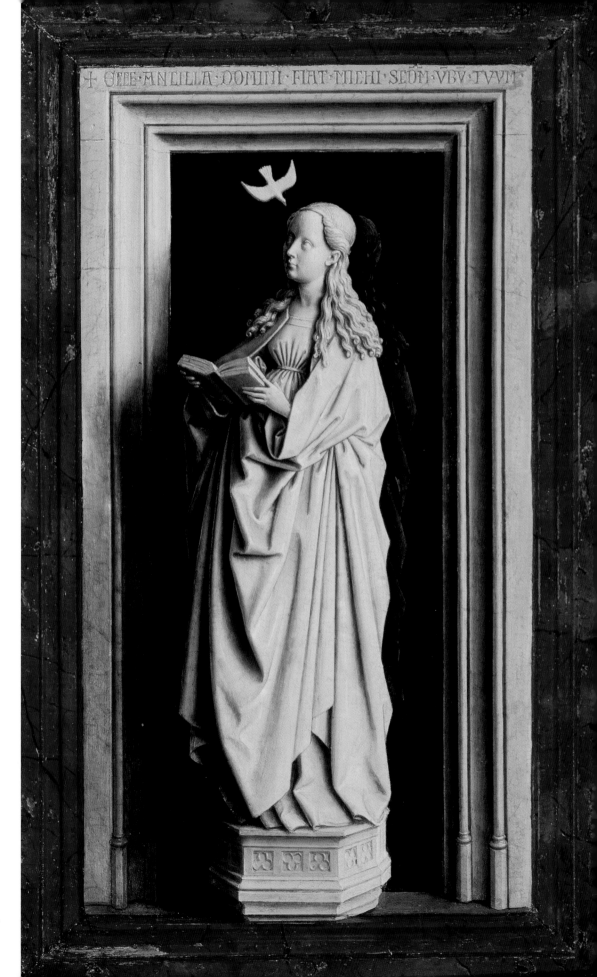

＋ ECCE ANCILLA DOMINI · FIAT · MICHI · SCDM · VBV · TVVM

The Annunciation Diptych,
c. 1433–1435,
oil on wood,
38.8 x 23.2 cm, and 39 x 24 cm, Thys-
sen-Bornemisza Museum, Madrid

MICHELANGELO
1475–1564

Painters in ancient Greece and Rome had already found pictorial ways to enrich interiors. At the start of the fourteenth century, Giotto went a stage further and began using trompe l'oeil in the decoration of religious buildings. Two centuries later, Michelangelo took the relationship between painting and architecture to a dizzying new level in his work in the Sistine Chapel.

In the early fourteenth century, as artists mastered the rules of perspective, decorative painting graduated from being purely decorative to becoming an extension of architecture. In the case of the Sistine Chapel it could even be said to transcend it. Michelangelo's decoration of the vault literally makes the ceiling disappear. The painting obliterates its support: the surface ceases to exist, the architectural masses lose all definition, and the painted scenes seem to float in space.

Work started on the Sistine Chapel in the 1480s, with famous artists including Perugino and Botticelli being hired to decorate the walls with religious scenes executed in trompe l'oeil. The scheme also included portraits of popes in painted niches. At this time the vault was decorated with a starry sky that was subsequently badly damaged when reinforcement work was carried out. This led to Michelangelo being commissioned to redecorate the vault in 1508. He launched himself into the work with great enthusiasm. It was a monumental undertaking which took four years to complete, and required a special scaffolding system to be built to allow him to paint a ceiling over 20 meters above floor level.

Along the 40-meter length of the ceiling, Michelangelo depicted scenes from the Book of Genesis: the Separation of Darkness and Light, and the Creation of Adam—the famous scene in which the finger of God reaches out to touch that of Man. But Michelangelo was determined to structure his decoration of the vault so that it tied in with the existing frescoes. By using trompe l'oeil he was able to connect the different spaces: the painted links he contrived between the walls and ceilings mean that we lose all spatial bearings. As far as the ceiling itself is concerned, Michelangelo's tour de force lies in the fact that he did not use a single point of view, but opted on the contrary for multiple and successive vanishing points. The effect is that the viewer, who is met on all sides by illusion, is completely immersed in the painted scenes. The biblical stories blend with the viewer's own existence, the figures come to life and enter the present moment.

Ceiling and Lunettes, Sistine Chapel, 1508–1512, frescoes, Vatican Museums, Rome

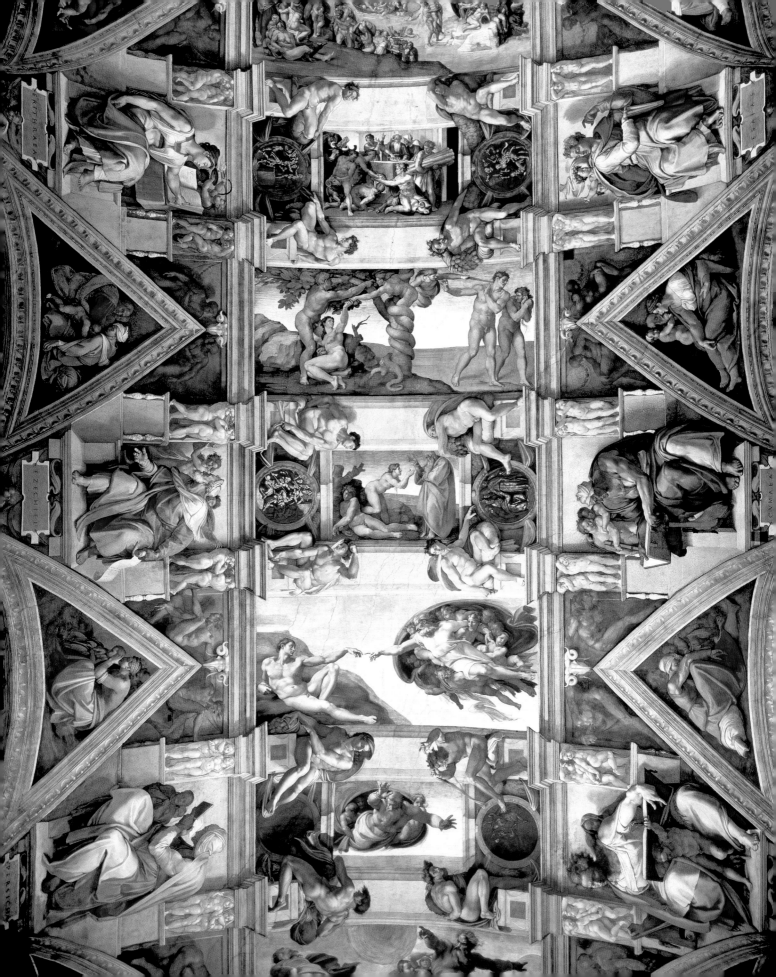

The reverse of a painting evokes the opposite of painting, the inherently unknown nature of things and the deceptiveness of art, but also the opposite of life, that it is to say death, the inescapable finality of human existence.

CORNELIS NORBERTUS GIJSBRECHTS
c. 1630–1683

Trompe l'oeil enjoyed unprecedented success in the seventeenth century. Once confined to frescoes and painted architectural elements, it found its way into easel painting and became an artistic genre in its own right. Some artists in northern Europe, including Cornelis Norbertus Gijsbrechts, made it their specialty.

The Baroque brought with it a renewed taste for optical tricks, illusions, and deceptions. Artists were expected to display their wit and trompe l'oeil gave them limitless scope to conjure up arresting images. At the beginning of the seventeenth century, a classification began of the different subjects and techniques of art, and a hierarchy of genres emerged that stretched from drawing all the way up to history painting. Trompe l'oeil became recognized as a genuine art form, albeit a minor one. It developed in the Netherlands and Flanders, where painters in the fifteenth century had used perspective to recreate the minutest details to perfection. Commissions from the aristocracy and the Church gave way to demands for paintings from the bourgeoisie, and the scale and subject matter of pictures changed to suit the more modest homes and tastes of this new clientele. Easel painting—mainly still lifes and landscapes—was more appropriate than the large formats required for history painting. Artists in Antwerp in particular specialized in illusionist and trompe l'oeil painting. Among them was Cornelis Norbertus Gijsbrechts, who began his career there around 1659, before being appointed painter at the court of Denmark. There he painted a series of pictures for the Danish kings exploring the potential of trompe l'oeil in all its guises, in no particular order, from the reverse sides of paintings to vanitas still lifes. Gijsbrecht's work is illusionist through and through. One painting even features a painted easel with a finished picture on it and a stretcher, palette, and medallion with an image of the painter hanging from it, all painted in trompe l'oeil on wood cut to imitate the contours of the real objects. As well being purely entertaining, trompe l'oeil pictures, like vanitas paintings, invite the viewer to reflect on the meaning of life and the vain pretension of art.

The Reverse of a Framed Painting, 1670, oil on canvas, 66.6 x 86.5 cm, Statens Museum for Kunst, Copenhagen

PERE BORRELL DEL CASO

1835–1910

Trompe l'oeil remained in vogue from the seventeenth to the nineteenth centuries, but art critics eventually derided purely illusionist painting. A now famous painting by the Catalan painter Pere Borrell del Caso conjures up in trompe l'oeil the difficult position faced by any artist of his day who chose to pursue the genre.

Although some European artists continued to produce paintings in trompe l'oeil, by the end of the nineteenth century the genre was increasingly reviled by art critics and by artists themselves. Both Romanticism and the Realism that was beginning to emerge in painting had very different ideas about how to conjure up reality, and were not remotely interested in the illusionist manner of trompe l'oeil. Art set itself new tasks and was now prepared to criticize society. Artists no longer hid behind the brilliance of their work, but instead asserted their presence as individuals ready to take a stand. Illusionism now seemed a superficial response to reality. Although Realist painters still strove to achieve a likeness, they were no longer content simply to copy reality—they wanted to interpret it. Trompe l'oeil continued to be useful as a means to an end, as a way of making details appear realistic, but it was no longer an end in itself as far as painting was concerned. Photography had arrived, and the mechanical reproduction of reality was now its province.

It is not surprising in the circumstances that critics should have been harsh towards Pere Borrell del Caso. He was forthright in his response, producing an image of an anxious young boy escaping through a picture frame, a painting he entitled *Escaping Criticism*. It is a striking visualization of the plight of an artist forced to abandon his art, so virulent is the criticism that pursues him. At the same time, Caso suggests that the painting in the picture is a window open to another reality, the imaginary world of painting. By accentuating the frame the figure clings to, he emphasizes the boundary between the space of the painting and that of the real world, calling both into question at the same time. The picture seems to come out to viewers, thereby pulling them into the scene and into the debate. Caso succeeded in his response to criticism, after his death at least, since this work has become emblematic of trompe l'oeil in easel painting.

Escaping Criticism, 1874, oil on canvas, 76 x 62 cm, Bank of Spain collection, Madrid

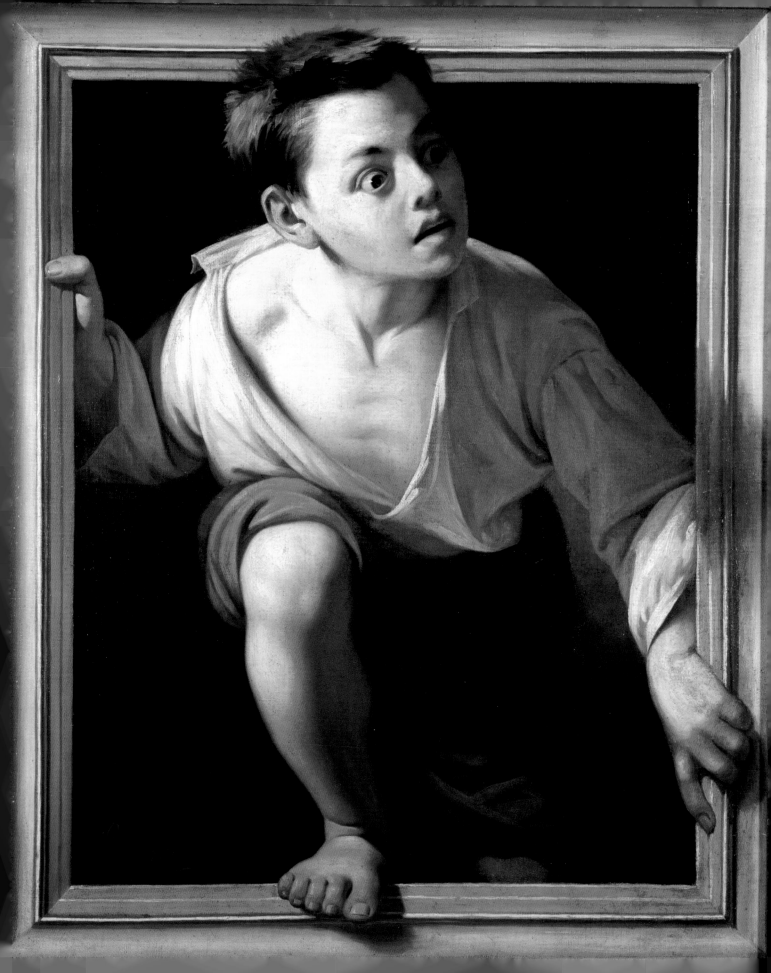

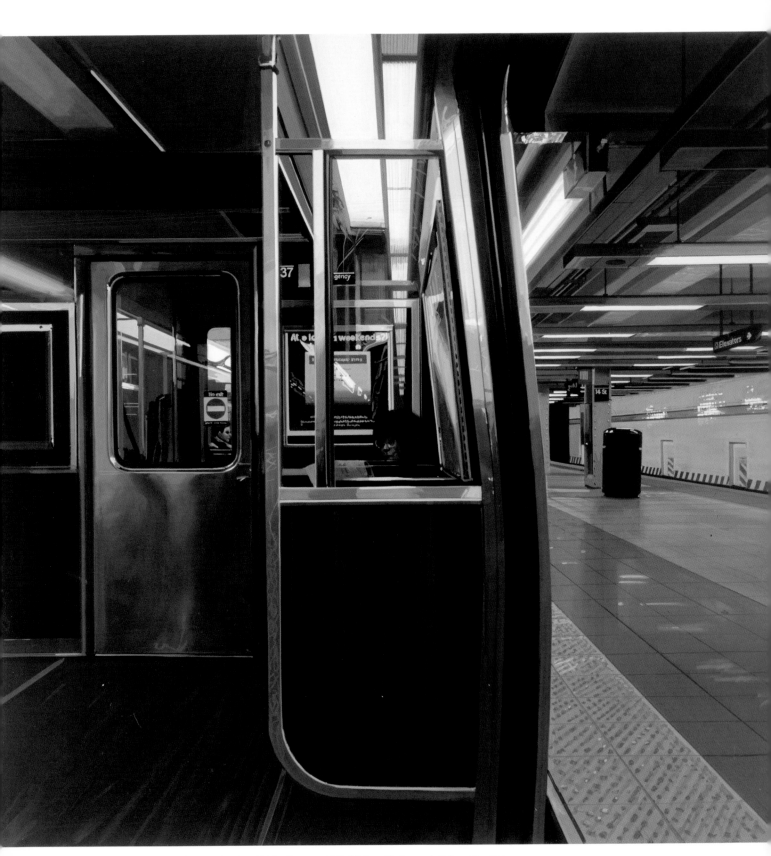

14th Street Subway Station, 2003, oil on wood, 52 x 50.8 cm, Marlborough Gallery, New York

RICHARD ESTES

1932–

In the mid-1960s in the United States a group of artists began producing enormous painted images that were so like photographs as to be readily mistaken for them. Art critics dubbed these artists "photorealists" or "hyperrealists." Richard Estes's work epitomizes this style of painting.

Photorealism was a surprising phenomenon at a time when anything and everything seemed to go in art, and even an artist's own body could be used to create an artwork in a performance or "happening." Its practitioners were studio painters who worked from photographs that they copied minutely onto canvas. They found their subjects in ordinary American life, and in this respect they followed in the footsteps of the Pop Art movement that went just before them. Their pictures do not have the same critical dimension, however, nor are they overtly ironic, though they do reveal the uniformity of consumer society. The hyperrealists portrayed the world around them in all its ordinariness: streets and shops, signs and neon lights, cars and motorbikes, suburban houses and diners. "Hyperrealist" was the term Europeans coined to describe such works when they first began to take an interest in them in the 1970s. They named this form of art "hyperrealist" because it does not seek in any way to represent reality: it imitates something beyond reality, an image of reality. These artists copied photographs precisely so that their works would give the impression of a photographic image.

Most photorealists use a slide projector to transpose an image onto canvas. Some use stencils in combination with this projection technique, while others use a grid to scale up the image. Some paint with brushes, others use an airbrush. Richard Estes's method is to paint from photographs which he projects onto a screen set up next to his easel, drawing from these in just the same way he would if he were drawing from an actual landscape.

Estes paints the background in acrylic and the details in oils. He takes a number of shots of the same scene to create each painting. This means he ends up with a landscape that does not exist, that no camera could capture. He reconstructs reality in his own way, sharpening areas that are blurred and accentuating colors. What is immediately striking about pictures of this kind is the sheer virtuosity of the artist. But this sense of awe is quickly replaced by a sense of unease, because these huge pictures seem to say nothing—they reveal nothing but their dazzling surface, just like contemporary society.

Following pages: *Supreme Hardware,* 1974, oil on canvas, 111.8 x 163.8 cm, High Museum of Art, Atlanta, Georgia

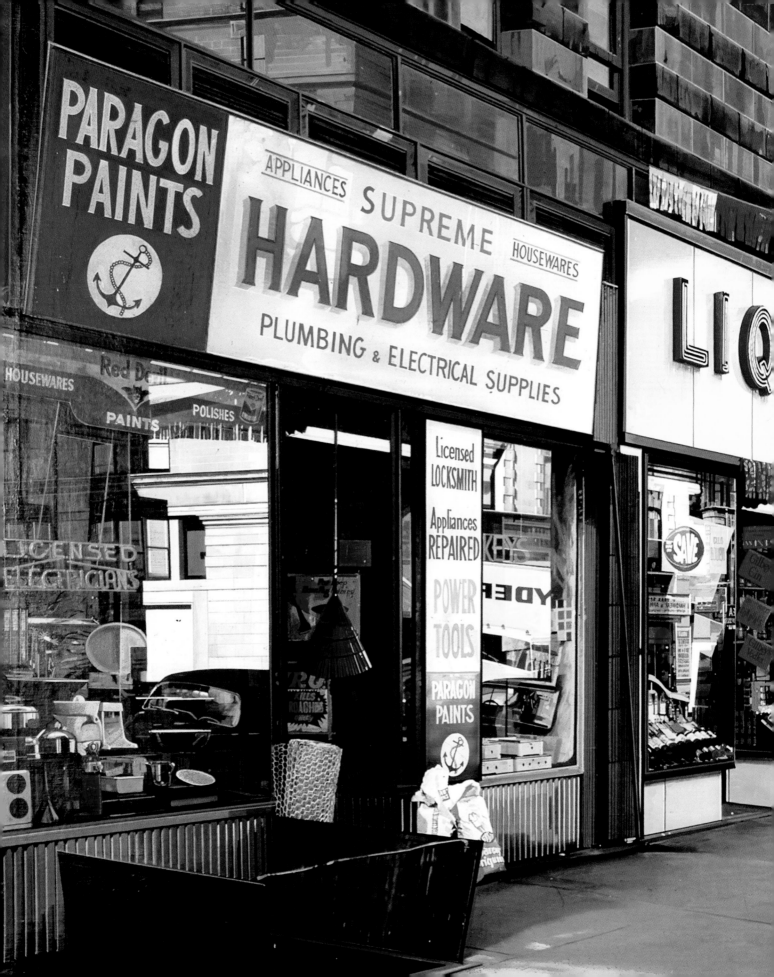

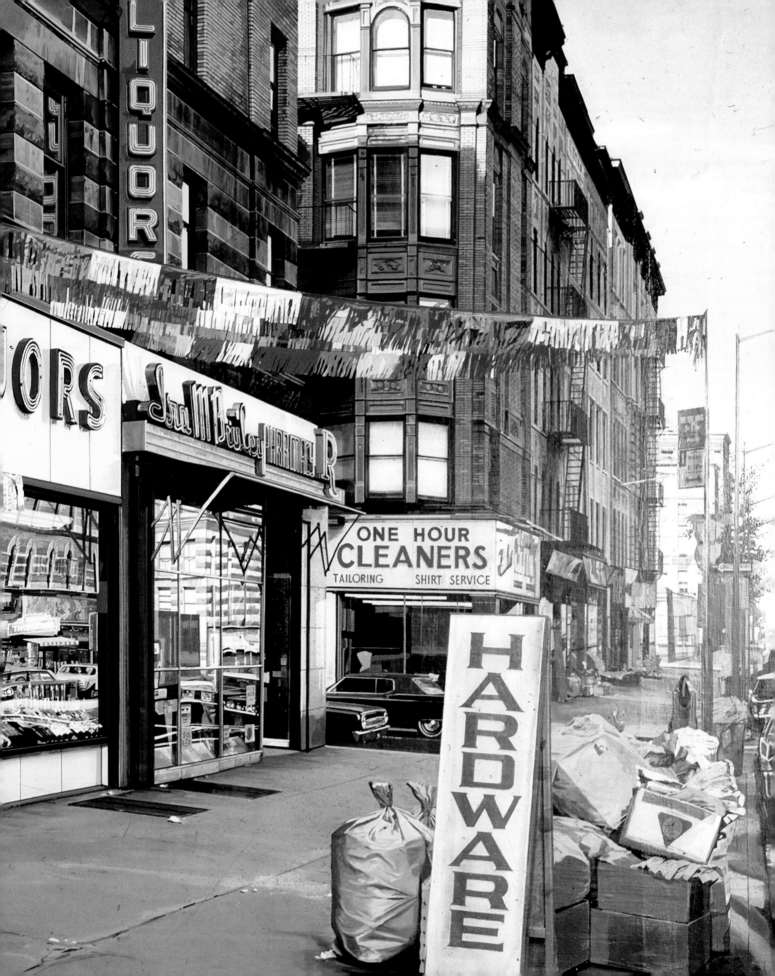

JOHN DE ANDREA

1941–

Since the late 1960s the hyperrealist sculptor John De Andrea has been ma▓ sculptures that are truer than life, working from living models to create pe▓ replicas of their bodies. Initially he used synthetic materials; more recentl▓ reverted to a more traditional practice and using bronze, which he paints in tro▓ l'oeil.

At the prestigious documenta show in Kassel in 1972, John De Andrea exhibited a sculpture of a naked couple locked in tight embrace. Cast in polyester and fiberglass from living models, these life-size figures looked disturbingly like real human beings. The nakedness and obvious intimacy of the figures made the illusion even more unsettling, forcing viewers into a kind of voyeuristic relationship with the sculpture. Visitors to the exhibition would have been able to appreciate just how perfect an imitation it was: every tiny variation in the surface of the skin is perfectly rendered, down to the smallest wrinkles and translucent veins, and with real hair grafted strand by strand. De Andrea's figures are generally nude, so they do not carry any sociological connotations or embody any critical standpoint. Nor is there anything erotic or directly provocative about these figures: for De Andrea the perfect imitation of life is part and parcel of sculptural practice. Some of his figures take up poses drawn from classical sculpture—ancient figures of sphinxes, for instance, or academic studies of sculptors and their models. The effect is to make viewers connect the sculptures not simply with real people but also with all the various attempts there have been to represent the human form in the course of the history art. This is undoubtedly what De Andrea has been working towards since 2000 with his work in bronze, that quintessentially classical sculptural material. His bronze sculptures demonstrate his command of traditional techniques, but there is more to them than mere virtuoso display. His sculptures of human bodies hark back to Greek sculpture, while disassociating themselves from its aims. No ideal of beauty informs these figures, in so much as they are modeled on real people and are therefore necessarily imperfect. De Andrea's figures subvert all academic ideas of order because their proportions vary from one piece to another depending on the model. It is the particular, unique character of the living person on which it is based that dictates the form of the sculpture, a form captured through the medium of a painstaking and meticulous trompe l'oeil.

DUANE HANSON
1925–1996

Throughout his career, the sculptor Duane Hanson made it his mission to turn reality into imitation. What distinguishes him from his hyperrealist contemporary John De Andrea is the critical edge to his work. His favorite subjects are the people society contrives to make invisible. Through his sculptures he gives their unobtrusive existence a physical presence and allows them to thrust themselves into a reality that generally tries to ignore them.

Duane Hanson undoubtedly does manufacture imitations from reality: not only does he cast his sculptures from living models, but he also dresses them in real clothes and surrounds them with real props. The figures themselves may be made from synthetic materials, but they look like living beings. The hair on their bodies and their heads is real hair, the clothes they wear have been worn before, their immediate environment is made up of secondhand objects with social and cultural connotations. With his meticulously rigorous technique, Hanson can imitate the smallest detail perfectly, and by making his figures life size he enhances the illusion that they are real people still further. What is really remarkable about his figures, however, is the authenticity of their poses and attitudes.

All of them look as if they have been caught mid-moment as they go about their daily lives, like the cleaning lady who has stopped her work as though to stare into the lens of a camera trained on her. Hanson takes it upon himself to cut sections out of real life and reproduce them in three dimensions. His figures are products of the American Way of Life, representatives of America's middle class. His work is akin to photography: it gives the illusion of not venturing beyond mere description. As a result, it makes the viewer wonder if it is society that makes these figures into the caricatures they are long before the artist has anything to do with them: consumer society has profoundly altered people as individuals, often without their realizing it. Pop Art had already held up a mirror to mass consumerist society, whose rise was contemporary with its own. But when Duane Hanson depicts a supermarket shopper or tourists on holiday, these figures physically obtrude into our space: these sculptures bring us abruptly face to face with our contemporaries, with our own image, and with what we refuse to see. These "truer" than life imitations reveal a sort of excessive reality that provokes a feeling of unease. Of course, once the illusion is dispelled, we know that these are only sculptures, but we are left with the niggling sense that our consumer society can turn people into mere figures that are far from heroic.

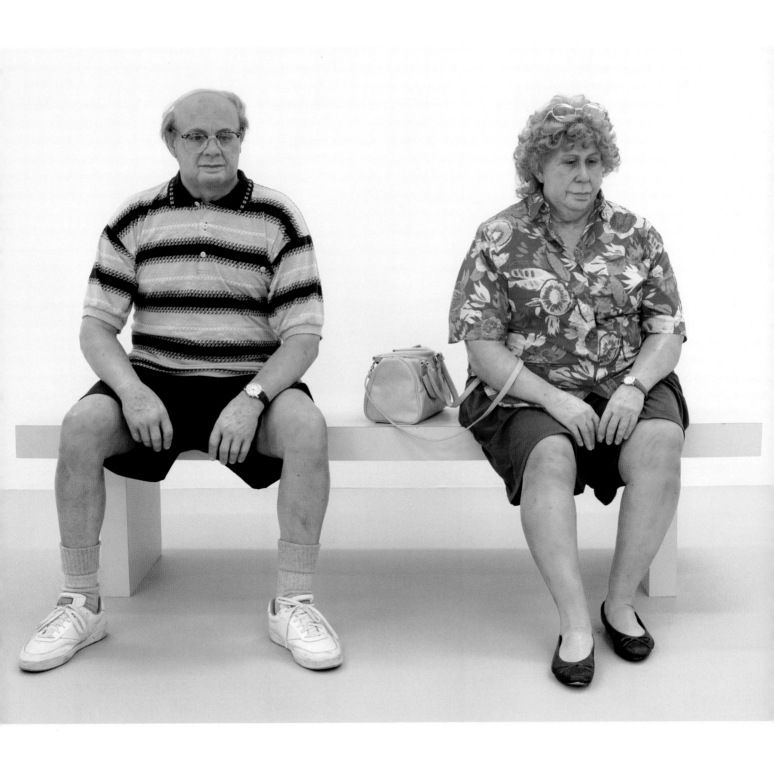

Old Couple on a Bench (edition 1/2), 1994,
polychromed bronze, mixed media and objects, life size, reverse order: Hanson Collection, Davie, Florida

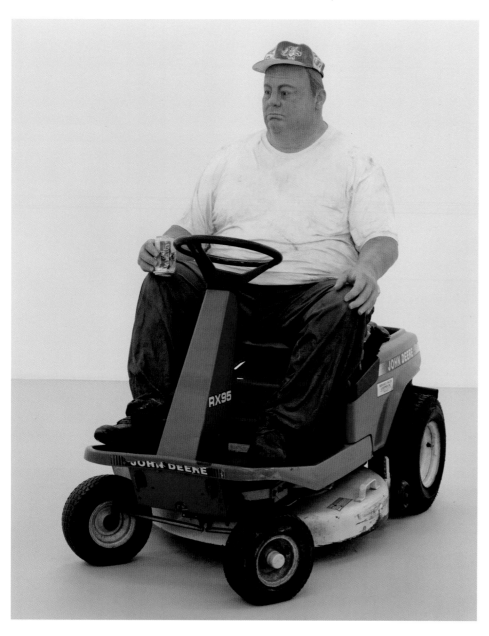

Man on a Mower (edition 1/3), 1995, polychromed bronze,
mixed media and objects, life size, Hanson Collection, Davie, Florida

Queenie II, 1988, polychromed bronze, mixed media and objects, life size,
Hanson Collection, Davie, Florida

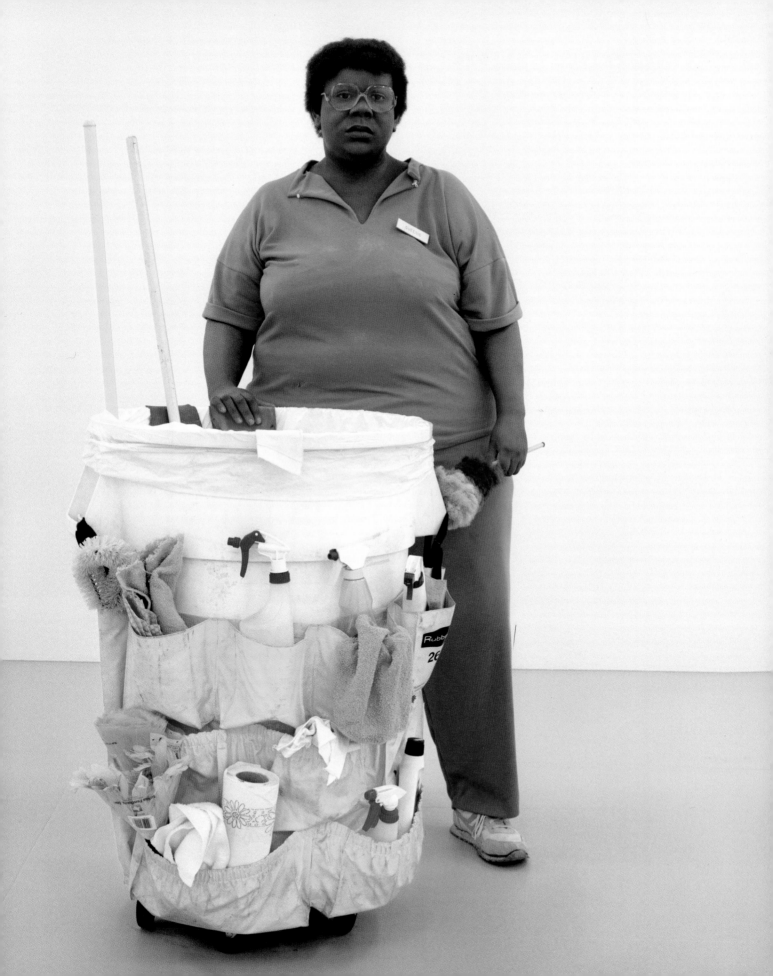

GERHARD RICHTER

1932–

The German artist Gerhard Richter does more in his work than painstakingly recreate the appearance of reality—he makes the point that artists do not invent beautiful pictures. He demonstrates how much our response to the world today is determined by the many images around us.

From the moment photography was invented, painters in the nineteenth century used it rather than drawing to gather and record information. Pop artists exploited photography in their turn in the 1970s, applying mechanical means of reproduction to art. Contemporary with Andy Warhol's first screen-prints, Gerhard Richter's paintings also draw on photography. Richter paints from black-and-white photographs, amateur snapshots, images in newspapers: he uses images that are flat and ordinary. Like the photorealists, he is interested in photography not for its ability to capture reality. In fact, he questions the validity of photographic reproduction. He produces paintings in the most traditional sense of the word—oil paints on canvas—but paintings that make obvious the unsophisticated nature of the photographs on which they are based. Richter's paintings show how photography has gone from providing a limitless fount of images to becoming a filter through which we are forced to look at reality. And it is not a neutral filter: by juxtaposing tragedy and comedy, and treating them in the same way, the images purveyed by the media ultimately reduce everything to the same level. Richter's painting shows photography to be a lie—but one that has comes to stand for truth in a society utterly in thrall to images. There is no question of his valuing painting at the expense of photography, however: these figurative works represent just as much of a criticism of traditional painting. By painting two lighted candles in a photorealist manner, for instance, Richter is in effect ridiculing the vanitas convention in art. What is traditionally a symbol of the fragility of life looks like a Polaroid snap and is treated without a shred of dignity. At the same time, he manages to make painting challenge both the way reality is represented and the way we see it, and a photorealist approach provides him with the perfect means to do so.

Betty, 1988, oil on canvas, 102 x 72 cm, Saint Louis Art Museum, Saint Louis, Missouri

Familie Am Meer, 1964, oil on canvas,
150 x 200 cm, Museum Küppersmühle
für Moderne Kunst (MKM), Duisburg, Germany

JEFF KOONS

1955–

The contemporary art star Jeff Koons follows closely in the footsteps of Pop Art, copying the materialist reality of consumer society and exaggerating it to the point of monumental kitsch. Some of his works draw on the techniques and seductive power of American photorealist images of the 1970s.

With their potentially vast scale and dazzling colors, advertising images have the power to thrust themselves into our everyday lives and turn the most humdrum reality into something spectacular. This was certainly the case in America in the 1960s and 1970s, and it is now true the world over. Jeff Koons is fascinated by objects and by the way images enhance their value, and this is what his work explores. He began his exploration in the early 1980s with a series of vacuum cleaners in glass display cases. He subsequently became interested in kitsch, developing a penchant for "bad taste" knick-knacks that he would reproduce in an exaggerated form and using expensive materials. He made a life-size replica of a figure of Michael Jackson, for instance, out of gilded porcelain, and his gigantic *Puppy* dog, which is 13 meters high and currently sits outside the entrance to the Guggenheim Museum in Bilbao, is made out of bedding plants. Koons enjoys blurring the boundaries between high and popular art, and between fine and decorative art. He gives a value to things that are scorned by good taste, and there is a large dose of both humor and irony in his work. He takes images from the least cultural contexts imaginable and manages to get them into the very best museums in the world and the collections of the keenest contemporary art buyers. He is interested in photorealism for the same subversive purposes, and for many his works in the 1970s border on the kitsch. Since the late 1990s he has been using software to break down photos into tiny numbered areas that are then projected onto huge canvases and filled in section by section by assistants. Trite subjects, huge scale, shimmering reflections, dazzling colors, perfect imitation—the recipe is as effective as ever. These pictures tell us nothing, seem to present nothing to look at beyond a brilliant surface. And despite the obvious sense of fun, there is something disturbing about their scale and the over perfect reproduction of materials.

Play-Doh, 1995–2007, oil on canvas, 333.5 x 282.1 cm, Jérôme de Noirmont Gallery, Paris

RENÉ WIRTHS

1967–

Using traditional painting techniques and materials, René Wirths captures reality as an entomologist captures specimens. For several years he has been slowly building up a catalogue of everyday objects, treating them in a way that reveals qualities not apparent when they are seen in their usual contexts. His illusionist work makes things that we thought very familiar suddenly seem alien.

Although he renders the objects he paints with extraordinary technical perfection, René Wirths does not seek to create trompe l'oeil images. There is no danger of mistaking his images for reality: the painted objects are always many times life size. Lettuce leaves over a meter high, bicycle wheels as tall as a man—such things do not exist. The artist may deceive us with his illusion, but he makes the deception obvious.

For Wirths it is not the object itself that is important, but what the painting can reveal about it. His subjects everything he chooses to paint to the same treatment. Just as in a scientific experiment, the object is taken out of context, set against a neutral white background, greatly magnified so that every detail is clear, as if it were being viewed through a microscope, and harshly lit as if for a surgical operation. The effect is of a butterfly mounted and pinned by an entomologist, or of a mugshot in a police file, but with a shoe, chair, or bicycle in place of a suspect's face. The object, whatever it may be, is stripped of all connotations, all idea of use. It acquires a certain purity, reduced simply to its form and color, and it is this that causes the strange unease that René Wirths's works produce. Perfect, solitary, and monumental, these images block our instinctive response to attach personal memories to familiar objects, and we become no more than spectators in front of a painting.

Embedded in some of his works is a trace of the painting process that went to produce them: the glimmer of a studio window, for instance, or the reflection of the artist himself. In 2008 Wirths exhibited his works under the title Still *Life*, but the following year he called his new series *Life*: it included drawings of children and a boat made out of folded paper, but also a skull evocative of the fragility of life. Drawing on a rich vein of tradition, but without allowing himself to become trapped in any one genre or kind of painting, Wirths demonstrates the continuing power of illusionist painting.

Paintbrush, 2007, oil on canvas, 190×110 cm

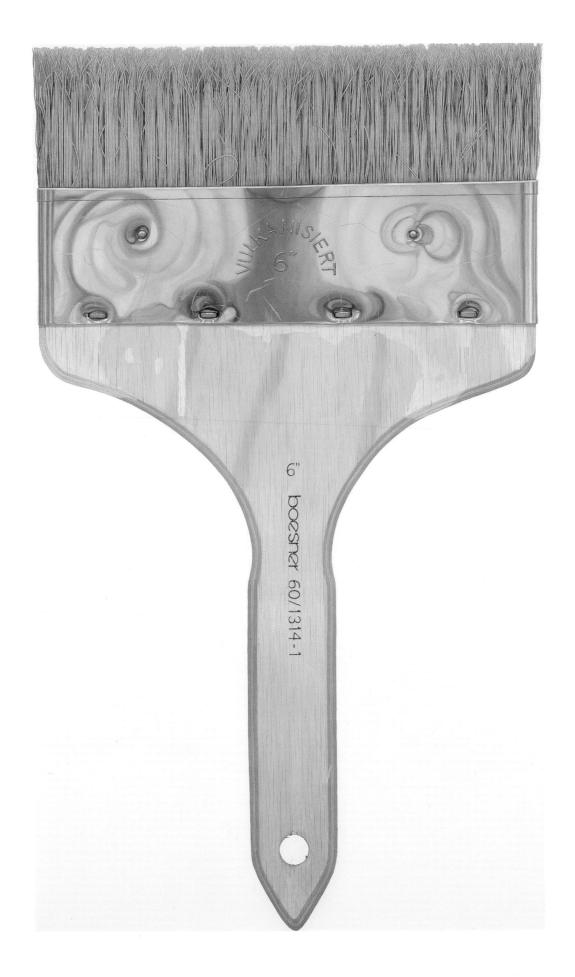

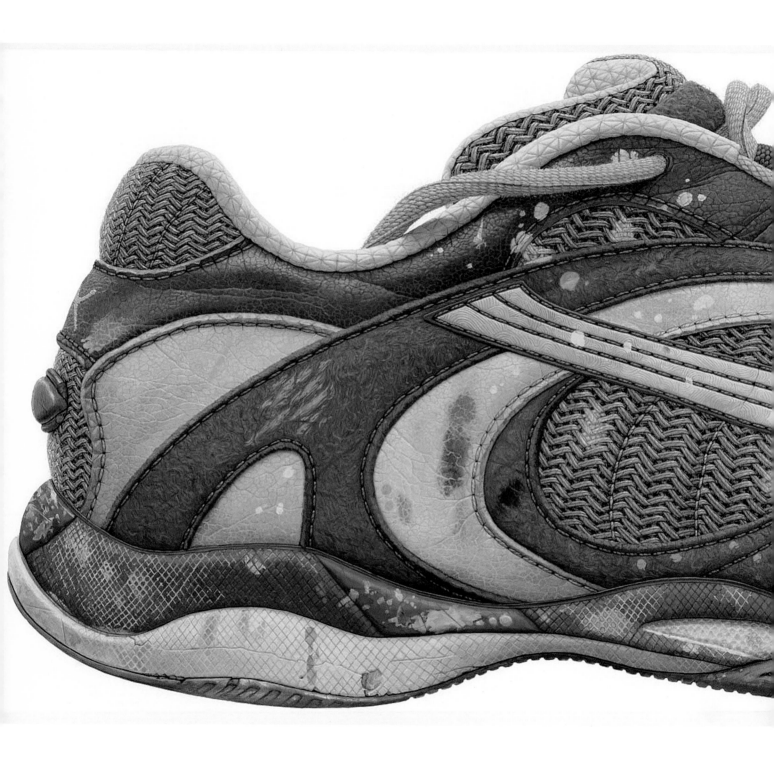

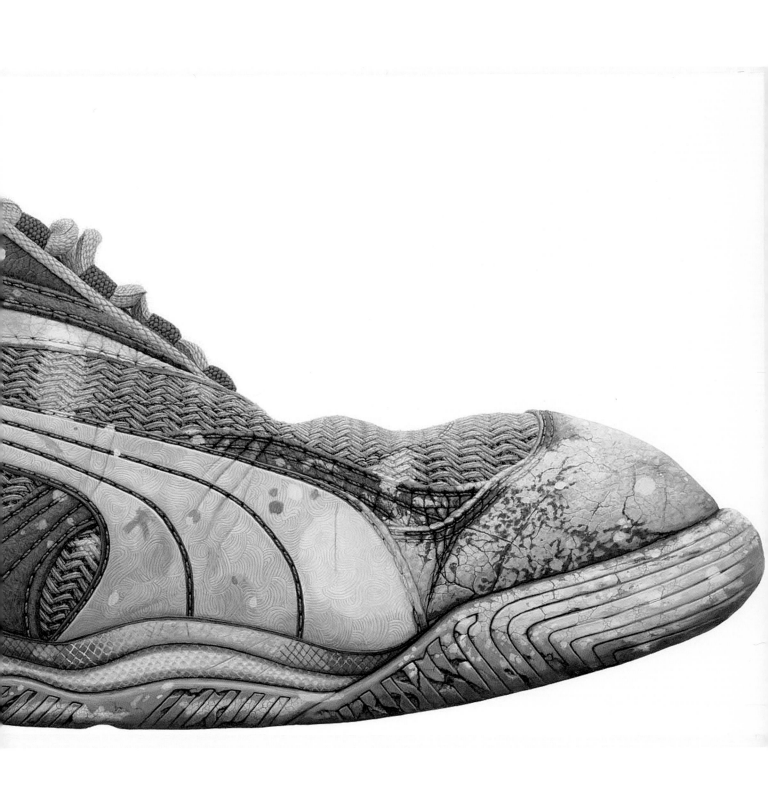

Shoe, 2008, oil on canvas, 100 x 204 cm

DAN WITZ

1957–

Over the last 30 years Dan Witz has been dividing his time between studio paint-ing and street-art installations, displaying a perfect mastery of pictorial illusion whether he works in the studio of in the urban environment. Equally at ease with old master techniques and the latest digital technology, he deftly combines the two, adding to the mix a distinctly twenty-first century way of seeing the world.

Dan Witz began his career in New York in the late 1970s. In his first large-scale project, *The Birds of Manhattan*, he painted delicate hummingbirds all over the streets of his neigh-borhood in Lower East Side, deliberately avoiding Soho because he thought there was already quite enough art there. Witz is minutely detailed in his approach, using tiny brushes and acrylic paints to get the painted birds to scintillate like real hummingbirds in flight. He paints in situ or on stickers which he later puts up in incongruous places so that they will create a poetic effect. He returned to the series of *Birds* in 2006 when he felt forced out of his studio in Manhat-tan by the tide of gentrification sweeping through the neighborhood. He marked the end of his time in New York with this final trademark piece. He had begun to comment on the way things were going in the Lower East Side in the early 1990s with his *Hoodies* series of hooded figures painted on posters. These ominous apparitions symbolized a kind of fighting back against the rising criminality and drug abuse driving residents out of the area. By night and completely ille-gally, he pasted a total of 75 hoody posters on façades and windows, particularly of condemned buildings. The same figure reappeared in 2005 on the streets of Brooklyn, where Witz is now based, but in miniature, pasted onto road signs, for example.

Dan Witz generally works in his studio before taking his work into the street, and he also paints pictures in the more conventional sense. In 2010 he produced a series of parallel scenes en-titled *Mosh Pits*, in which bodies are heaped on top of another in a mosh pit at a gig, business-men pour out of a subway station at rush hour, scores of fighting dogs pile into one another ... The series creates a staggering sense of despair, but this is perhaps offset by the echoes there are of Flemish Old Masters or Caravaggio, so complete is Witz's mastery of their technique. The allusion to Old Masters is particularly obvious in Witz's series of night scenes: where in a painting by Georges de la Tour a candle would have lit up a character's face, in a scene by Witz it is a mobile phone.

Birds, 1979, acrylic on iron column, Greenwich Street, New York

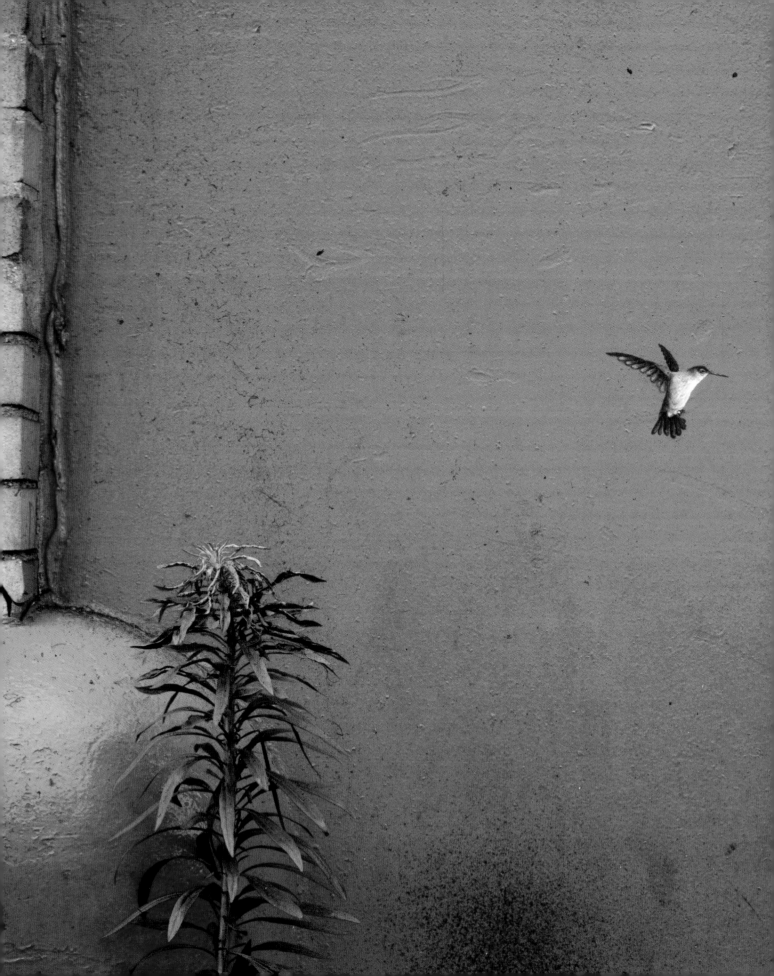

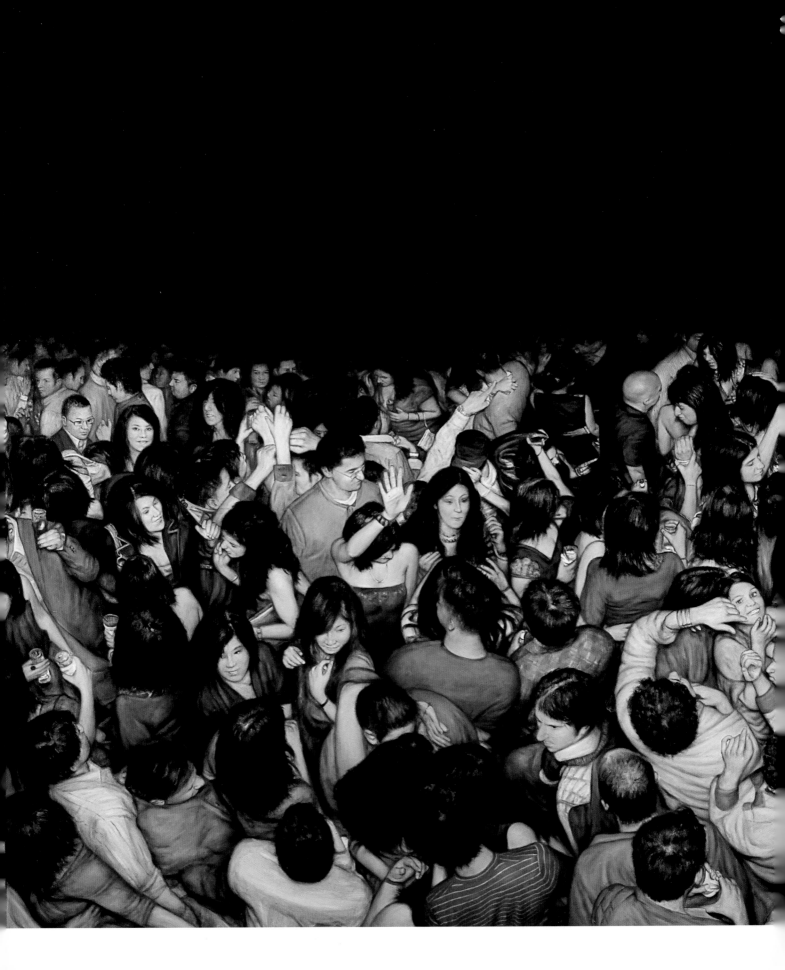

Lotus Lounge II, 2008, oil on canvas,
mixed media, 26 x 32 cm, Jonathan LeVine Gallery, New York

Big Lotus Lounge, 2010, oil on canvas,
51 x 57 cm, Jonathan LeVine Gallery, New York

EDGAR MÜLLER

1968–

Edgar Müller is a self-taught German artist who for the last few years has been turning the streets of Europe into giant trompe l'oeil paintings. With none of the provocative or critical quality of street art, his style of painting, by contrast, is decorative and playful.

The many different forms art can take in public spaces reflect the differing ideas artists have about the relationship between art and society. With the emergence of graffiti art in the 1960s, a new art form was born, at the boundary of popular art and the often provocative street culture known as "underground." These impermanent images, created in direct contravention of the city's bylaws, began to interest galleries in New York in the 1980s. Being taken up by institutions legitimized them to some extent, but free images continued to proliferate all over the world. One of the first exhibitions of street art took place in Washington in 1981 and soon a new post-graffiti art began to emerge, characterized by new techniques, including the use of stickers, posters, stencils, and even ceramics. A new kind of painting began to appear on city streets that was more pictorial and less graphic than the tags of graffiti art, and sometimes involved large trompe l'oeil effects. As a result of the Banksy exhibition at Bristol City Museum in 2009, street art has begun to be recognized as an art form by the art world and continues to gain legitimacy. Another, less provocative, strand has developed alongside street art, however, with some artists choosing to treat the urban environment simply as a backdrop for purely decorative purposes.

Since the 1980s town planners and councils have commissioned painters to revive façades or brighten bleak, gray gable-ends of buildings with huge trompe l'oeil wall paintings. Painting is being used in the same way that it was in the Renaissance, to make up for the limitations of architectural spaces. But another rather more marginal movement, dubbed "street painting," has taken off in a rather different direction, more along the lines of street performance. Edgar Müller takes over an entire section of street, for example, right under the public's nose, and spends days painting the bare pavement. As he creates illusionist paintings covering hundreds of square meters, his work is unmissable and he has been commissioned to paint site-specific pieces for festivals and public spaces all over the world.

The Crevasse, 2008, acrylic on pavement, Festival of World Culture, Dún Laoghaire, Ireland

Following pages: *The Crevasse*, 2008, acrylic on pavement, Festival of World Culture, Dún Laoghaire, Ireland

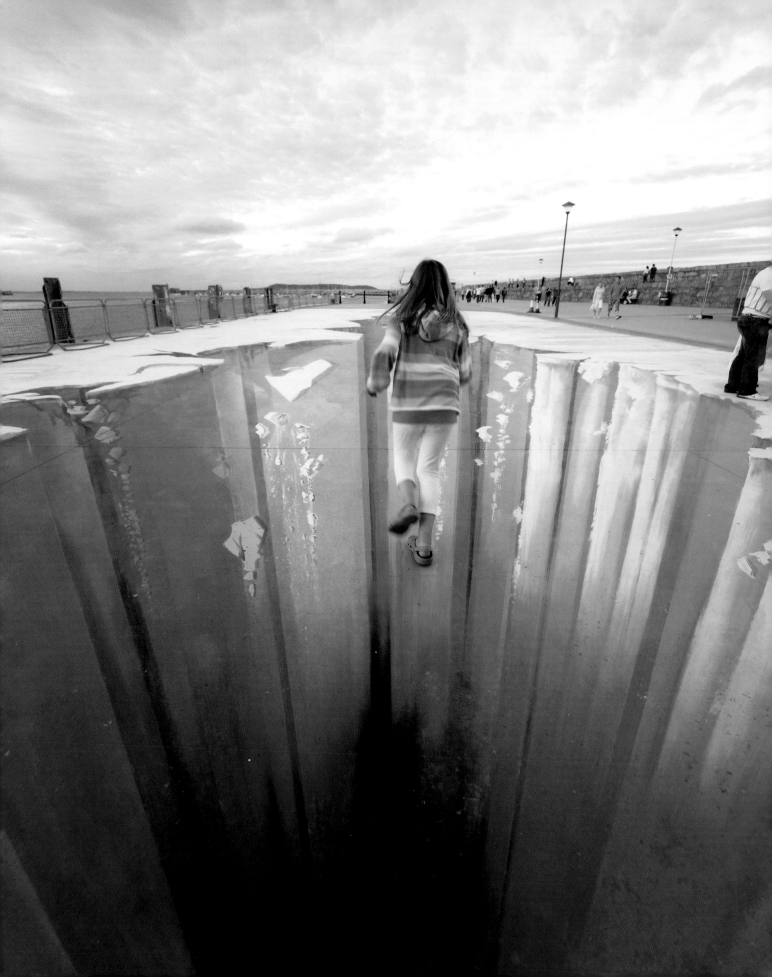

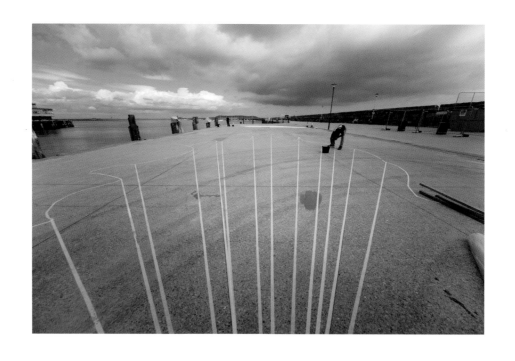

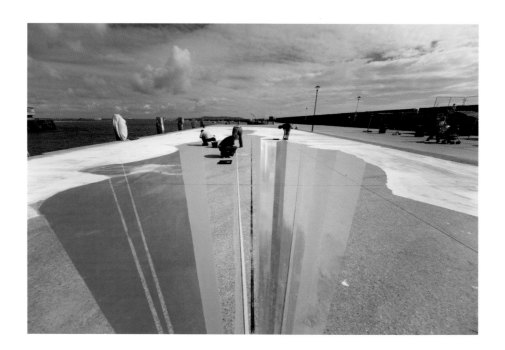

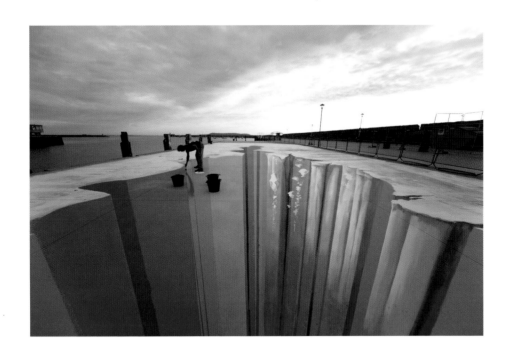

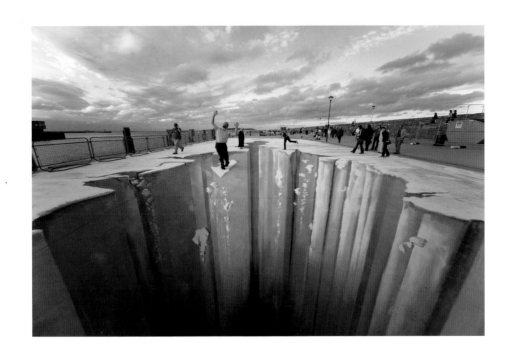

BANKSY
1974 ? –

Banksy has become a legendary figure among followers of street art and an unmistakable killjoy for the art world ... With his irreverent stencil paintings he has set his provocative and humorous stamp on public spaces from Bristol to Jerusalem.

The British artist Banksy started out in the late 1980s as part of a collective of graffiti artists in Bristol. He typically uses stencils in his murals, which amount almost to manifestos in defense of the oppressed. He takes his art into the places where such people are to be found: a central feature of street art is that it takes art out of museums and into the street, out of cultural centers and into the "real" world. Banksy painted many murals in the deprived area of Stokes Croft in Bristol. When New Orleans as ravaged by Hurricane Katrina in 2005, he went to paint walls there. In 2005 he went to the Occupied Territories and painted trompe l'oeil cracks on the wall dividing them from Israel, offering glimpses of palm-covered beaches beyond, and a girl being carried up into the sky by a string of balloons. Banksy's statements are direct, but always shot with tender humor. Two policemen kiss passionately on a wall in London, while at the zoo the animals campaign for liberation with the help of spray-painted slogans. But Banksy remains a subversive activist, sneaking in a life-size replica of a Guantanamo Bay detainee and setting it up in Disneyland, for instance.

If that were not enough, Banksy taunts the art world and its institutions and market. He has repeatedly contrived to get his work into major museums and hang it there without permission and without being seen by warders. The Tate, the British Museum, the Museum of Modern Art, New York, and the Louvre have all been the victims of his stunts. Some of his works, neatly framed and appropriately labeled, have managed to remain hanging undetected next to old masters for weeks. This is because they are camouflaged, embedded in doctored versions of famous paintings: abandoned detritus floats in the middle of Matisse's water lilies, a seventeenth-century noblewoman is pictured sporting a gasmask. Banksy also champions his own form of art in his work. One of his murals shows a council worker cleaning cave paintings off a wall: street art is similarly fragile and under threat. Yet it is a very peaceful weapon as epitomized by Banksy's masked demonstrator—he hurls flowers not stones.

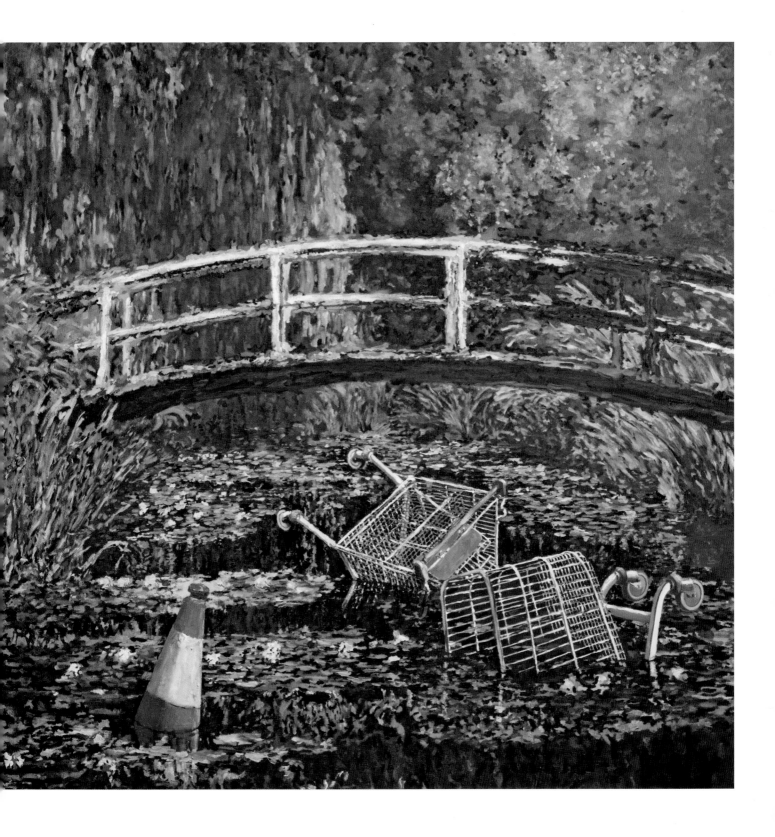

Show Me The Monet, 2005, spray paint and oil on canvas

Following pages: ***Cave Painting Cleaner,*** 2008, spray paint, Cans Festival, London

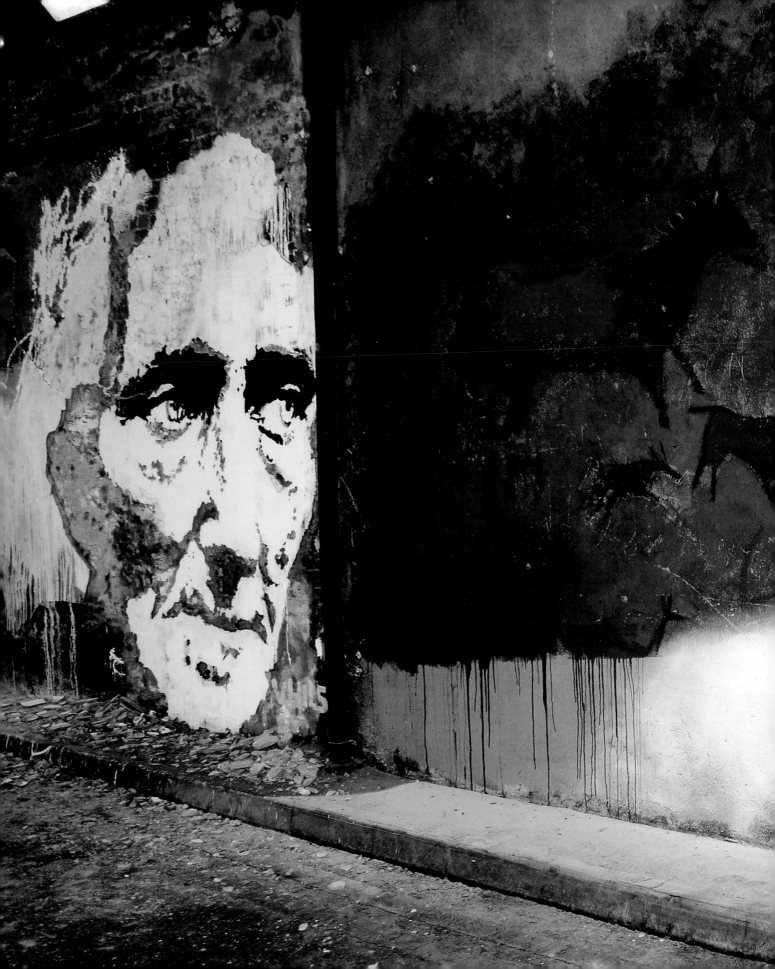

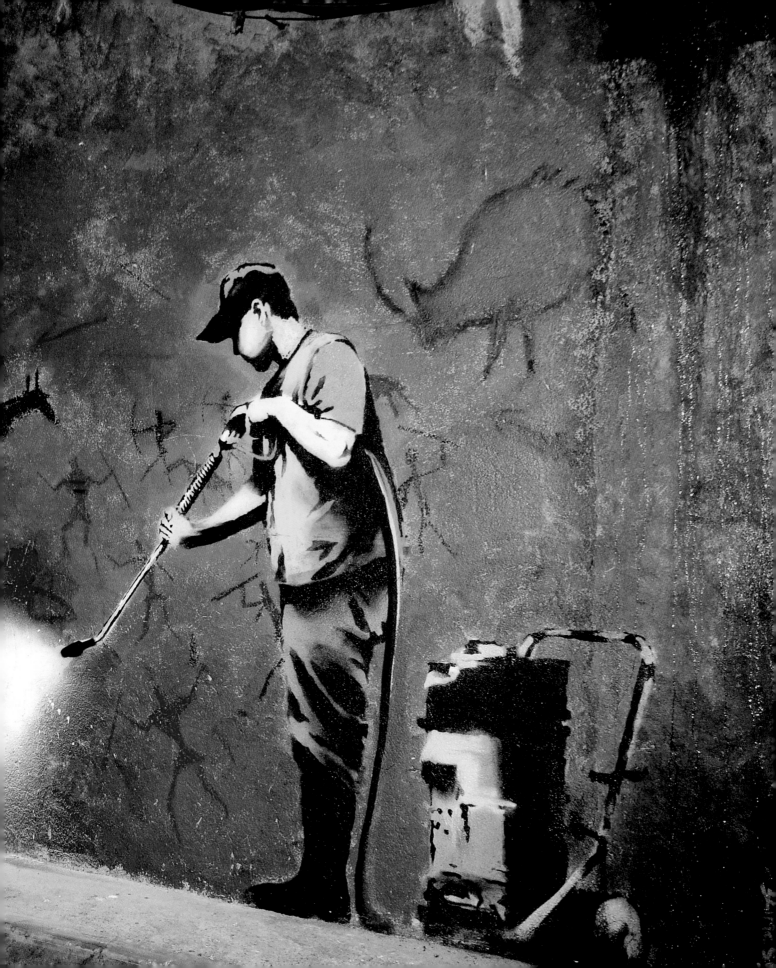

CAYETANO FERRER

1981–

While many artists have used trompe l'oeil to foreground their skills, the young American artist Cayetano Ferrer uses it to opposite effect, to make his installations disappear. His works are concerned to reveal the almost invisible links between objects and their environment.

Whether he works in the enclosed space of an art gallery or a Chicago street, Cayetano Ferrer makes simple objects interact with the exhibition space or the environment in which they are set. In 2004 he began papering over street signs in such a way as to create the illusion that they were transparent. He achieved this by creating a single image for each sign that blended the sign itself and everything obscured behind it. He would then print this and stick it onto the sign, thus contriving to manufacture a transparent object and introduce it into the real world. In a gallery environment he works in the same way and, for example, places a cube covered in trompe l'oeil in a corner: the edges of the cube disappear, the corner of the gallery fades from view and we lose all solid sense of space. For his *Western Imports* series, Ferrer set up cardboard boxes in a series of abandoned sites in Western Avenue in Chicago. He wrapped each box in paper on which he printed an image of what the box would obscure when in position. The result was to create an impossible impression of transparency: we can still make out the box, but it is ghostly, with contours that melt; we seem to see through it. Far from making the insignificant objects that he sets up disappear, however, the illusion makes us look harder at them. We find ourselves strangely mesmerized by a simple cardboard box abandoned in the entrance of a disused building, and led to wonder about the relationships forms have with each other, as well as about our own way of looking at them without seeing them. *Western Imports* is a series of photographs of the sites taken before and after the installation of the boxes covered in trompe l'oeil, each framed in exactly the same way. Ferrer invites us to consider the nature of appearances, to ask ourselves what familiar sights conceal, what forms enclose. On a metaphorical level, his work also makes us think about how easily the past can be covered up and obliterated. Memory is the only way the history of a place and the people who lived there can be preserved: just as Ferrer's work makes us look again at simple forms, it can encourage us to reassess our memory of the world.

Western Imports, 6/6, 2008

HIDDEN MEANINGS

THE VENUS OF MILANDES
Upper Paleolithic

In the 1980s, close to the Chateau of Milandes in the Dordogne valley in France, a young boy discovered a strangely shaped stone. The unusual form was essentially natural in origin, but the stone had also been worked by hand some 25,000 years ago to exploit its unusual and suggestive form.

Unusually shaped stones were much sought after by scholars in the sixteenth and seventeenth centuries for inclusion in their cabinets of curiosities, but the earliest instances of strange natural forms being collected date back to the Neanderthal period. In the Renaissance, Leon Battista Alberti maintained in his treatise on painting that art springs from an imitation of the strange forms produced by nature; his argument was that artists began by detecting a similarity between these and human figures that they then went on to refine or exaggerate. This is a thesis that the Venus of Milandes would seem to support. Paleontological analyses have revealed that the statuette was made from a limestone pebble that already had a naturally anthropomorphic female form. It was then worked on by a sculptor who added a second, phallic, form to it, and so gave it a double meaning.

Prehistoric Art is known to include small incised, painted, or carved objects that are anthropomorphic in character. The existence of other figurines with similarly worked natural forms has made it possible to date the Venus of Milandes to the Upper Paleolithic. The statuette's twin sexuality may have given it a magic function. This type of fetish object would have been used to help catch game or promote fertility. Some scholars argue that Paleolithic art reflects a cosmogony built on an awareness of the opposite and complementary nature of the sexes. The Venus of Milandes certainly embodies such a duality in its forms. Be that as it may, this prehistoric Venus figurine testifies to a very early interest in the tricks and surprises of nature. It is also interesting because it is a manifestation of the seemingly universal desire artists have for creating ambiguous images. Art historians have linked this work to a famous sculpture by Constantin Brancusi, *Princess X*, which plays on a similar duality. Brancusi began by making a sculpture of a woman looking at herself in a mirror that he then polished and simplified until a second form emerged, as though it had always been contained in the first.

Two views of a phallic-feminine statuette discovered at Castelnaud-la-Chapelle, Paleolithic, silicified limestone, 7.73 x 3.9 x 2.2 cm, Musée national de Préhistoire, Les Eyzies-de-Tayac, France

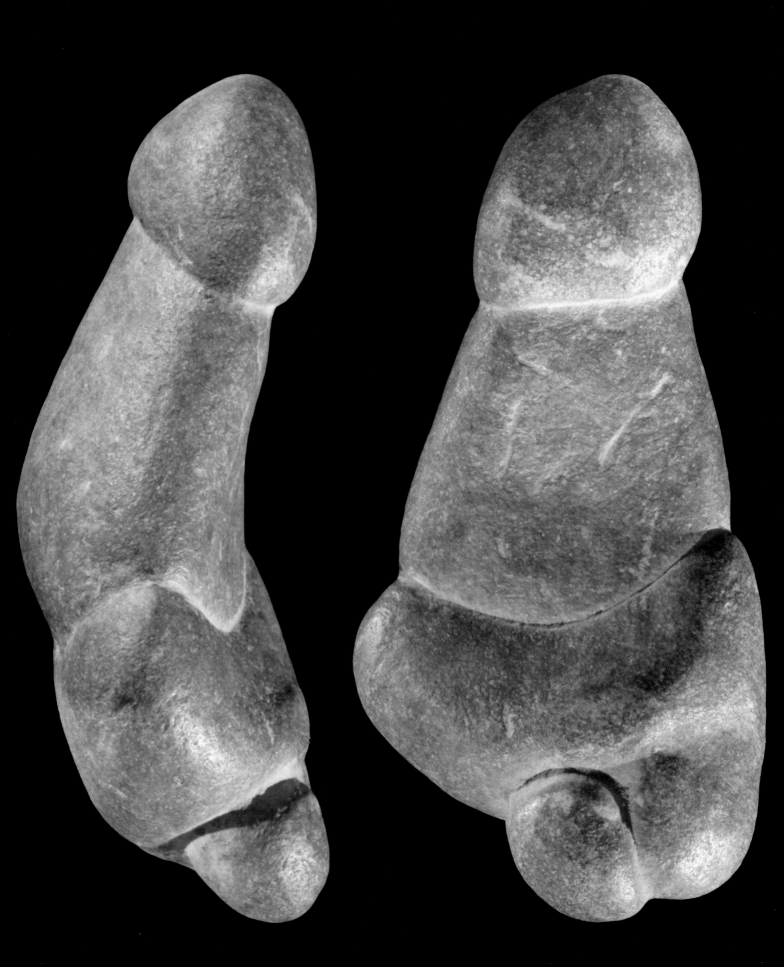

ANDREA MANTEGNA
c. 1431–1506

During the 1470s the painter Andrea Mantegna was commissioned to decorate the palace of his patron, the Duke of Mantua. The Bridal Camber is famous in particular for its ceiling, which gives the illusion of opening onto the sky. As always with Mantegna, it is important to look closely at the detail, notably the clouds in this case.

From the beginning of the fifteenth century architects and painters began to exploit the illusionist potential of perspective to create magnificent trompe l'oeil paintings in religious buildings. Rich individual clients then started to commission artists to produce decoration on a comparable scale for their private residences. Andrea Mantegna, famous for his talent as a fresco painter, entered the service of Duke Ludovico II Gonzaga of Mantua as court painter in 1460, and was eventual charged with part of the decoration of the Castello San Giorgio that the Duke had acquired and turned into a ducal palace. Mantegna concentrated on a small room that became known as the Bridal Chamber, but was in fact a small stateroom, a space that was both private and public, rather like an atrium in a classical Roman villa. Mantegna produced a decorative scheme that lent drama to the space and underlined the Gonzaga family's ties with the Court and the Church by including carefully arranged portraits of representatives of both. The entire scheme is illusionist in character. The walls are painted to imitate a loggia open onto a landscape, complete with columns and curtains drawn back to reveal the painted scenes beyond. Pilasters, bas-reliefs, plants: everything is painted, in other words everything is false. But the illusion does not stop there. It culminates with the ceiling, on which Mantegna painted a classic cupola, superimposing this structure onto the real space to create an entirely imaginary one. The ceiling with its *sfondato*—its painted oculus open to the sky—demonstrates Mantegna's perfect mastery of perspective. His use of foreshortening increases the sense of depth and creates the impression that the figures on the balcony are leaning over the painted balustrade, looking down at the viewer in a reversal of roles. Somewhat mischievously, Mantegna turns the spotlight onto his patron (and his guests) who, as it happens, will deal with important state affairs in this room. What is more, Mantegna makes a point of signing his spectacular creation in a unique way. In the biggest of the clouds in the oculus, in the very center of the dome, anyone who looks carefully will be able to make out a face that is none other than Mantegna's.

Oculus on the Ceiling of the Bridal Chamber, 1473, fresco, 207 cm in diameter, Ducal Palace, Mantua

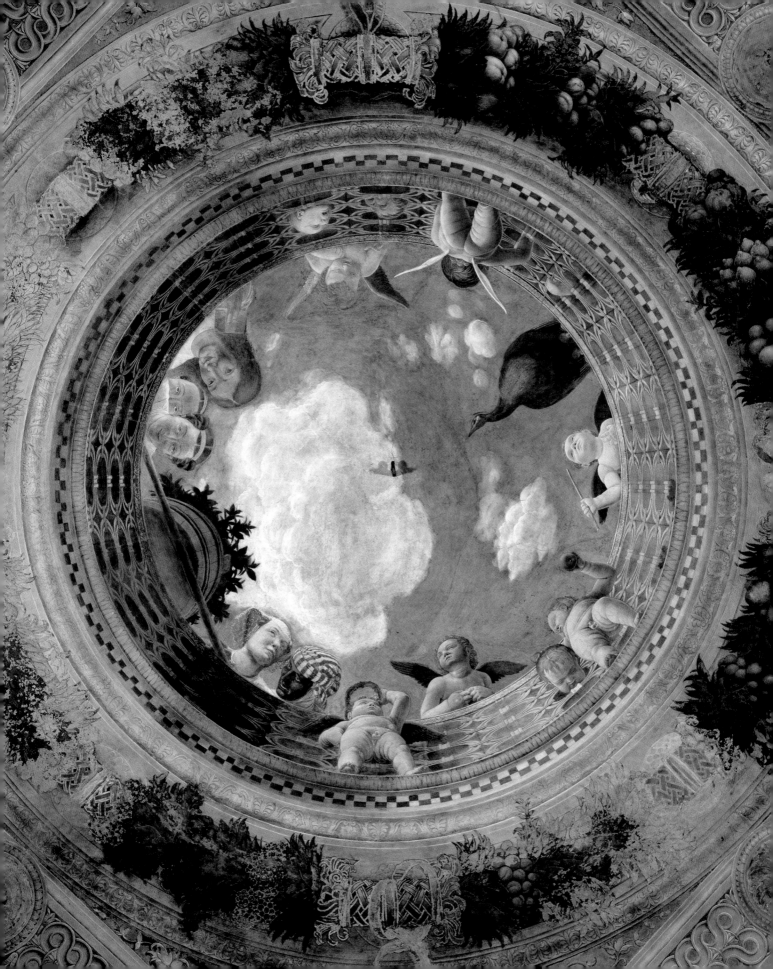

ERHARD SCHÖN

c. 1491–1542

The engraver Erhard Schön was an inspiration to other artists fascinated by such optical puzzles. There was a vogue for these in the sixteenth century: not only did they give artists an opportunity to show off their skill at transforming images, they also provided a perfect vehicle for satirizing religion or power.

Spurred on by the advances then being made in Italy on the question of how to render "mathematical" proportion and perspective, artists in northern Europe similarly began to explore a more scientific approach to the subject. Not least of these was Albrecht Dürer, who published two treatises on geometry in the 1520s, and it was in Nuremberg at the feet of this undisputed master that Erhard Schön learned the technique of woodcut.

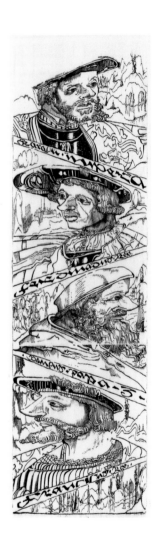

Engraving in Renaissance Germany was influenced by two major developments: progress in printing technology and the Protestant Reformation. The advent of printed images was a godsend for engravers: it meant they could sell their prints at markets and extend their reputation. Like Dürer's prints, Schön's reflect a period marked by bitter scourges: peasant revolts, the plague, and the threat of Turkish invasion, Church corruption. Schön openly advertised his sympathy with Protestantism and his prints were vehicles for Lutheran and Reformist ideas. The satirical nature of his collections of prints and posters critical of Catholicism ensured that they met with popular success. Given the scope they offered, it is not surprising, therefore, that Schön should have been so keen on anamorphic images. For a start, they represented a technical challenge and allowed him to show of his skill in drawing. More to the point, these cleverly distorted images turned deciphering them into a game for the general public. Some of the series are deliberately crude, even downright obscene, viewed from the right angle. Schön was obviously not averse to using anamorphosis for its powers of concealment.

In 1535 he produced a large-scale anamorphic image, a "picture within a picture," that conceals portraits of four great European rulers. At first sight, all that can be seen is a landscape dotted with little villages and figures. But when the picture is looked at from the side, four heads begin to come into view. The dual image (the faces of the rulers and the background scene) contained in the anamorphosis give the picture a critical edge: kings and popes are detached from the backdrop of tragic and contemporary events (wars, sieges, relations with the Turks …), for which they are in some measure responsible, suggesting, perhaps, that rulers bring misfortune rather than peace to the world.

Anamorphic Image of Charles V, Ferdinand of Austria, Pope Paul III, and Francis I (adjusted)

Anamorphic Image of Charles V, Ferdinand of Austria, Pope Paul III, and Francis I,
c. 1535, woodcut, 44 x 75 cm, Kupferstichkabinett (SMPK), Berlin

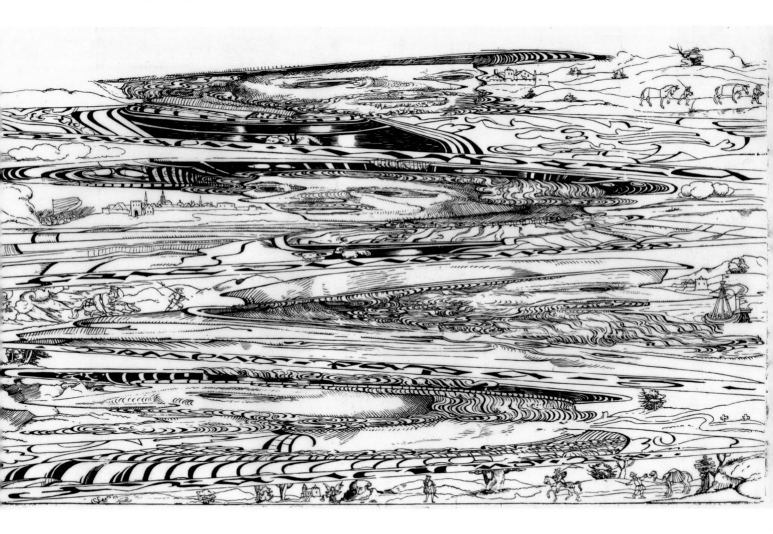

HANS HOLBEIN THE YOUNGER

1497–1543

For some artists, anamorphosis was a useful satirical tool, others saw it as purely entertaining, but in the hands of Hans Holbein the Younger it had the resonance of a vanitas. Would *The Ambassadors* have become so famous without that gigantic aberration floating in the foreground of the painting?

By 1533 Hans Holbein the Younger had established a solid reputation for himself and was widely sought after for his skills as a portrait painter. He was appointed court painter to Henry VIII, no doubt thanks to French diplomats such as Jean de Dinteville, who had settled in London. Dinteville commissioned a portrait from Holbein to hang in his family castle, hence the scale of the finished picture. In it, Dinteville and his friend Georges de Selve, a young bishop from the south of France who came to pose for Holbein for several weeks, are shown life size. Both have a stately air and exude a sense of the importance of their roles. Indeed, through their roles they symbolize the meeting of secular and ecclesiastical power at an extremely turbulent time. Despite the great complexity of the picture, it can be read as an allusion to the Protestant Reformation and to the conflicts of belief and power it engendered. Holbein was very close to Desiderius Erasmus and to Thomas More and was in favor of enlightened Catholicism. In this humanist picture, politics and religion are still founded on learning: the two protagonists are shown propped against a piece of furniture covered in scientific and musical instruments. But the balance is precarious, even bound to collapse. Minutely built up though the scene is, through an extraordinary wealth of detail, the integrity of the illusion is inevitably destroyed by the shapeless blot that seems to float in the foreground of the painting. The anamorphosis is fairly easy to read: it is a skull, that traditional emblem of death that often appears in vanitas paintings to highlight the ephemeral nature of all worldly ambition. It is also an allusion to Dinteville's family motto, *"Memento mori"* ("Remember that you will die"); Dinteville himself wears a tiny brooch in the form of a skull pinned to his hat. According to the art historian Jurgis Baltrušaitis, the viewer's engagement with this work is essentially theatrical. Viewers first see the two men and are transfixed by their splendor and their attitude, but the indefinable form at the men's feet forces them to draw closer to the picture to identify it. When they cannot, they step back and then to the right to look at the picture from the side; they then see the skull, the symbol of the end of everything, of power, of knowledge, and of art.

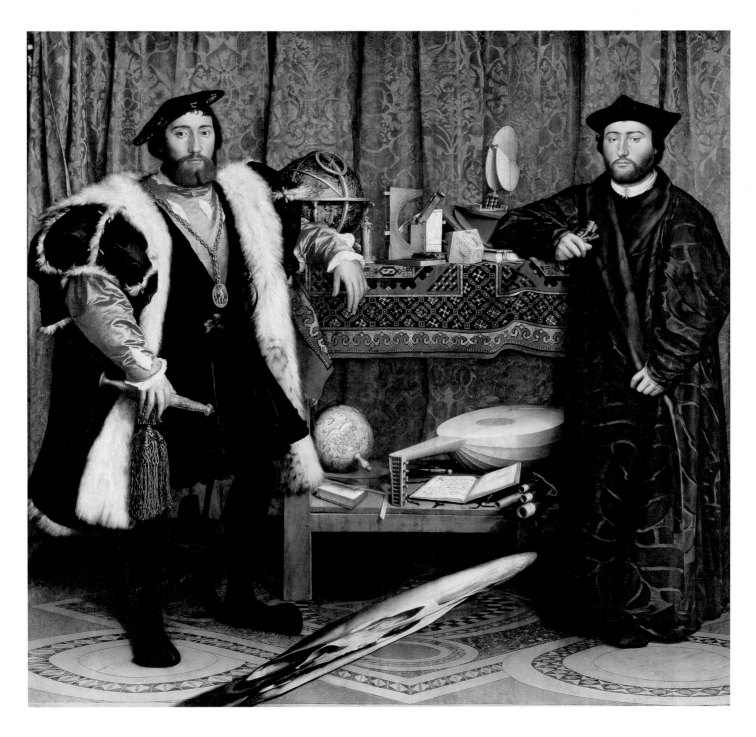

The Ambassadors, 1533, oil on oak panel, 207 x 209.5 cm, National Gallery, London

The Ambassadors, 1533, altered detail

WILLIAM SCROTS
fl. 1537–1553

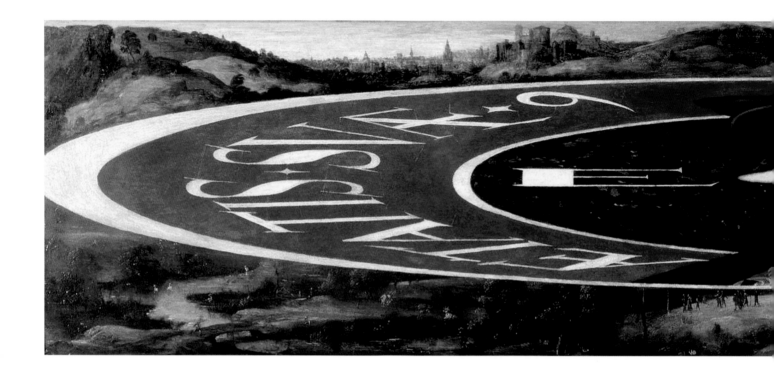

From the end of the fifteenth century the Tudor dynasty employed some of the most brilliant artists in northern Europe. These included Hans Holbein the Younger, who entered the service of Henry VIII in 1536. Employed to paint portraits of the king and his court to hang in the royal palace, Holbein successfully created a regal portrait of Henry VIII's only son, Edward, Prince of Wales, on the occasion of his first birthday in 1538. It shows the child in princely costume wearing a cap with a feather, standing behind a parapet, looking down on the viewer. A great many portraits were painted of Edward VI as a child, no doubt because he was the sole heir to the English throne. In 1543 the Dutch artist William Scrots, painter to the Tudor court, painted a delicate medallion portrait of Edward VI in profile. The painting is in the Metropolitan Museum in New York, where it is attributed to the workshop of Hans Holbein the Younger, who died the same year. William became court painter to Henry VIII in 1546, a few months before Edward VI succeeded his father. He subsequently painted a second portrait of the king's son

A court painter's job was to gratify his sovereign, to portray him in all his majesty. But when the future king was only nine years old, painting a portrait that invests him with suitable authority was no easy task. William Scrots therefore opted instead to produce an image that would entertain his sitter, the young Prince Edward VI of England.

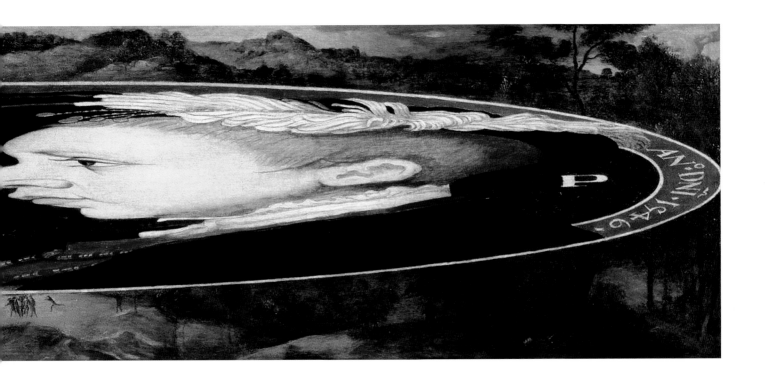

that is very similar to the first but includes a sophisticated element of distortion through its use of anamorphosis. It was a technique that was very much in vogue at the time and had two distinct advantages for Scrots: it allowed him both to show off his skills to his patrons and to produce a picture that would entertain his young sitter. The viewer has to get right up to the picture and squint at it from the right-hand side to make out the face of Edward VI. Recent scientific examination of the painting at the National Gallery in London has revealed that the colors were originally very bright and that the browns we now see, for instance, were actually violets. With both its distorted perspective and its vivid colors, the painting was clearly intended to captivate and entertain viewers. It is known to have left the Royal Collection in the Palace of Whitehall in 1649, when it was sold for two pounds. It may have entertained the prince, but the portrait does not seem to have amused the king for very long.

Portrait of Edward VI, 1546, oil on panel, 42.5 x 160 cm, National Portrait Gallery, London

MUGHAL SCHOOL
17th century

Originally influenced by Persian miniature painting, in the sixteenth century the Mughal School began using composite animals ridden by religious or political heroes to depict the soul's mastery of the body. Sometimes, however, demons take control of the mounts.

From the thirteenth century onwards the Mughal invasions of Iran caused an influx of Persian-speaking refugees into what is now India. The great masterpieces of Persian literature were disseminated in manuscripts illuminated with miniatures, and Islamized Persian culture and imagery spread to areas where they developed in new ways as they came into contact with the Hindu world. In the sixteenth century the Mughal emperors who reigned from then on over what is now northern India set up workshops where Muslims and Hindus worked together. It was from these, and influenced by Persian miniature painting, that the Mughal School developed. The mixing of cultures that characterized the School reflected a wider political endeavor: the pursuit of cultural harmony through a syncretic religion that was to bring together Jain, Hindu, and Muslim beliefs and practices by the end of the sixteenth century.

The Mughal School revisited Persian motifs in its own way and showed a particular taste for visual riddles and images that could be read two ways, as exemplified in the clever paintings of composite creatures that appeared in Mughal miniatures in the sixteenth century. It was a time when the emperor and his court were keen on marvels and legends, and the idea of these imaginary animals derives from popular old Persian tales in which a saint full of the love of God contrives to straddle the wildest of mounts. In these legends, the mounted animal symbolizes the human personality animated by all the urges that a brave and virtuous soul must learn to master. Whether it is a horse, a dromedary, or an elephant, the animal encompasses all the other creatures in the world, including vipers. Composite animals also feature in Hindu mythology and in Muslim fable, where the prophet Mohammed rides through the skies to God on similarly fantastic creatures. These recurring images can be interpreted more widely to suggest that the soul can ascend only when physical nature is brought under control. In Mughal miniatures it is not just the prophet who is shown in the role of rider. Emperors also appear in this role, and the emphasis is sometimes on how difficult it is for them to retain control of their mount when harried by demons eager to unseat them and make them lose their soul forever.

Composite Elephant Mounted by a Genii with the Head of an Ibex, early 17th century, ink on paper with green, blue, red and gold highlights, 21.3 x 16.3 cm (entire sheet: 42.9 x 29.5 cm), Bibliothèque nationale de France, Paris

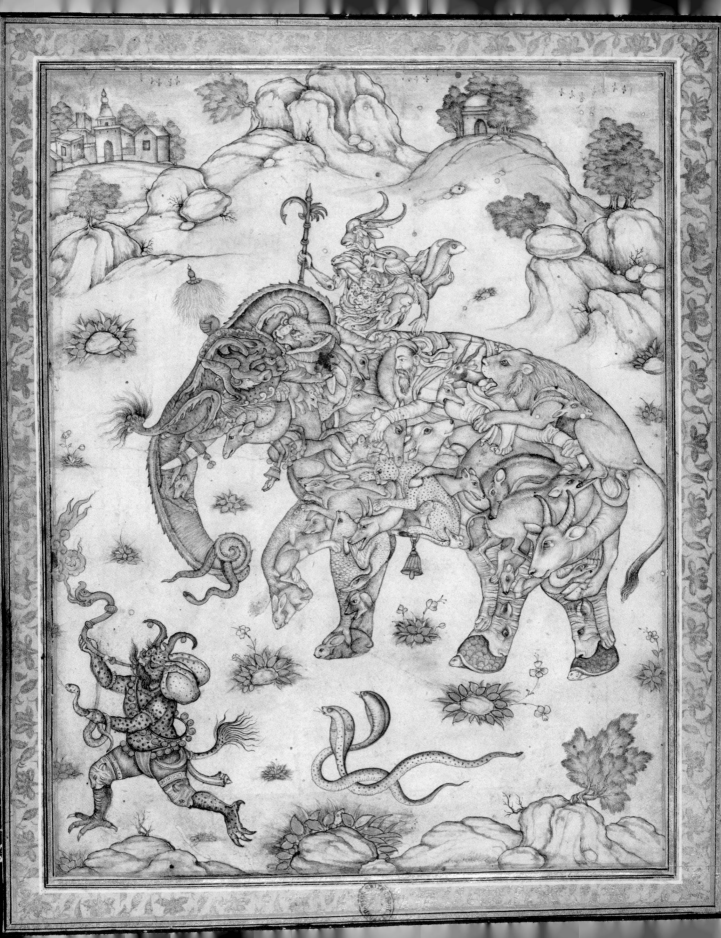

UTAGAWA KUNIYOSHI

c. 1797–1861

Japanese prints make many people these days think of landscapes by Hiroshige or the famous *Wave* by Hokusai. Much less well known are the more playful prints that some great masters of the art such as Utagawa Kuniyoshi, who both entertained themselves by making such prints and showed off their ingenuity and panache to the full.

Printmaking took off in Edo (Tokyo) at the end of the seventeenth century, when prints were used to depict scenes of everyday life in a prosperous and bourgeois society: kabuki theatre, sumo wrestling, the beauty of women, and licentious pleasures. Woodblock prints were easy to reproduce and disseminate, and at first they were used in a supporting role, to promote shows and luxury goods. In the early nineteenth century, prints of landscapes began to appear and helped establish printmaking as a genre in its own right. Western artists were captivated by their immediacy, their use of light and color, and the boldness of their design and composition.

Until the end of the nineteenth century, the Japanese used their prints as packaging material to separate layers of porcelain being shipped to Europe, which was then obsessed with all things Japanese. Western art lovers were entranced by these colored images when they saw them at the world fairs, and soon they were displayed in fashionable shops specializing in "exotic" goods. They became a direct source of inspiration for the Impressionists: Van Gogh studied and made copies of them, and Monet collected them. In Europe and America, then, the thousands of prints in circulation at the time were all were considered works of art.

Originally, however, Japanese prints were designed simply to entertain their owners. Sometimes they were even aimed at children and took a whole range of forms: puzzles, spelling sheets, card games, shadowgraphs, magic lanterns, kites or dolls' clothes to cut out. Japanese printmakers also played on the idea of dual images: grotesque reversible heads, anamorphic views, and hidden satirical images. Utawaga Kuniyoshi's *A Young Woman Who Looks Old* is an extraordinary display of graphic inventiveness: the face is made up of a motley assortment of objects and people who are either naked or in kimonos, all piled together, with a pair of sickles for the eyebrows; the hand is made up of naked bodies with legs outstretched to form the fingers. Kuniyoshi underlines his skill by adding a little note to his drawing: "Many people have come together to make my face, for which I am very pleased. Thanks to them, I have a human face."

A Young Woman Who Looks Old, 1847, woodblock print, 36 x 25 cm, Nagoya City Museum, Nagoya, Japan

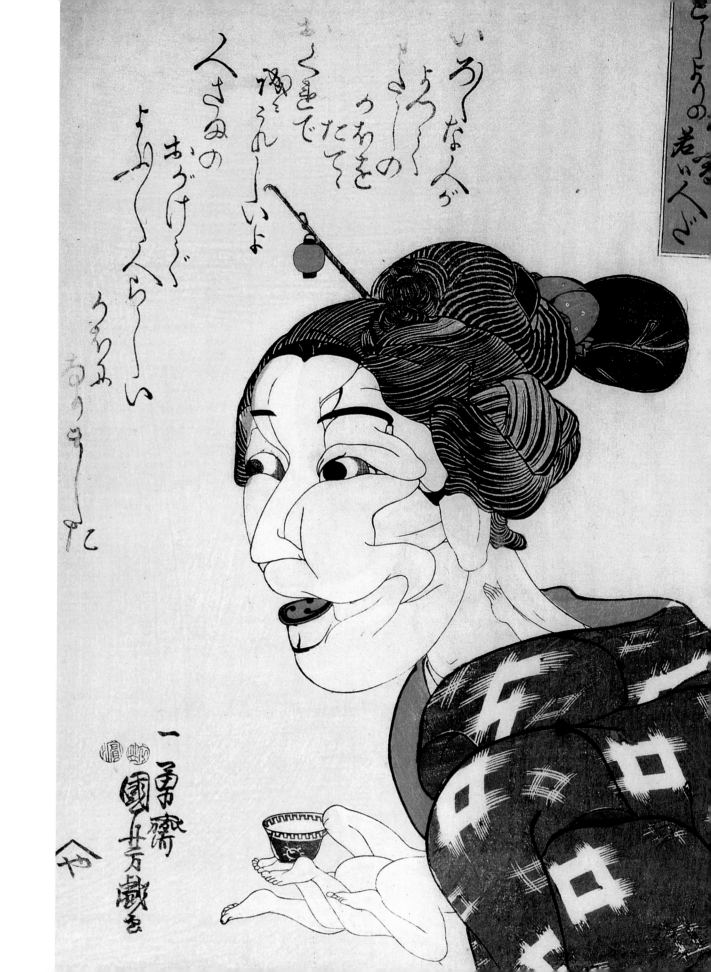

WILLIAM ELY HILL

1887–1962

Even in the very early days of printing, during the Renaissance, printers published ambiguous images that met with great popular success. At the turn of the twentieth century, erotic or simply humorous postcards that played on double meanings were common.

The British cartoonist William Hill took an image from a German postcard of 1888 and turned it into a graphic image that he published in the satirical magazine *Puck* in 1915 under the title *My Wife and My Mother-in-Law*. The title sounds a somewhat lewd note and immediately suggests that there may be more than one way to read the image by giving the reader a clue. Scientific tests have shown that people have to be alerted to the picture's double meaning before they can see the two figures. Some people see the pretty young woman in profile first, others the older hag-like woman. As well as being humorous, images like this are intriguing for what they reveal about the way we see. If we look at it for long enough, the picture starts to change of its own accord, and once we have seen both of the images in it, we can switch easily from one to the other. It is impossible, however, to see them both at the same time. Our vision is bound to alternate in this way because one set of neurons is constantly giving way to another: one set understands the first image, but it gets tired and a second set then takes over which understands the second image. What our reading of these ambiguous images indicates, however, is that human vision can process reality in a number of different ways and that it can move from one image to another, which suggests that perception is intimately bound up with the mental faculty of understanding. These double images have interested artists as well as scientists. Once relegated to the realms of popular culture, they were restored to artistic favor by the Surrealists, who made extensive use of them in their work. Such images can defy all logic and reveal unexpected similarities between very disparate elements. Their effect is reminiscent of those surprising transformations that happen only in dreams. They have the quality of metaphor and generate a sense of unease that could not but appeal to the Surrealists: reality becomes thick with mystery, and the only way to apprehend it is to leave abandon behind.

One of many versions of *My Wife and My Mother-in-Law,* drawing, probably first published in *Puck Magazine*, November 1915

SALVADOR DALÍ

1904–1989

By radically changing the rules of art, the Surrealists took illusion to an entirely new level. Salvador Dalí was the undisputed master of this new universe, which both transcended and subverted the rational world and lauded the supremacy of the unfettered imagination. Fashioned using the traditional techniques of illusionist painting, Dalí's works create distorted images of reality by subjecting them to the logic of dreams.

Influenced by his meeting with the Surrealist group, and by the psychoanalytical theories of Sigmund Freud, in 1929 Salvador Dalí devised what he called the "Paranoid-Critical" method. This entailed giving free rein to hallucinations and to the many associations of ideas that could be prompted by looking at the real world—associations that reason normally disallows. When applied to art, this method meant that he could take images of real things—people, objects, famous works of art—and turn them into something strange and mysterious by multiplying and transforming them. Dalí's works conjure up images like those that appear in dreams, when the unconscious overrides reason.

What makes Salvador Dalí's paintings so deeply disturbing is that they make worlds that are incompatible co-exist: real, recognizable objects are changed into impossible, fantastical forms. They feature familiar landscapes, figures, objects, even classic motifs from art history, which are made all the more readily identifiable by the meticulous precision with which they are painted. The trompe l'oeil is perfect, the drawing and perspective are academically correct. But Dalí's paranoid-critical method ensures that any illusion of reality is subverted: forms melt and images split into two. With the use of simple reflections, a recurrent device in illusionist painting, swans turn into elephants, necks become trunks. Like the compressed images in dreams, Dalí's pictures have layers of meaning to unpack.

They are put together like puzzles that cannot be solved, potent combinations of contradictory elements. They present the appearance of unified images, like Old Master still lifes for instance, while embodying a method that disrupts their meaning. To have any hope of making sense of them, viewers have to accept them and let their own association of ideas guide them.

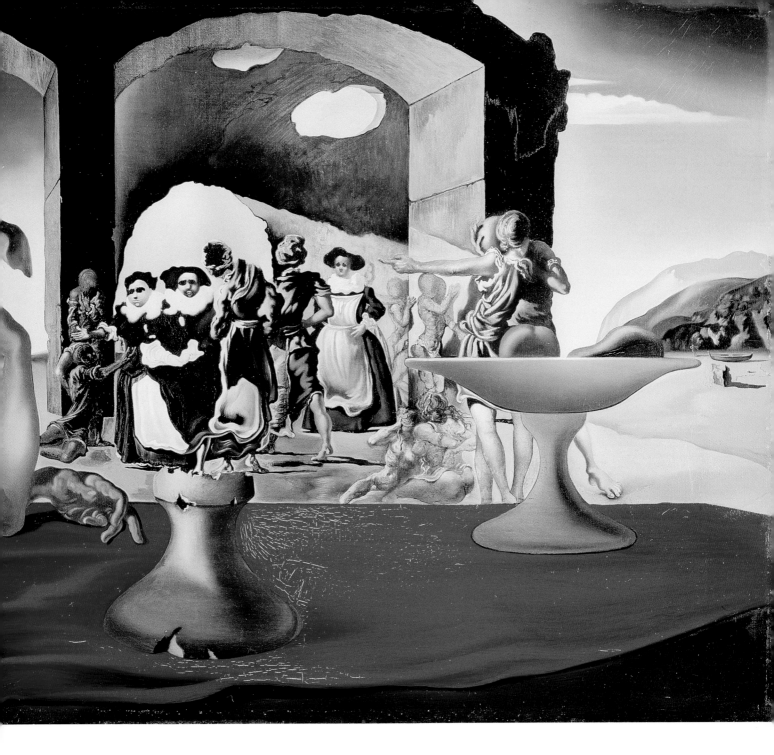

Slave Market with the Disappearing Bust of Voltaire, 1940, oil on canvas, 46.5 x 65.5 cm, Salvador Dalí Museum, Saint Petersburg, Florida

Following pages: *Swans Reflecting Elephants,* 1937, oil on canvas, 51 x 77 cm, Cavalieri Holding Co. Inc. collection, Geneva

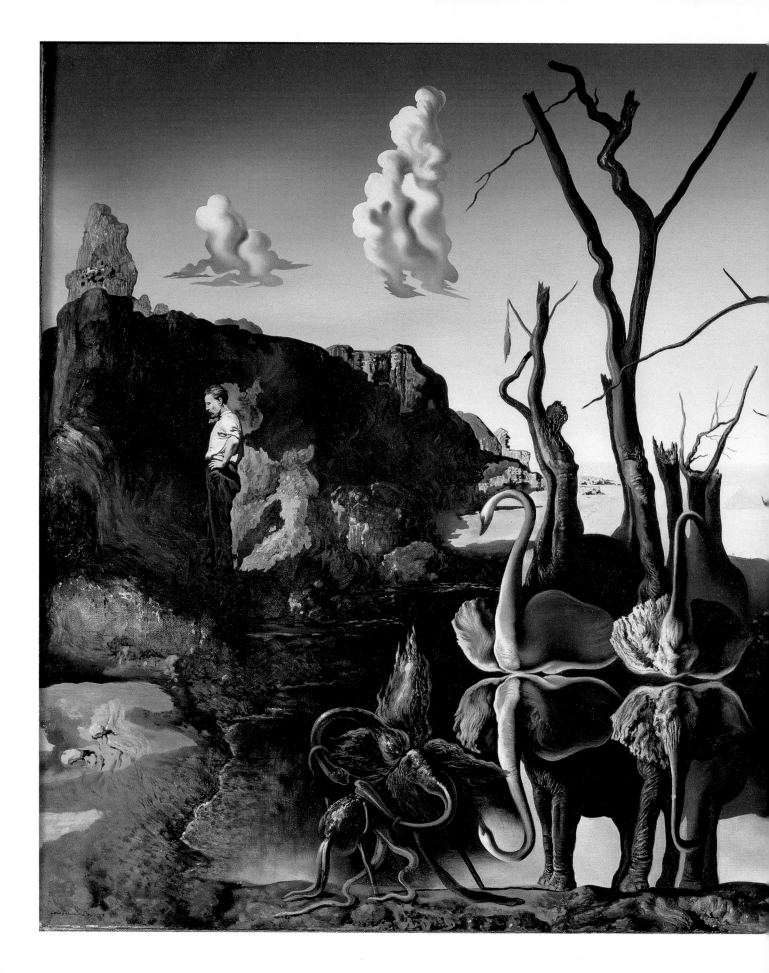

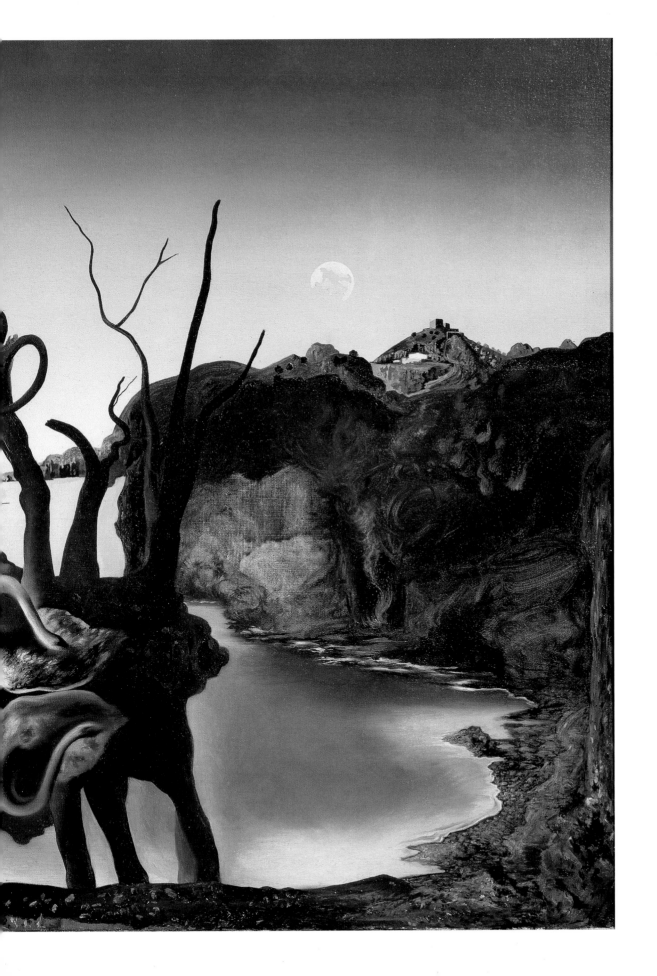

MARKUS RAETZ

1941–

There is always one form waiting inside another in the works of Markus Raetz, in the same way that there is always a rabbit ready to pop out of a magician's hat. Raetz creates three-dimensional anamorphoses, drawing forms in space that become infinitely variable as the viewer moves round them.

By creating forms that play with substance and void, shadows, curves, and reflections, the Swiss artist Markus Raetz explores the process of seeing and our modes of perception. He takes lengths of wire and draws with them in space, hooking them in front of mirrors or hanging them up like mobiles. It is up to the viewer to make out the objects and faces these shapes contain. In Raetz's hands, a human profile can tip over and become a mountain range. Every image seems reversible, every object conceals a human form, every face can turn into a landscape. In order to pull off these anamorphic feats, Raetz experiments endlessly, playing with forms with the intense concentration of a child engrossed in a game. He constantly sets himself new problems to solve, such as how to turn "Yes" into "No." One of his sculptures says one or the other depending on how you look at it. Despite its apparent air of simplicity, Raetz's work is full of artistic and literary allusions. Marcel Duchamp and René Magritte are never far from view and Raetz often pays homage to them. *Metamorphosis II* conjures up Joseph Beuys. Depending on how they are viewed, the abstract forms of this sculpture settle into the shape of a rabbit or the profile of a man in a hat, immediately recognizable as Beuys, who famously cut just such a figure. The rabbit takes its shape from one of those chocolate bunnies that appear in French confectioners' windows at Easter. An animal with a roughly 360-degree field of vision was bound to be of particular note to an artist like Raetz, but this was not the only reason he was drawn to it. For documenta 7 in 1982, Beuys had cast a replica of Ivan the Terrible's crown in an Easter bunny mould to transform it into a "symbol of peace." He had also incorporated a hare into his work in the 1980s, according it the role of victim in an analogy with Christ, and said he identified with the animal. *Metamorphosis II* explores the point of transition from one recognizable form to another, from simple form to work of art, that uneasy moment between the two when nothing is identifiable. Raetz's work demonstrates how intricately bound up our knowledge, our memories, and our feelings are to our ability to see and recognize the world around us.

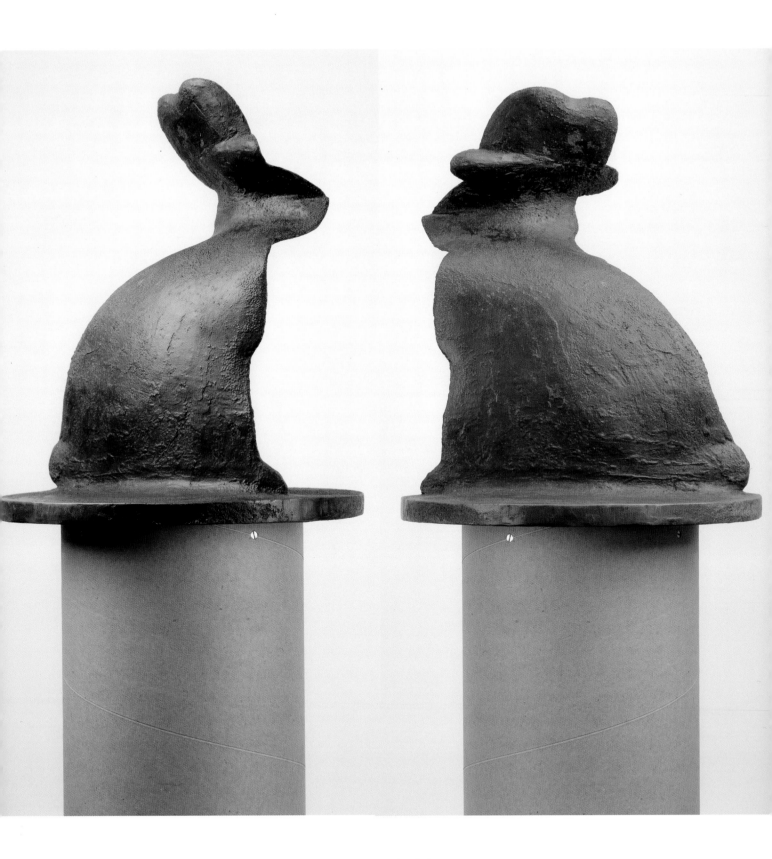

Metamorphosis II (Beuys Rabbit), 1991–1992, cast steel on wooden plinth,
40 x 33.5 x 33.5 cm, Farideh Cadot Gallery, Paris

TONY CRAGG
1949 –

In both his early installations of found objects and also his later pieces using more traditional sculptural materials, Tony Cragg has been preoccupied with form and the way it can shape images. His work suggests that sculpture has an energy of its own.

In the 1970s Tony Cragg began searching skips and beaches for industrial waste material that he collected avidly, particularly anything made out of colored plastic. He makes a palette for himself out of these new art materials, sorting them into colors and shapes, as epitomized by his emblematic *Palette*. Cragg outlines human figures and objects in relief on walls and floors, piecing them together like mosaics. The materials he uses acquire an entirely new standing and value in the process: bits of discarded scrap become select ingredients in a work of art as he recycles them. The accumulated objects are diverted from their original functions, but all remain clearly recognizable: spades, plates, spoons, buckets, sieves, dolls, even watches. Viewers take in the overall image while identifying each of the many components that go to make it up. The work gets its meaning through this dual perception. Cragg's fragmented compositions give objects new life, and in so doing subvert consumer society by adding a new stage to the cycle of production, consumption, waste, and recycling: creation.

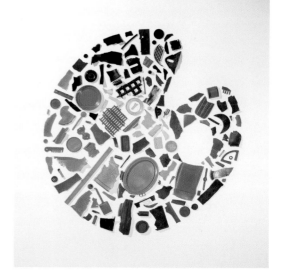

The sculptures Cragg has been making for the last ten years or so seem to generate forms by themselves. They work like three-dimensional anamorphoses. Seen from different points of view, abstract masses suddenly seem to give way and suggest human or organic forms. Jumbled profiles emerge, faces loom out, colliding with one another. Cragg now uses traditional materials such as plaster, bronze, wood or marble, which he works in such a way that his pieces seem to be moving. It is of course the viewers who are drawn to move around the sculptures: these pieces have to be looked at from multiple viewpoints before they reveal themselves. Cragg imbues inert and monumental masses with a creative energy that rises up in layer upon layer of flowing, undulating, and oscillating forms. These pieces look almost stratified, as if formed gradually over the natural course of time. They are formed anew as the viewer emulates the process and moves around them, constantly moving from one form to the next as each new one is apprehended.

Palette, 1985, plastic, 186 x 178 cm, Frac Bourgogne, Dijon, France

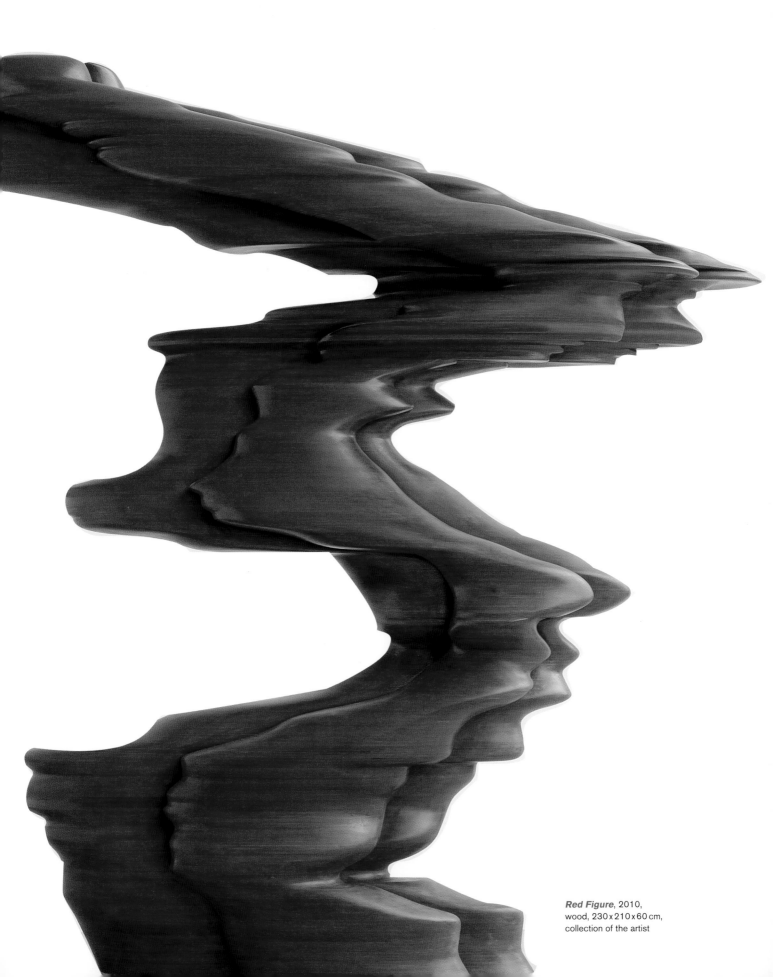

Red Figure, 2010,
wood, 230 x 210 x 60 cm,
collection of the artist

TIM NOBLE AND SUE WEBSTER

1966–/1967–

The first solo exhibition of Tim Noble and Sue Webster, in London in 1996, was called *English Rubbish*. Their work offers a punk take on the nature of perception, which it explores by transforming what is generally thought of as the opposite of art—rubbish, carcasses, and kitsch—into works of art.

Tim Noble and Sue Webster specialize in creating silhouettes of couples from shadows cast by cleverly lit and assembled piles of worthless objects, rubbish, left-overs picked out of bins or off the street. Sometimes the silhouettes are of rats—fitting creatures of shadows and waste—but more often than not they are of the artists themselves. Their works are effectively a new brand of self-portraiture, which only adds to their provocative nature.

Tim Noble and Sue Webster are obviously not the first to recycle and assemble non-art materials, to draw on what society throws away in order to create objects that have a cultural value. But this is not the only way in which their work is subversive. In the way it is staged, it puts the human figure firmly in the frame and creates a disturbing link between rubbish and us. Their works are all the more unsettling because they rely on what seems to be a precarious transformation, and constantly oscillate between shapelessness and recognizable form. The conditions that allow them to take shape are such that their very existence hangs by a thread, or a ray of light. To get to the projected image, the crisp little silhouette, viewers are obliged to look at what they do their best to avoid looking at in the ordinary course of life—heaps of rubbish or piles of little dead animals—because these are an integral part of the work. And it is difficult not to give into the thought that, without the lighting, this is all there would be. Viewers vacillate between childlike pleasure at being able to recognize the shapes in the shadow play—a somewhat voyeuristic pleasure at times—and fear lest the lights go out. The perverse nature of the process forces the pleasant and the unpleasant to co-exist: man does not exist without rubbish, the living without the dead, the comfort of the light without the distress of the dark. Viewers are compelled to look at both images simultaneously. They cannot satisfy their longing to identify recognizable forms without first overcoming their repressed loathing of the formless.

A Couple of Dirty Fucking Rats, 2000,
rubbish, projector, 51 x 46 x 25 cm, private collection

Following pages: *The Undesirables,* 2000,
rubbish, electric fan, 3 projectors, colored gels and smoke machine, variable dimensions, private collection

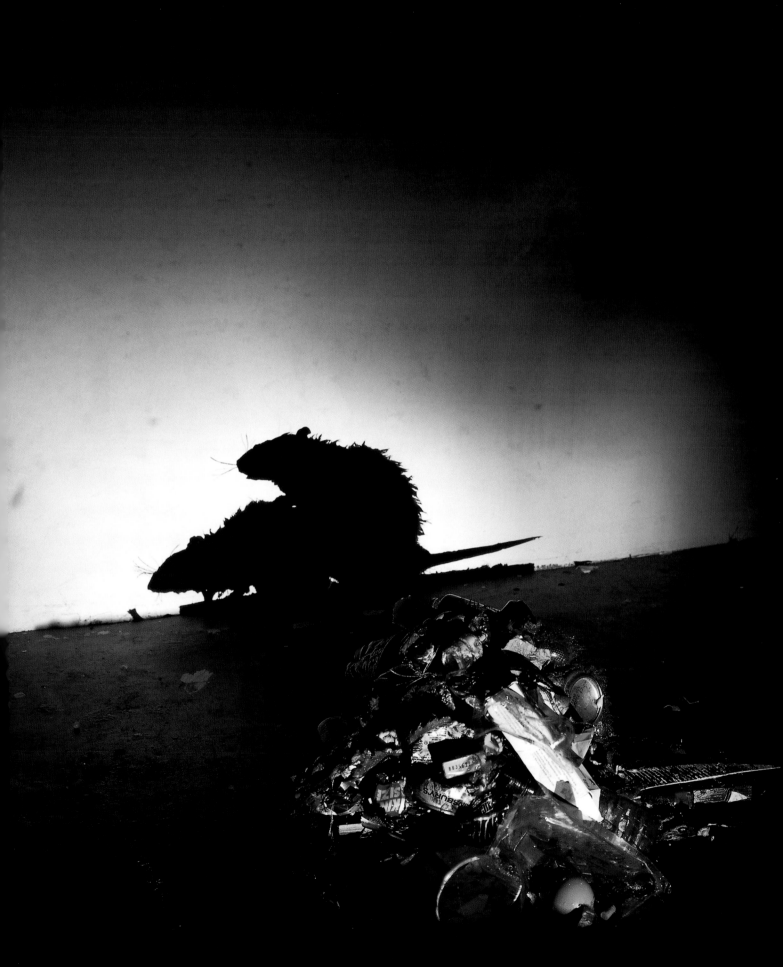

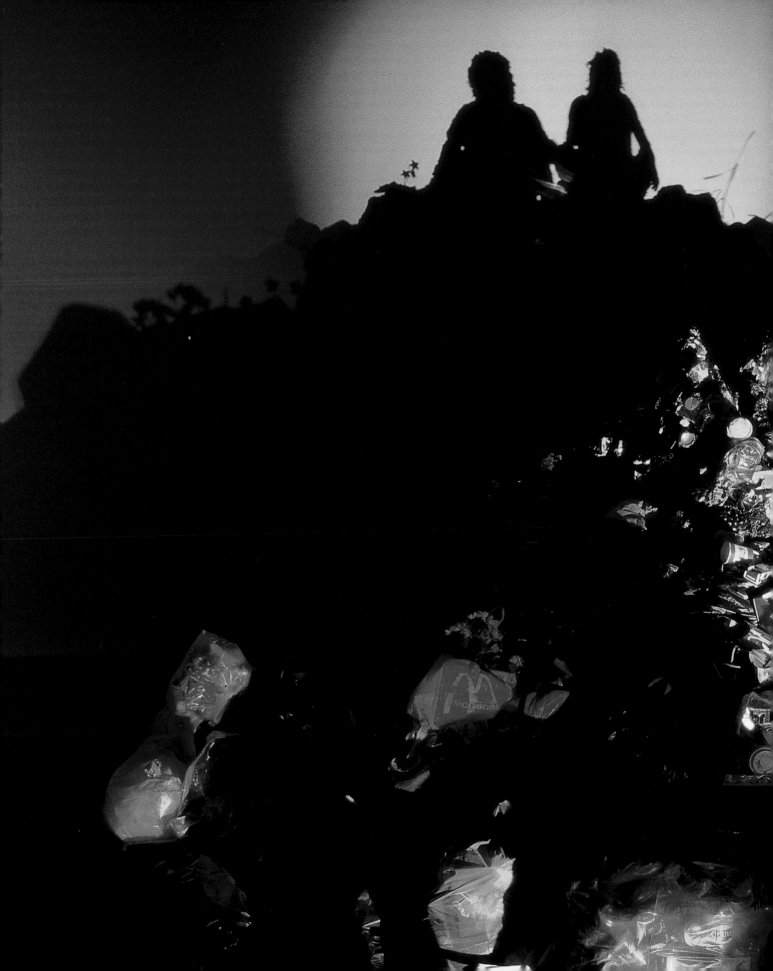

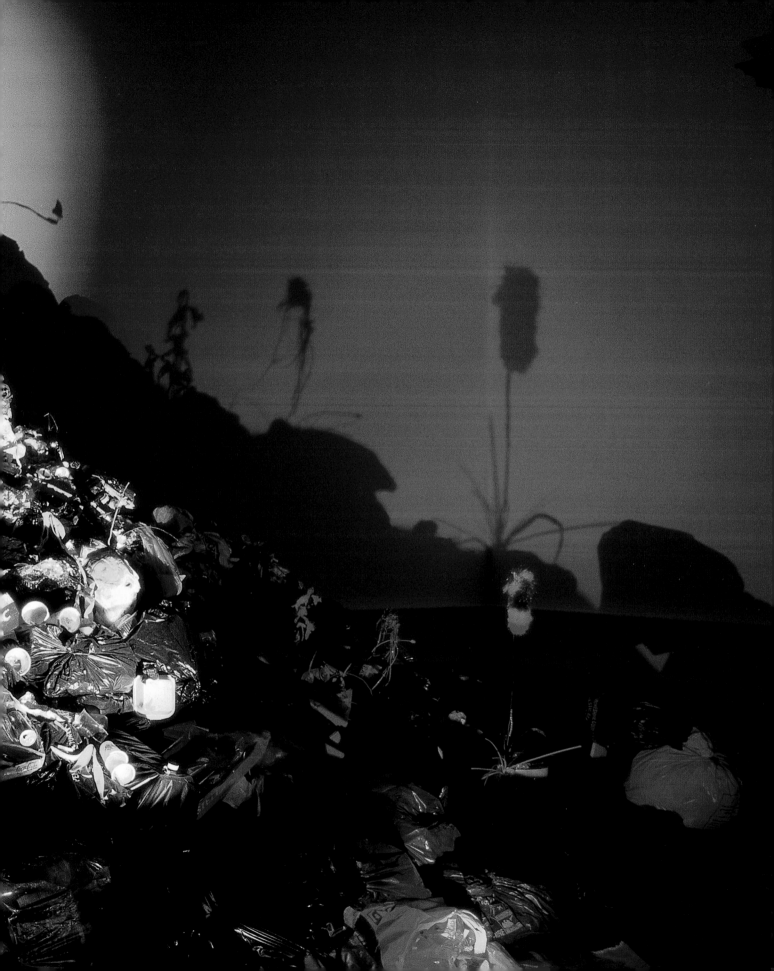

THE (IN)HUMAN BODY

GIUSEPPE ARCIMBOLDO
1527–1593

The composite heads that Giuseppe Arcimboldo invented while at the court of the Hapsburgs may originally have been intended simply to entertain, but they broke new ground. They subverted established genres by combining still life and portrait painting, and engaged viewers in an intellectual game very much to contemporary humanist taste.

In 1562 the young Milanese painter Giuseppe Arcimboldo entered the service of the Hapsburgs, where he became court portrait painter to the emperor. His duties went far beyond painting, however: he charmed the Austrian court with his talents as an inventor and as a producer of court entertainments.

To mark the New Year in 1569, Arcimboldo presented Emperor Maximilian II with the first of his series of composite heads, *The Four Elements* and *The Four Seasons*. In their accumulation and juxtaposition of disparate elements, these painted "collages" are not unlike cabinets of curiosities, in which art objects, natural oddities, and scientific instruments sit side by side.

The Habsburg court welcomed scholars and artists from all over Europe during this period. Arcimboldo took on the role of artistic adviser and helped his enlightened patrons assemble their collections. It takes a particular kind of eye to turn a motley assortment of objects into a cabinet of curiosities, the same sort of eye it takes to put one of Arcimboldo's "puzzles" together mentally and make them into a head.

With their teeming mass of disjointed detail, Arcimboldo's composite heads generate a sense of unease. There is something monstrous about them: they do not respect the lines dividing the animal kingdom from the vegetable, the animal from the human, but straddle them all. Some of the pictures are reversible, so everything becomes inverted and our values are turned upside down, just as at carnival time. Arcimboldo's composite heads undermined a respected branch of painting, portraiture, by crossing it with one that was little valued at the time, still life.

In their day, these paintings were recognized as complex allegories in praise of the emperor and his power, and also as ironic allusions to certain individuals at court. They were soon dismissed as Mannerist oddities, however, and remained largely ignored for centuries. The Surrealists rediscovered them in the 1930s, and we can now appreciate how "modern" Arcimboldo really was.

Flora, 1591, oil on panel, 72.8 x 56.3 cm, private collection, Paris

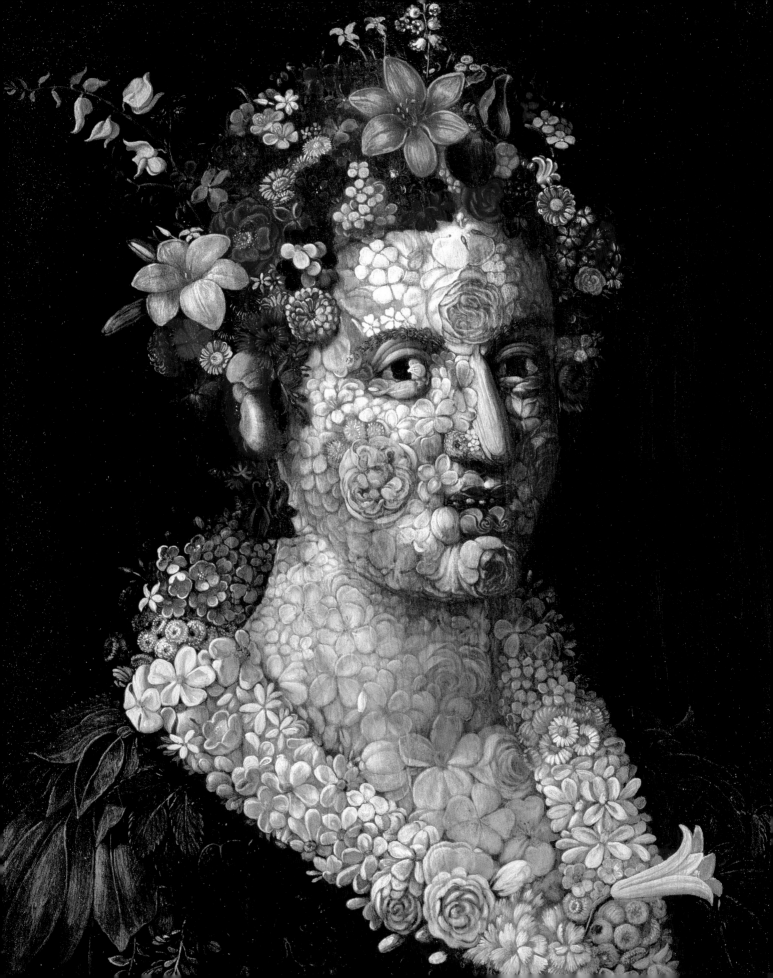

Set amid a slightly oppressive profusion of flowers, fruit, and vegetables, man is shown here from a quintessentially humanist point of view, taking his place at the heart of the natural world.

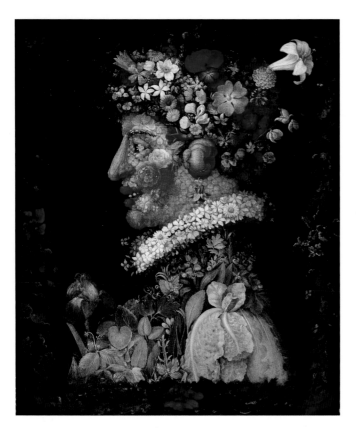

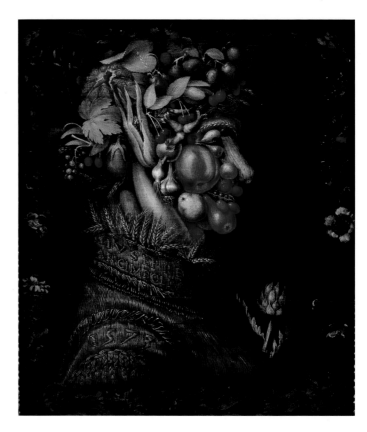

Spring, 1573, oil on canvas, 76 x 64 cm, Musée du Louvre, Paris

Summer, 1573, oil on canvas, 76 x 64 cm, Musée du Louvre, Paris

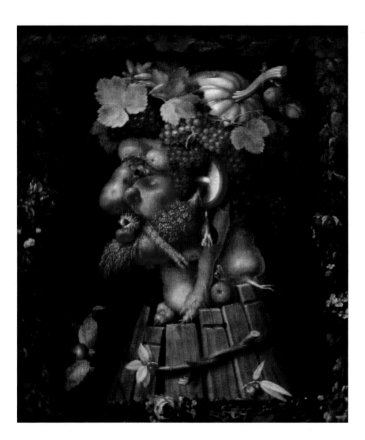

Autumn, 1573, oil on canvas, 76 x 64 cm, Musée du Louvre, Paris

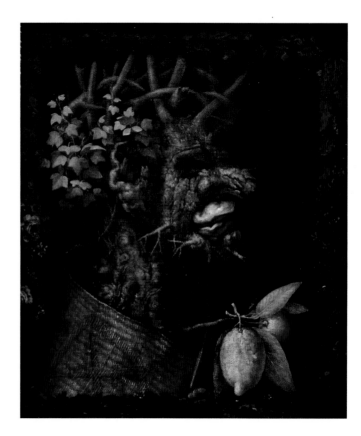

Winter, 1573, oil on canvas, 76 x 64 cm, Musée du Louvre, Paris

In order to make sense of these images, viewers have to change where they stand, and how they identify and interpret details.

MATTHÄUS MERIAN

1593–1650

Matthäus Merian became famous as an engraver and a publisher, but he also produced some extraordinary anthropomorphic landscapes that had a considerable following up to the nineteenth century.

Anthropomorphic landscapes were enormously popular in the Renaissance because they were very much in keeping with the humanist way of thinking. They placed man at the center of the universe and portrayed him as occupying a place in nature. Reflecting new ways of looking at the world in the wake of advances in scientific knowledge, Renaissance thought saw nature as tamed or at least tamable. The body-landscapes of the period are a visual evocation of this. Through the surprise they provoke and the moment of discovery they trigger, these paintings prompt viewers to consider how intricately bound up man and the universe are, each effectively containing the other. The German artist Albrecht Dürer first experimented with this kind of image in 1495, with a landscape in which a human profile merges into a mountain, but it was in Matthäus Merian's day, in the middle of the sixteenth century, that anthropomorphic landscapes became very popular. Some artists treated only parts of a landscape in an anthropomorphic way; in Matthäus Merian's paintings, however, the landscape as a whole becomes a double image. The images work by operating on two distinct levels: seen close up, it depicts little figures going about their daily business in a village setting with a castle built into a cliff; but from a distance, the landscape turns into a face, a giant face in comparison to the size of the villagers. What makes the picture unsettling is that the two images overlap completely, and the change in scale brings an element of the fantastic into what appears to be a realistic scene. The sheer scale of the giant head gives it an allegorical character and force: this is not an image of anyone in particular, but of humanity in general. Importantly, it does not dominate but merges with the rest of the picture: the goatee beard is made of bushes, the forehead of pastureland, the hair of plants.

While they undoubtedly offer a form of visual entertainment, these paintings also seek to convey a new understanding of man's relationship to the world. At the time he produced them, the Swiss Matthäus Merian was also working on his master work, *Topographia Germaniae*, a collection of hundreds of printed maps and views of German towns. Merian was every inch a humanist, eager to contribute to the advancement of knowledge.

Anthropomorphic Landscape, Recumbent Man, c. 1630–1650,
oil on panel, 31.8 x 41.3 cm, Mrs. Alfred H Barr Jr. Collection, New York

CINDY SHERMAN
1954–

For almost 40 years Cindy Sherman has been working with a single model: herself. Her photographic self-portraits are a rigorous parody of stereotypes of women in Western society.

In one of her earliest series of photographs, Cindy Sherman parodied the glamour image of women presented by the cinema of the 1950s and 1960s by posing herself in the attitudes of stars in films ranging in genre from Italian neo-realism to American film noir. However different the make-up, costumes, accessories and settings are in each of these photographs, the same woman is recognizable in them: the artist herself playing with innumerable disguises. Sherman uses her body and her face as if they were those of a model posing for her. Although this is a form of self-portraiture, it has nothing to with a search for an identity. If Sherman is her own model, it is for practical reasons: she is the most flexible and readily available vehicle for her own compositions.

For Sherman, the alienation of women stems in large measure from whatever prevailing images of "feminine nature" are imposed on them. She recreates stereotypical representations of women to show how the female body is used to create these images, and scrutinizes in turn the worlds of tabloid journalism, advertising, horror films, fashion, fairy tales, and pornography. From 1988 to 1990 she produced a series of photographic works that reference Old Master paintings of the past. She transforms herself and adopts poses that imitate the likes of Raphael, Caravaggio, and even Botticelli, but she uses her own visual language in these re-creations of classic paintings. Where the Old Masters used all the techniques of illusionist painting to give life and dignity to their models, Sherman does the opposite in her parodies of them. She introduces the living into her work from the start, by photographing herself—but all the costumes, outlandish make-up, prostheses, and tawdry jewelry make her look like a lifeless mannequin. She creates illusions that deliberately betray their artificiality. She contrives to debunk both high art and the culture of feminine beauty it purveys at one and the same time. She exposes and deconstructs representations of women that influence the image women have of themselves: in each of her recreations of images of beauty and elegance lies a grimacing, sometimes morbid, over-painted figure. For Sherman, photographic portraiture is a tool for challenging the way images are made and used.

Untitled, 1989, color photograph, 223 x 144 cm (240 x 160 cm framed), edition of 6, (MP# 216), Metro Pictures Gallery collection, New York

VIK MUNIZ
1961–

The Brazilian artist Vik Muniz produces photographs of strange recreations he makes of famous portraits or of masterpieces from art history. His works seek to question both the illusionist nature of photography and the way we look at works of art.

One of the first series of photographs Vik Muniz produced was of views of clouds. Not only were the clouds in fact not clouds, but bits of cotton wool suspended from the ceiling on clear wire, but they were shaped like objects and animals. The effect was to expose the apparent truth of photographic images as entirely illusory. The photographs were also a nod in the direction of Renaissance illusionist artists such as Albrecht Dürer or Andrea Mantegna, who embedded portraits of himself in the clouds in his painted skies. There was a link, too, to the theory dating back to antiquity that a study of clouds was the best way to trigger an artist's imagination.

For about 20 years Muniz has been recreating famous images and pictures using unusual materials: jam, peanut butter, shredded ballot papers, puzzle pieces, plastic toys, torn up magazines. He photographs these complex creations and then destroys them. The final work consists simply of a documentary record of its making: it is now just a photograph. Muniz makes us look differently at images we have seen countless times too often, while also highlighting the ephemeral quality of his artwork. He wants us to think, too, about the relevance of the materials he uses for each subject: fake blood for Andy Warhol's Marilyn, for instance, and chocolate for the portrait of Sigmund Freud. In his recent *Pictures of Pigment* series he used traditional art materials to recreate paintings by Impressionist masters, but use them in an unusual way. His version of Monet's *La Japonaise* took six and a half months to complete and the pure pigment was painstakingly applied with dental tools.

Vik Muniz now lives in the United States but returned to Brazil to work for three months with rubbish sifters at Jardim Gramacho, a massive landfill site in Rio de Janeiro. He got the men to pose for portraits that he made out of the rubbish they sifted through. One of them is a rendering of Michelangelo's *Atlas*, but made of rubbish instead of marble. The photographs of the pieces were auctioned at Sotheby's and the proceeds went to the models.

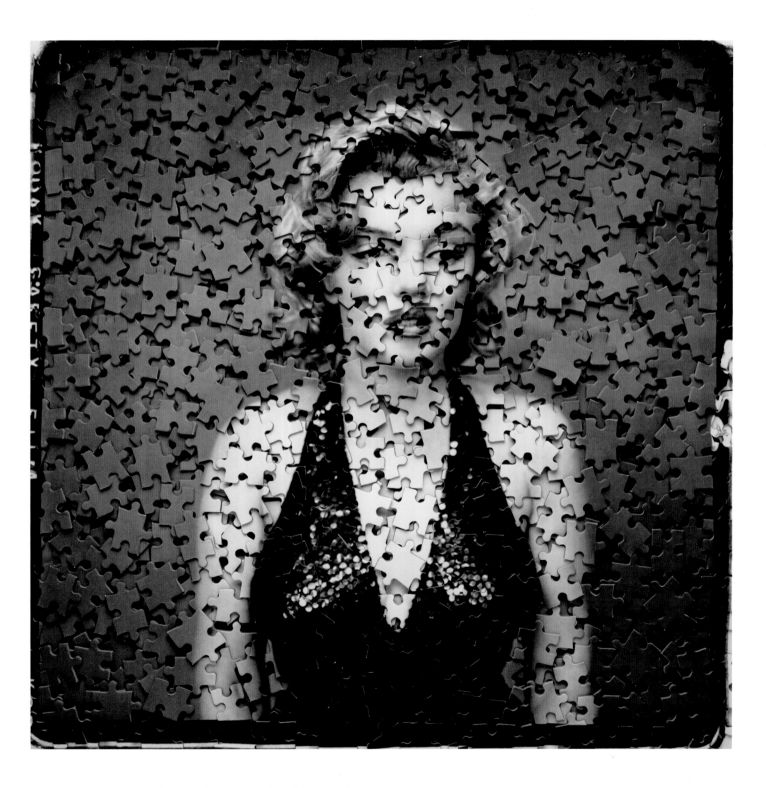

Marilyn Monroe, Actress, NY City, May 6, 1957, after Avedon, 2008,
photograph of painted puzzle pieces, 147 x 122 cm

Otahi (Alone), after Paul Gauguin, 2006, photograph of pigment, 170 x 259 cm, Xippas Gallery, Paris

Carlao (Atlas), 2008, photograph of rubbish, 130 x 102 cm, Xippas Gallery, Paris

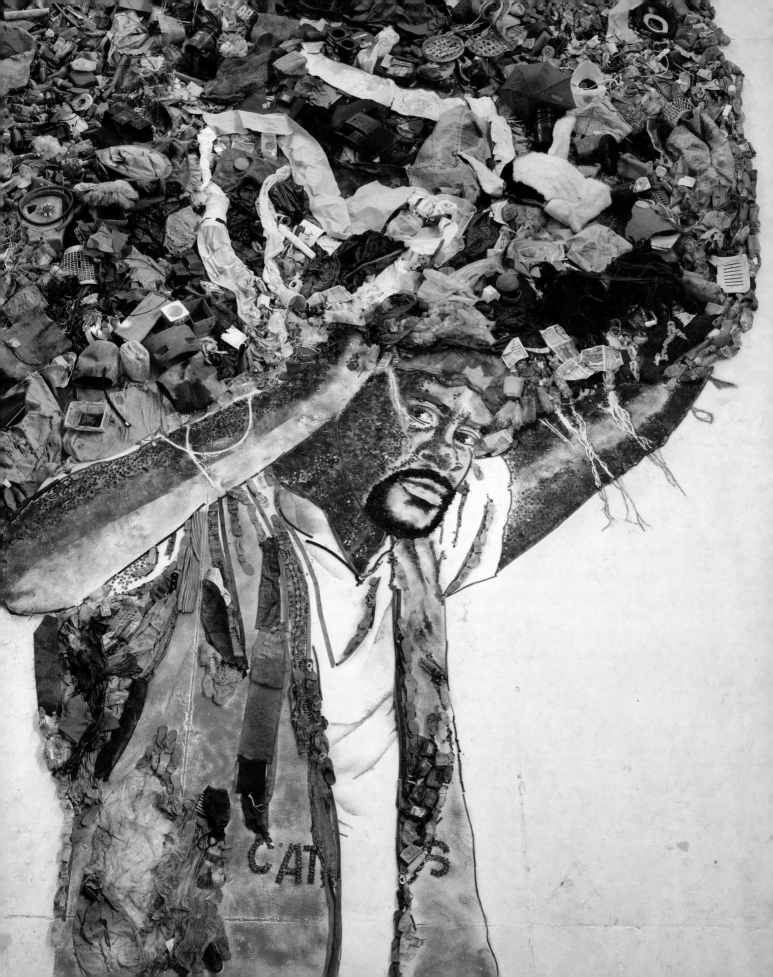

BERNARD PRAS

1952–

Bernard Pras makes portraits out of assemblages of objects that he then photographs. In his way he follows in the footsteps of Giuseppe Arcimboldo, while playing with the rules of perspective and our ways of seeing.

Since the end of the 1990s Bernard Pras has not been making pictures but assemblages that recreate famous images from art history or the media. He first decides on his subject, draws it, then collects together objects with which to reconstruct it as a sort of anamorphic sculpture. After a lengthy process of assembly, the piece has its first incarnation in the shape of an often monumental installation, made up of elements as diverse as colored plastic toys, lead soldiers, household implements, pieces of furniture, and even clothes. With the help of a camera, Pras arranges the compositions so that they work from a single viewpoint, rather like anamorphoses. The last stage is to photograph the installation: the final work consists of an image of the strange sculpture. The artist's goal is the direct opposite of what Italian painters in the Renaissance were trying to achieve with the development of pictorial perspective. Rather than seek to give the illusion of three dimensions to a painting that only has two, he takes a figure in relief and deliberately reduces it to a flat image. It is up to viewers to reassemble it in their mind's eye, to identify and separate out the individual elements of which it is composed. The strength of the work lies in the double way it operates. On one hand, the fact that it is made up of countless elements, each with its own particular character, means that it has layers of meaning embedded within it, not just the surface meaning of the work as a whole, but the implicit connotations of all the everyday objects it comprises. On the other, the fact that there is a single definite viewpoint means that the chaotic mass does inevitably turn into a precise and recognizable image. Even if viewers do not see anything but the final photograph, their perception of the famous image it recreates is disrupted by the press of objects introduced into the picture. That is to say, the act of recognizing a face does not obliterate the teeming mass of details of which it is composed. Bernard Pras calls his portraits "Inventories," as if to suggest that what he is doing is analyzing the faces he conjures up, itemizing their component parts in terms of the cloying mass of consumer products that characterize our world. His manipulation of scale obviously adds to the disquieting quality of the images: how can a piano represent a neck, a mannequin in a shop window be the size of a nose?

The Wave, 2007, photograph of installation, Inventory 79

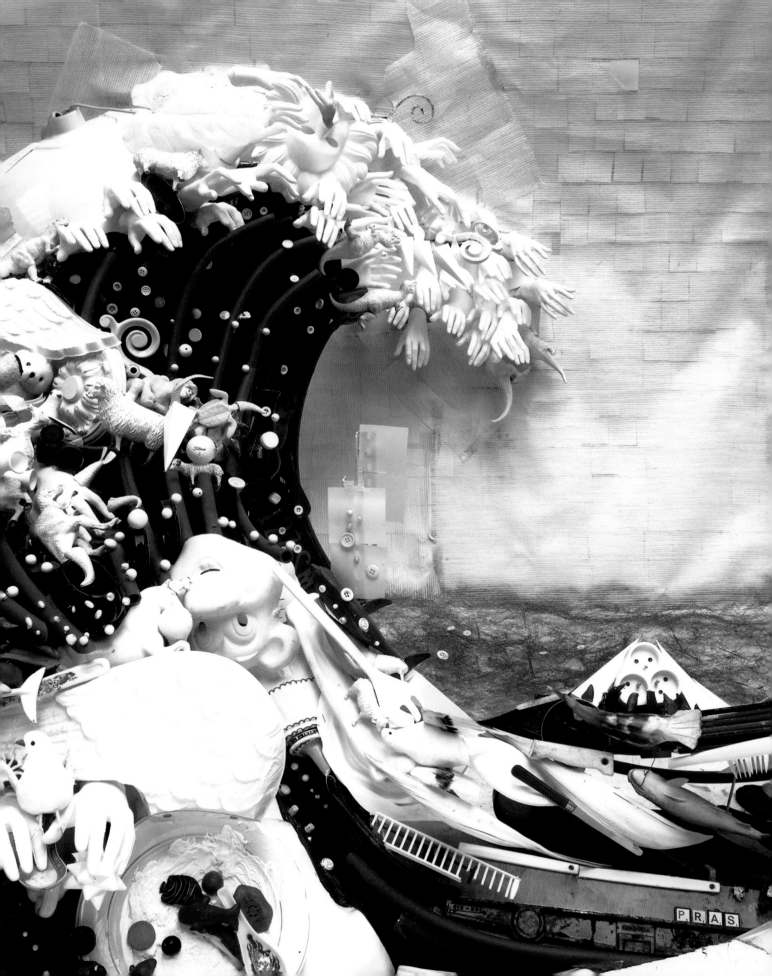

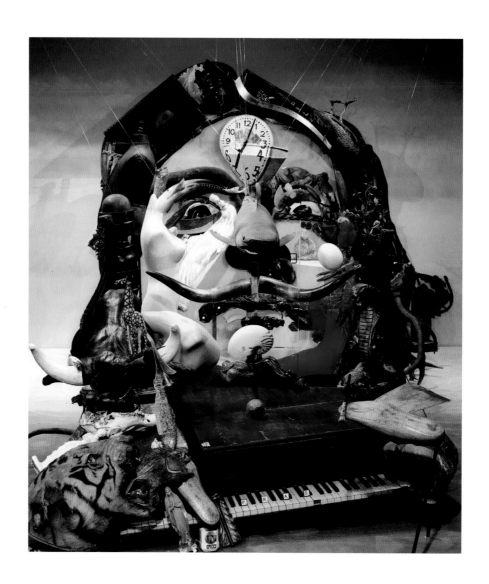

Dalí, 2004, photograph of installation, Inventory 53

Einstein, 2000, photograph of installation, Inventory 25

EVAN PENNY

1953–

Evan Penny's sculptures and photographs demonstrate the impossibility of creating a perfect imitation of reality. He uses illusionist effects in his own work in a perversion of the classic pursuit of a likeness and so questions our perception of the human figure.

Evan Perry's work is based on the idea that all representation of reality is to some extent artificial, that it involves artifice. Since 2007 he has been using 3-D digital imaging technology to transform scanned photographs of living models or sculptures of models. Having first scanned a photograph, he sets about creating distortions using anamorphic effects. He next uses the three-dimensional image to make a mold, from which he then makes a silicone cast. In the same way as hyperrealist sculptors, he paints his sculptures in trompe l'oeil to imitate every change in flesh tone, and attaches real hair on the body and head. By translating photographic images in all their detail into sculptures, Penny in effect makes photorealist sculptures. Generally speaking we expect photographs to capture moments, to preserve the memory of an instant, a fleeting expression across a face. By transforming photographic images into sculptures, however, Penny takes that moment and holds onto it, prolonging it "unnaturally." The distortion he applies to the images further increases the viewer's sense of unease: according to Penny, it is what makes us realize the impossibility of producing a perfect likeness of reality. Penny's work explores the gap that exists between our perception of a real face and our perception of the image of one. There is nothing unusual about human figures being distorted in images—we are quite used these days to techniques of digital enhancement and special effects. But through sculpture Penny gives these images physical form and brings them out into the space we inhabit. His sculptures work as a kind of trompe l'oeil, but one in which the illusion is shattered by a monstrous distortion or fragmentation that turns the human body into a mere object. Although they may be perfect imitations of real beings, Evan Penny's sculpted figures are utterly unalive. Their fixed expressions reveal nothing. They are "sculpted images," symbols designed, somewhat ironically, to illustrate the fundamental impossibility of representational art.

Self, 2008, silicone, pigment, hair, aluminum, 117 x 59 x 53 cm

TONY OURSLER
1957–

Artists have been using video images and techniques since the late 1950s. With his witty and somewhat unsettling installations, the contemporary artist Tony Oursler is one of the latest to exploit the powerful fascination video images have for us.

We are now surrounded by televisions, computers and games consoles, and images from their screens permeate our lives. They are different from photographic images and what makes them particularly fascinating is their capacity to diffuse light. The fact that they move gives them an illusion of depth, of density. They take on the illusion of substance, as if they had the consistency of real stuff. Since the late 1970s Tony Oursler has been using these images as his sculptural medium. He takes images off television screens and sets them floating in the real world by projecting them onto objects. The video artist Bill Viola once described video installation as "intellectual sculpture." It is a description that fits Ourlser's work perfectly. Oursler's installations tend to be rather disconcerting but they are always funny: he sets up small scenes involving objects, mannequins, and even smoke, and onto these he projects videos of faces, eyes, and mouths. Embedded in pieces of furniture, locked in suitcases, or suspended from the ceiling, these bits of body are hardly human, but they exude a presence that draws viewers into the installations. The images have somehow escaped from their context and this creates a sense of invasion: viewers are sucked into a world of moving images that talk to them. These sculpture-creatures of Oursler's often call for help or deliver strange simpering monologues, turning the viewer into an unwilling confidant or witness. In *Eyes*, images of eyes are projected onto big fiberglass balls to create huge eyeballs. As viewers get close, they realize the eyes are watching a television program: there is a reflection of a television set on the retina and the pupils move in response to the events being broadcast on the screen.

In Oursler's installations the human body is under threat from the accumulation of technology in contemporary society. It is always broken up, in pieces; the pieces become huge, but they never join back together again. And yet the pieces keep talking, they continue to express themselves, and seem determined to fight back, to preserve the little humanity they have left.

Switch, 1995, video installation, Musée national d'Art moderne–Centre Georges Pompidou, Paris

MARK JENKINS
1970–

Mark Jenkins is a street artist who makes installations in public spaces that are both cheeky and poetic. His installations are a new form of trompe l'oeil and the figures he creates are designed to make us wake up and think of others.

Mark Jenkins has described his work as a "social experiment." His first installation was directed at children in the streets of Rio de Janeiro, and involved placing a figure in a skip to get their attention. This kind of installation stresses the need for sharing and exchange in public spaces: the street is a forum for advertising and politics, but it needs to be one for artists and local people, too.

One series of installations involved placing a series of babies cast from dolls in cities all over the world. Jenkins wanted them to invade the space, just like taggers (graffiti artists). The babies symbolized human beings in need of care, and the installation was designed to make people stop, look, and show their compassion. If a passer-by made off with one of the babies, for Jenkins it was as though they had adopted it.

Jenkins has developed his own peculiar technique for casting life-size figures. He starts by setting his model—which can be himself, a mannequin, or a living model—in the pose he wants. Next, he covers his model with cling film or sticky tape to make a mold that he then cuts off and finally puts back together like a puzzle. For another series of installations, he dressed his figures and installed them in the street in highly unusual positions: with their head stuck in the wall of a building, upside down in a bin, lying in a bed. Jenkins turns the city into a theatre and films the reactions of passers-by. He highlights the unease that is overtaking our cities and makes people invisible to one another even when they are exhibiting signs of extreme distress and need. His trompe l'oeil works have been so successful in some cities that passers-by have called for the police or an ambulance. His figures do give off a great sense of gloom, but this is always balanced by a touch of humor or hope: the man who seems to have drowned in a river is about to be lifted out of the water by a string of colored balloons. Jenkins has invented a kind of collective art therapy for us on a huge scale.

Orebro, Sweden, 2008, installation, life size

EMMA HACK

1973–

The Australian artist Emma Hack combines body painting with photography to create portraits painted in trompe l'oeil. She transforms living models into veritable chameleons by making them merge with the designs in the background.

E mma Hack started out as a make-up artist before taking up body painting. She began to develop her own form of this in the early 2000s, after coming across wallpaper designs by the Australian interior designer Florence Broadhurst, who died in the late 1970s. She obtained permission to use Florence Broadhurst's designs and began to pose living models in front of them. She works out her composition using the viewfinder in her camera. She lines up the patterns on the wallpaper with the contours of her nude model's body and then begins to paint, constantly using her camera to check how her work is going. She literally makes the nude body merge with the background by painting it in trompe l'oeil. Instead of paint she uses a kind of make-up used in the film industry that does not crack. The painting process takes about ten hours; when it is complete, she takes a photograph of the result, and that is the final piece.

Emma Hack's form of body painting is akin to trompe l'oeil painting, but the illusions she creates are becoming increasingly complex, as is evident in her *Wallpaper Collections* of 2005–2010. The effect her pieces have on the viewer in their final photographic form is different from the sort hyperrealist works produce. At first sight, the photographs look rigged, but they are not. In fact, the opposite is true: the bodies are not fake but very real, while the background is nothing more than painted wallpaper.

More recently Emma Hacks has begun to include animals in her compositions. Their obvious reality gives the lie to the trompe l'oeil that she paints on the nude bodies of her human models. In this new series she uses traditional mandala designs to explore the body's relationship to its surroundings. In her work, this relationship becomes blurred: the human body acquires a characteristic normally found only in a few animals such as chameleons, and so becomes capable of camouflage.

Fingers A, 2008, photographic print, 90 x 90 cm or 50 x 50 cm

KIMIKO YOSHIDA
1963–

The Japanese artist Kimiko Yoshida uses photographic self-portraiture as an endless way to explore identity by concealing and breaking it down. As she puts it: "To be there where I think I am not, to disappear where I think I am, that is what matters."

For Kimiko Yoshida, self-portraiture is not about creating images of herself, but about engaging in a critical exploration of the idea of identity. By producing multiple images of one person, she illustrates the impossibility of anyone having a single, stable identity. Since 2001 she has been producing photographic images of herself according to the same strict formula: they are all self-portraits so have the same subject, they are all framed using the same square format, and they are all lit in the same way. Everything is the same, and everything seems to be repeated, but the subject is always changing. This effect is increased by the color Yoshida uses in the portraits. This verges on monochrome and acts as a kind of mask or veil, dissolving her identity by merging her into whatever space she finds herself in. The figure becomes almost abstract, the near monochrome erasing any difference in genre. By breaking down her identity, Kimiko Yoshida can erase it, and perhaps reinvent it in the process. She defines photography as a celebration of disappearance. As a Japanese woman now living in elective exile in France, Kimiko Yoshida seeks to free herself through her art from the constraints and stereotypes imposed on her by a strict family and very regimented society. Her first series of self-portraits, which consisted of almost two hundred photographs, was called *Single Brides*. The oxymoronic title constitutes an implied criticism of the Japanese practice of arranged marriages and reflects her very particular approach to self-portraiture. Her portraits are concealed behind

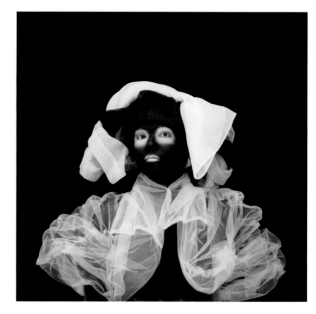

masks and make-up and disappear into the monochrome backgrounds of the photographs. In 2010 she produced another series, called *Paintings: Self-Portraits*, which conjure up masterpieces in European art history. The aim of these is not to imitate a famous picture, but to lose a self-portrait in the timelessness of a masterpiece: yet another way of turning identity into an abstract, disembodied idea. Above all, what Yoshida turns on its head is the genre of self-portraiture itself and the pursuit of a perfect likeness: none of her self-portraits is remotely like any other. In the process, both painting and photography are also challenged and the lines between them blurred.

Painting (Rembrandt by Himself): Self-Portrait, 2007–2009, print on canvas of a digital photograph, with anti-UV varnish, 142x142 cm

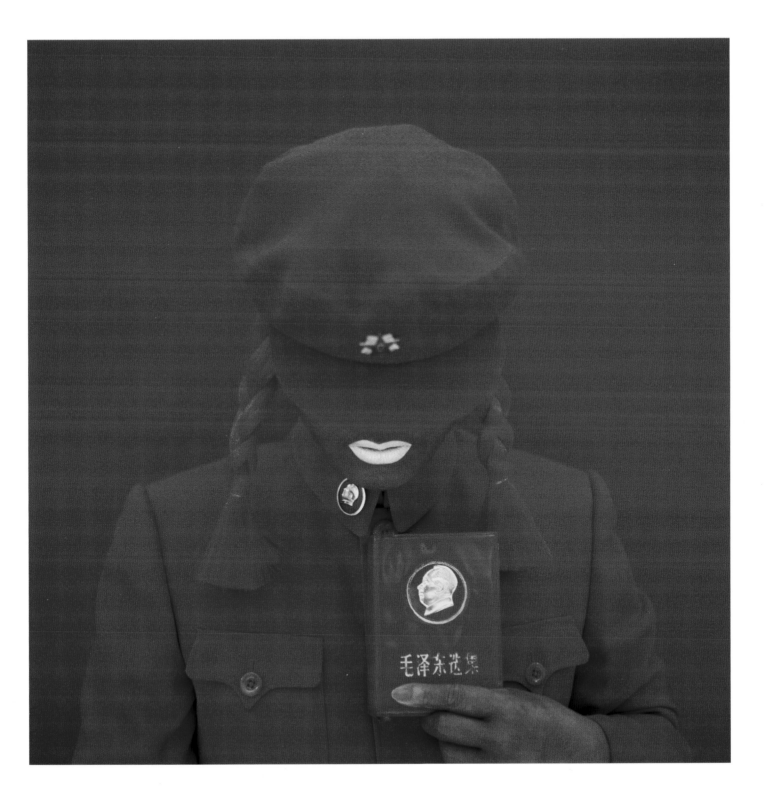

Mao Bride (Red Red Guard): Self-Portrait, 2009, photographic print on aluminum and Plexiglas, 120x120 cm

LIU BOLIN

1973–

The Chinese sculptor Liu Bolin invented a form of invisible performance art, of camouflage protest, after he was evicted from his studio by the Chinese authorities. This silent, "invisible," resistance has made him famous on the international art scene.

Liu Bolin was primarily a sculptor before the Chinese government decided he was an "undesirable artist." He made identical caricature figures of soldiers, peasants, and workers to show the difficulty of being a unique and autonomous individual under the Chinese system. In 2005 Liu Bolin was evicted and his studio in the artists' quarter in Beijing demolished. This traumatic episode radically altered his artistic practice. He took the message of the demolition of his studios literally: since society wanted him to disappear, he would stage his own erasure from view. He produced the first of his photographs of himself as a living sculpture painted in trompe l'oeil, in front of the rubble of his former studio. This was followed by his *Camouflage* series. For the most part these feature Liu Bolin himself, though sometimes a male or female model takes his place, painted in fixed attitudes, with eyes shut, in such a way as to merge with the surroundings. The settings he chooses are significant: we see him blending chameleon-like into the middle of hoardings with election slogans or flags, in front of industrial or political monuments, such as the mausoleum of Mao Zedong, in front of building sites with bulldozers, or in supermarket aisles. Each performance involves lengthy preparation and the help of a team of assistants: every detail of the chosen setting is carefully reproduced on Liu Bolin's body until the illusion is perfect. Once it is, the image is captured with a camera. The slowness of the process can be seen as a kind of deliberate opposition and resistance on Liu Bolin's part to the frenetic economic course on which his country has embarked. It is a slow process for the viewer, too. It takes time to decipher the image: the human figure takes shape gradually. The eye has to adapt before it can see any change in the contours of the setting. Liu Bolin's photographs lead us inevitably to reflect that perhaps man is now no more than this, an invisible part of his environment. Liu Bolin has developed a new form of trompe-l'oeil that uses the artist's body and photography as its tools and makes just as much sense when transposed to Europe—to La Scala in Milan, for instance, where he painted himself red to merge with the Chinese flag.

Hiding in the i-City n° 64, photograph of installation, 150 x 118 cm, 120 x 95 cm or 80 x 63 cm, Eli Klein Fine Art, New York

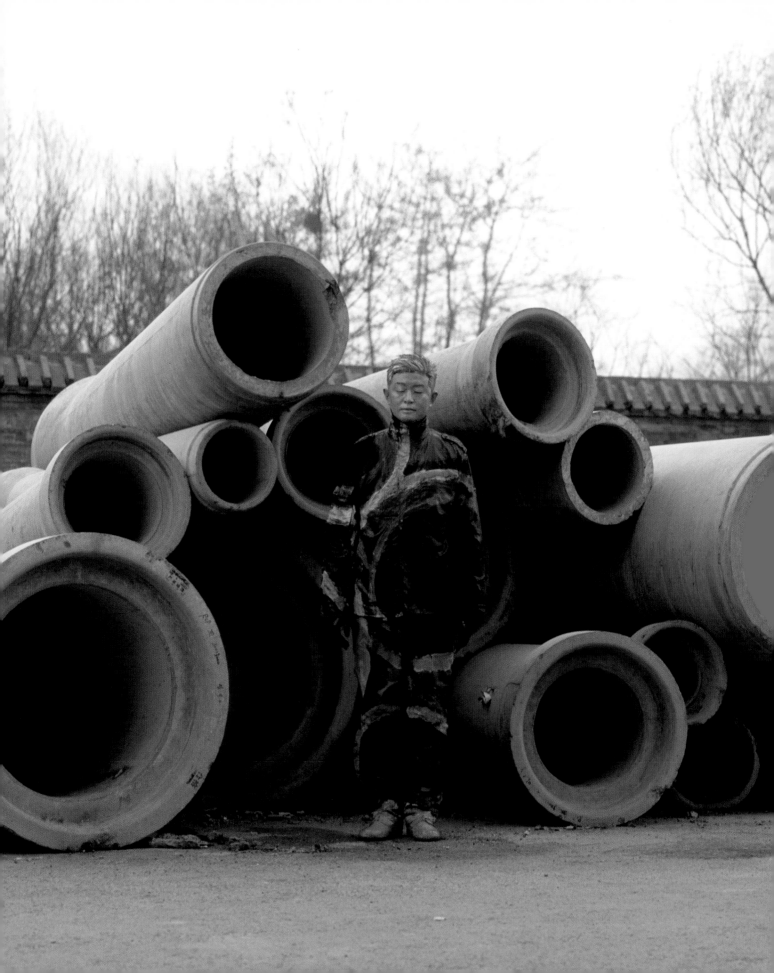

OPTICAL CHALLENGES

PIETER BRUEGEL THE ELDER

c. 1525–1569

What appears to be a genre painting of a quiet bucolic scene is really a carefully constructed allegorical composition by Pieter Bruegel the Elder, brimming with hidden meanings. To apprehend it, viewers have to look to the central device of the gallows, which is the key to its meaning.

Panoramic landscapes with far-reaching views are a familiar element in the work of Pieter Bruegel the Elder. The peace and harmony suggested by the fields and meadows in the valley that opens out in *The Magpie on the Gallows*, however, are almost immediately disrupted by the dismal image of the gallows firmly planted in the foreground. It is pivotal to the picture: its angular geometric form draws our eye inexorably, the strange twists in its posts directing the viewer to the picture's hidden meaning.

We know that *The Magpie on the Gallows* was not painted as a commission; Bruegel wanted his wife to keep it for herself on his death. The magpie on the gallows symbolizes unrestrained gossip; this makes the picture's first implicit lesson a warning to beware of tittle-tattle, the danger of which is highlighted by the gallows. Bruegel was very keen on adages and proverbs, and had previously based several paintings on them. Here, there are two visual representations of common sayings to be discovered. Barely visible in the foreground, in the left-hand corner of the picture, a man is literally "shitting on the gallows," which figuratively means not caring about either death or authority. There are countrymen and -women "dancing under the gallows," another phrase that implies a lack of fear of, or an obliviousness to, any danger. The central image of the gallows ties all these symbols together. Its message could be a personal one from Bruegel to his wife, or it could perhaps be a broader, more political one. In contrast to death by the sword or by fire, death by hanging was seen as dishonorable in Bruegel's day, and the gallows here may be an allusion to the persecutions to which Protestant reformers were sometimes liable at the hands of Catholics.

The Magpie on the Gallows is a didactic picture, but the ideas it contains are delivered by way of an altogether contrasting scene. One of the figures in the foreground is pointing and his gesture takes our eye towards the tranquil valley, and to the dancing men and women, who conjure up life and the sweetness of nature. This optimistic vision is immediately negated by the gallows, the cross and the tomb, symbolizing death. The composition of this picture is central to the communication of its many messages: it is highly complex, and every element contributes to Bruegel's meaning.

The Magpie on the Gallows, 1568, oil on oak panel,
45.9 x 50.8 cm, Hessisches Landesmuseum, Darmstadt, Germany

GEORGES SEURAT

1859–1891

Georges Seurat belonged to the second generation of Impressionists. He sought to add legitimacy to the revolutionary work of his predecessors by rooting it in science, specifically recent discoveries in optics. The style he invented in this way is known as Divisionism.

Scientific progress in optics in the mid-nineteenth century led to some unprecedented experiments in art. The Impressionists took a particular interest in these advances and developed new techniques of painting. Like Claude Monet before him, Seurat wanted to represent the modern world as he saw it. In Seurat's day the island of La Grande Jatte was well known as a place of entertainment with restaurants and cafés, and Seurat spent the summer of 1884 there painting on small wooden panels. Back in his studio in Paris he transferred these studies to a very large canvas: the figures in the foreground are life size. The painting amounted almost to a scientific project; it was through it that Seurat invented Divisionism. He was influenced by the writings of the French chemist and color theorist Eugène Chevreul, who was director of dyeing at the Gobelins tapestry works, and he applied Chevreul's law of color contrast to the painting. According to Chevreul's "law of simultaneous contrast," a red will suggest its complement, green, in the viewer's eye. A green will therefore look even greener when placed next to a red. The same goes for yellow and blue. By extension, a blue will look greener when placed next to a red. According to the "law of successive contrast," if the eye looks first at a red, then moves to another area, it will see this tinted with green. Seurat applied these findings methodically to his painting, as is clearly illustrated by a palette he used, which is now in the Musée d'Orsay in Paris. The colors are all carefully arranged in the order in which they appear in the spectrum: the idea was to work with light and break down each area of color into the component colors of the spectrum. Seurat worked across the grainy surface of his canvas dividing each area of color he wanted in the picture and painting it in with countless tiny dots of pure color. The precise colors he wanted appeared through the blending of different color rays in viewers' eyes when they look at the picture from a distance. It was no longer a case of colors being mixed on the artist's palette, but of them coming into being in the eye of the beholder. This is what was revolutionary about this new kind of painting.

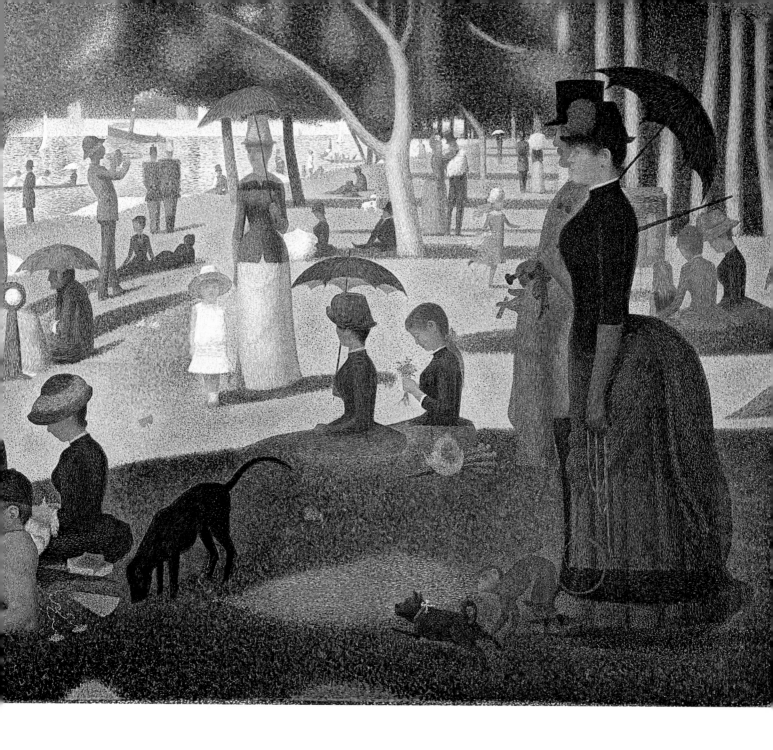

A Sunday Afternoon on the Island of La Grande Jatte, 1884–1886,
oil on canvas, 207.6 x 308 cm, Art Institute of Chicago, Chicago

GIACOMO BALLA

1871–1958

In 1909 the poet Filippo Marinetti published his *Futurist Manifesto* and soon a group of Italian painters came together to develop its ideas. They called their new style of painting "dynamic art"—their mission was to capture movement and to make people experience the thrill of it.

Based on a passionate belief in progress, Futurism promised a program of cultural and political change. The movement was born in Milan, one of the first major industrial cities in Italy. For its leader, Filippo Marinetti, industrialization was a glorious phenomenon, however brutal it might be. The early twentieth century was marked by a succession of revolutionary inventions: the Futurists witnessed the first motorcar races, saw cities set ablaze by electric light, experienced images moving on cinema screens, watched planes conquer the skies: "We declare that the splendor of the world has been enriched by a new beauty: the beauty of speed," boomed Marinetti. Henceforth, "the supreme aim of painting will be to express movement." Man and art had to recognize the power of progress and adopt a radically different approach in keeping up with it. The Futurists declared war on all that belonged to the past. They abandoned traditional subjects in favor of seething cities, the restless urban masses, and roaring machines, and were particularly interested in contemporary scientific research into the nature of energy and light.

This was particularly true of Giacomo Balla, who studied scientist Étienne-Jules Marey's work on chronophotography and transposed the photographic method Marey used to analyze movement to painting. He first experimented with using this method to depict the different stages of movement in *Dynamism of a Dog on a Leash*. The seriousness of the title, the focus on the dog's paws and the cropping of the image all give the picture something of the feel of a scientific study. When Balla addressed his attention to the movement of an automobile, in *Abstract Speed + Sound*, the result was very different. The car became entirely lost in an image of pure speed, as Balla depicted the moment when the contours of things become blurred, when the eye sees only lines and colors and jagged abstract shapes. The speed that suddenly engulfed people at the start of the twentieth century, when Balla was painting, profoundly altered their perception of reality. Transport and communication were dynamic, and art, for the Futurists, should generate a similar dynamism: it should propel viewers into the hectic race towards a bright new world.

Dynamism of a Dog on a Leash, 1912,
oil on canvas, 90.8 x 110 cm, Albright-Knox Art Gallery, Buffalo

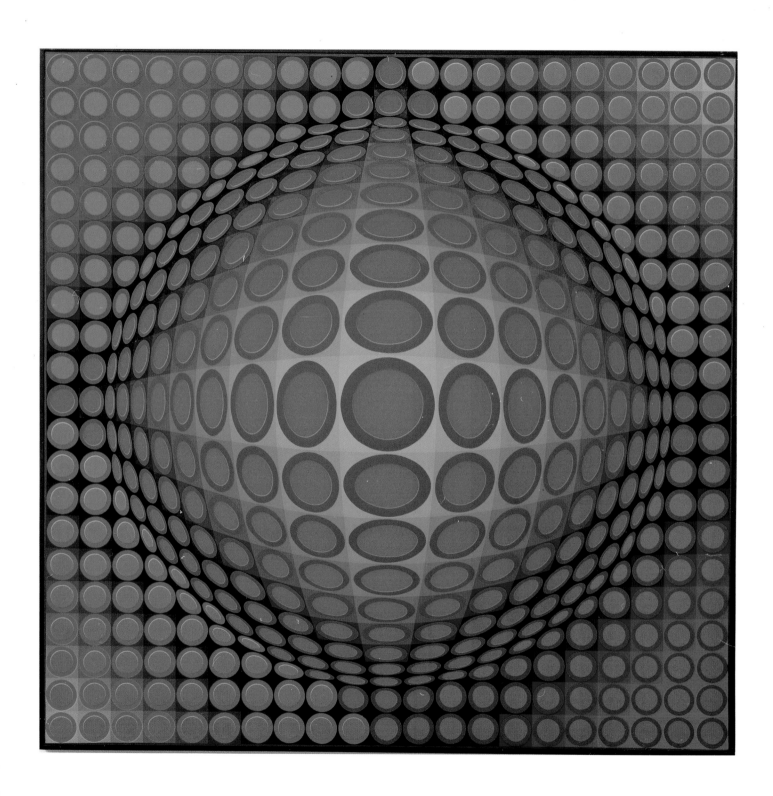

Vega 200, 1968, acrylic on canvas, 200 x 200 cm, Michèle Vasarely collection

VICTOR VASARELY

1906–1997

Victor Vasarely's work was by no means limited to exploring combinations of abstract forms, but instead sought to evoke a sense of life, of cells pulsating to the movement of the galaxies.

Op Art (Optical Art) came to fame through *The Responsive Eye*, a big exhibition held at the Museum of Modern Art in New York in 1965. This brought together a range of abstract works that presented viewers with some visual situation or optic phenomenon that could be apprehended only through their active perceptual participation. The exhibition led to Victor Vasarely's being hailed as one of the major figures in Op Art.

In the 1930s Victor Vasarely was preoccupied principally with line and how to convey substance and tone, though works such as *Zebra* already betray his interest in optical illusion. After focusing on graphic art for a period, he explored some of the contemporary art movements of his day, such as Cubism. His painting became abstract in the late 1940s, when he began to work with pure form and color. He wanted to "recognize the internal geometry of nature" by looking at the way forms are affected by the coming and going of waves or the movement of water on pebbles. He concluded that an ovoid form, for instance, embodied "the feeling of the ocean." From then on he endeavored to create a sense of movement through all that he did. His graphic and kinetic interests came together in a series of black-and-white paintings that set up a contradictory interplay of linear grids and undulating distortions. From 1960 onwards Vasarely developed what he called his "plastic alphabet," a systematic way of generating art accessible to all. The alphabet allowed him to create artworks by combining endless permutations of basic geometric forms and minute variations of color. He continued to explore movement and perception, and his paintings produce both a kinetic effect and an illusion of depth or density. Using simple circles inside squares he managed to create a sense of volume: the lines and colors suggest a three-dimensionality in something that is only a flat surface. The vibrating, throbbing, or undulating movement of a painting exists only in the eye of the viewer. The canvas seems to pulsate as if it were breathing: here Op Art uses a cold and abstract system to conjure up a sense of life.

Following pages: *Zebra,* 1938, lithograph, Musée national d'Art moderne–Centre Georges Pompidou, Paris

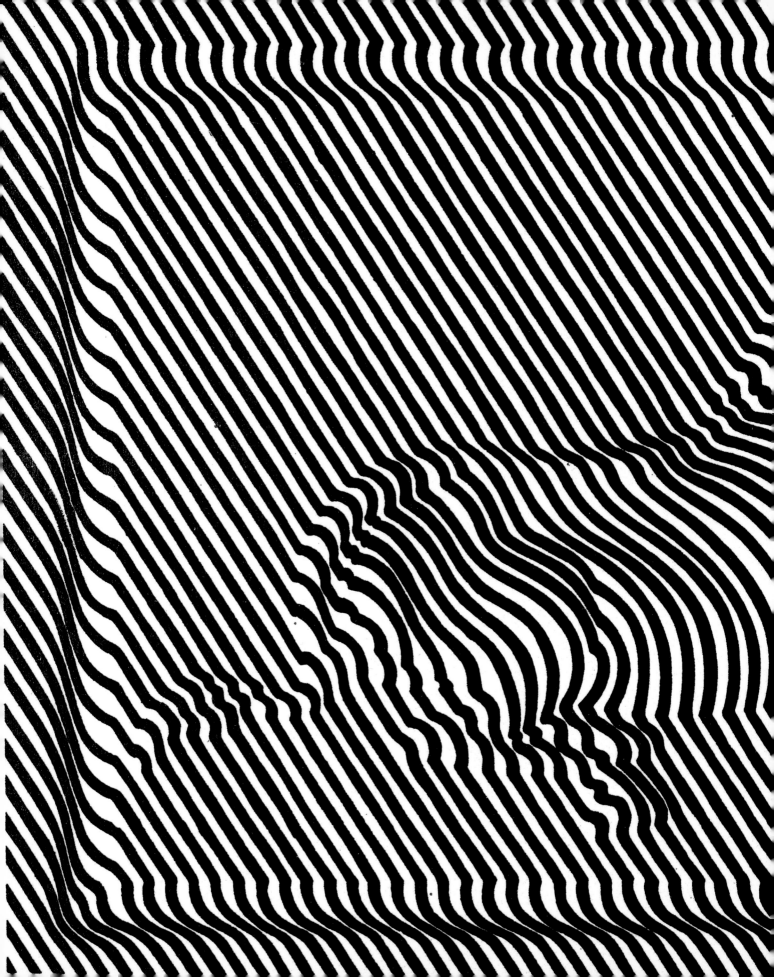

BRIDGET RILEY

1931–

Bridget Riley is often linked to the Op Art movement that began to enjoy popular success at about the time that she came onto the art scene in the 1960s. What prompts her work, however, is not so much an interest in scientific aspects of visual perception as a fascination with the potential painting has to stimulate sensation.

Bridget Riley's aim in using illusion is not to achieve a likeness of a subject, but to exploit the properties peculiar to painting so as to create and transmit sensation. For Riley there are still lots of possibilities to be explored in painting.

Riley was inspired by the work of modern painters such as Monet, Seurat, Matisse, Mondrian, and Klee. Her first paintings were influenced by the Neo-Impressionist painter Seurat, whose work was based on Divisionist color principles and the eye's ability to combine adjacent colors to create a third. Riley copied Seurat meticulously in order to understand his method completely.

Throughout her career, Riley has returned to her personal experience of nature and used it as a starting point for her work: her sense of the undulation of grass in the wind, for instance, the reflection of light in water, or the transformation of clouds in a changing sky. While she is working out a painting, she continues to develop her ideas in the light of her own sensory experience and makes countless preliminaries studies on paper. These are a fundamental stage in the process and allow her to experiment with the way colors and forms interact by repeating them and adjusting their scale. Riley initially worked in black and white and only later introduced color into her work. She typically explores the potential of any one element to the full before adding another. Using simple means, she achieves complex visual effects: luminous vibrations, a sense of space, an impression of movement.

In 1961 Riley began to hire assistants to execute her paintings, getting them to paint precise, neutral shapes for her. This was so that she could judge her work objectively by being the first to view it. Riley's paintings require the presence of a viewer, with the act of viewing becoming a creative process in itself: only when they are viewed do Riley's paintings finally come together. Their immediate effect is hallucinatory, but then new images appear that come into being fleetingly, when the viewer is at a certain distance from the picture: hitherto unseen movements, forms, and effects of lights appear, and do so anew in every work we look at.

Zing 1, 1992, acrylic on canvas, 101.6 x 88.9 cm

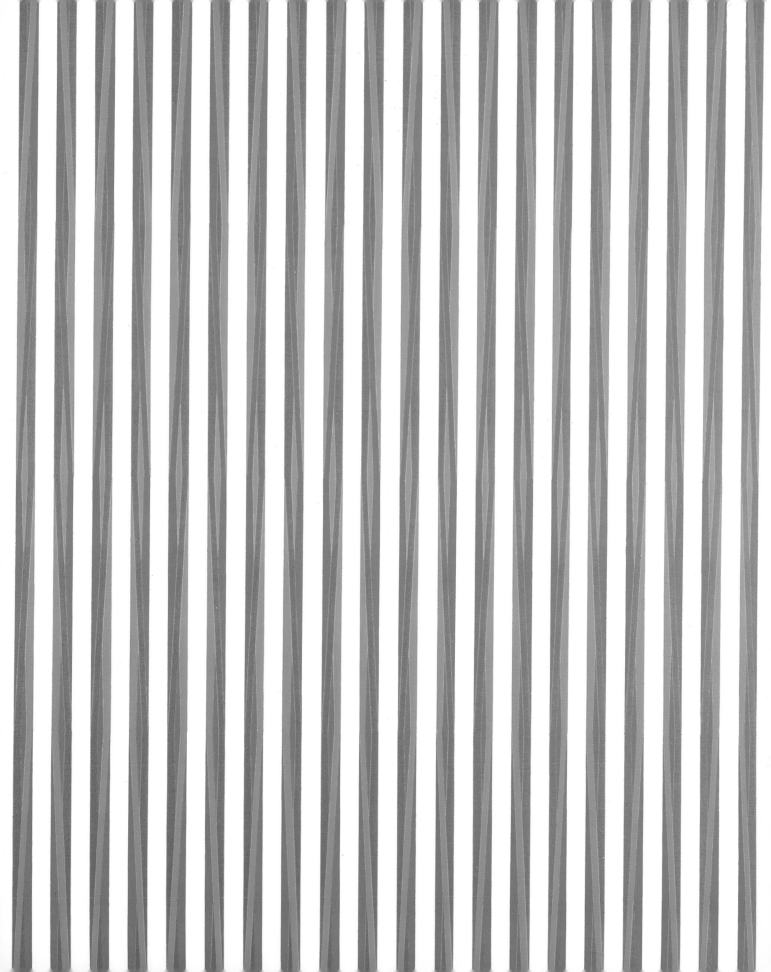

Movement in Squares, 1961, tempera on panel, 122x122 cm

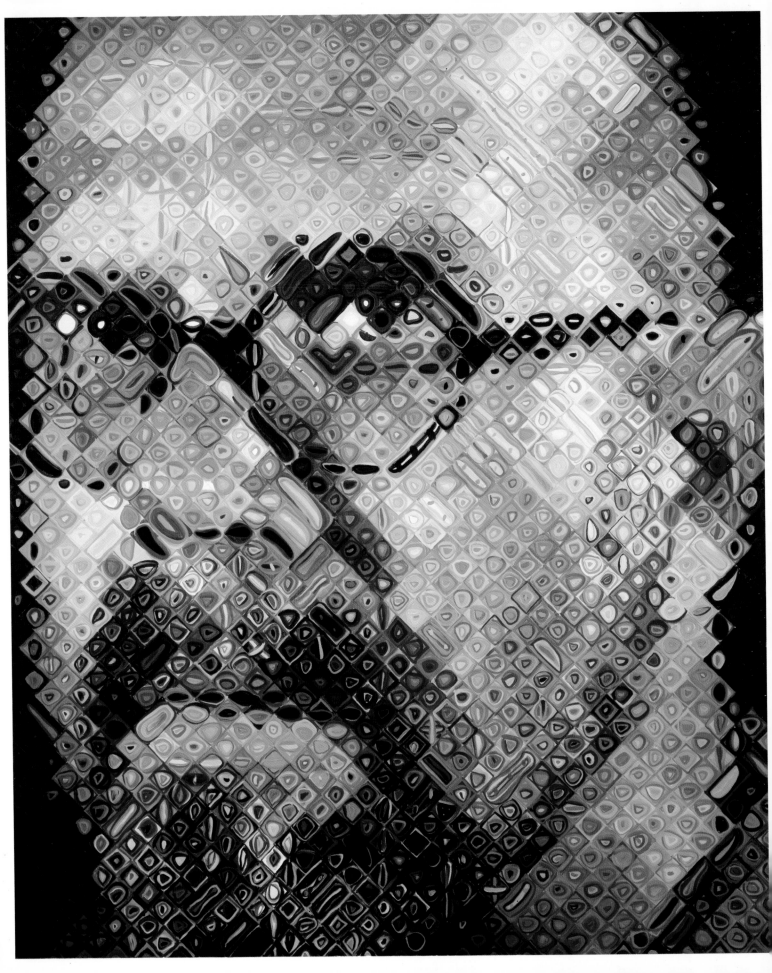

CHUCK CLOSE

1940 –

For more than 40 years Chuck Close has painted nothing but faces, and, more specifically, faces from photographs, tirelessly exploring the gap between reality and the representation of it. His huge paintings demonstrate that images are by definition constructions.

Chuck Close started his first series of portraits in 1967, working initially from black-and-white passport photographs. He does not subscribe to traditional portrait painting and seek to plumb the depths of his sitter's soul. For him, portrait painting serves an entirely different purpose and he approaches it almost as a scientific experiment: his concern is not with his subjects but with the images he creates of their expressionless faces. He deliberately works in black and white and on a huge scale to eradicate all possibility of confusing the images with reality. Every detail in his *Big Self-Portrait* of 1967–1968 is rendered with disturbing perfection. This includes the blurred areas at the edges of the face, which Close has faithfully reproduced from the photograph. He paints with the limited eye of a camera, seeing only what it sees, and makes the viewer do the same. His work foregrounds technique: what it reveals is the treatment of the image. His portraits show the apparent realism of photography to be nothing more than an illusion. His subject has not changed, but Close has varied his technique. Like other hyper-realist artists, he has experimented with projecting slides onto the canvas and using an airbrush. In the end, however, he prefers to paint with a brush, using a grid that he draws on the photograph to transpose the information onto a corresponding grid on the canvas, meticulously, square by square, in a method that predated digital images in origin but anticipated pixilation.

In 1971 Close began to use color in his work, and here again he has experimented with different approaches. He does not create colors in a traditional way by mixing pigments on a palette: instead, he uses only the three primary colors and applies them one after the other, as if he were superimposing three monochrome paintings, a blue one, then a red one, and finally a yellow one, in what is effectively an imitation of the color process used in photographic printing. Close also produces portraits using rubber stamps or his finger tips. In his 2004 *Self-Portrait*, each square of the grid is filled with a geometric shape (a ring, a dot, a lozenge) that enhances the abstract quality of the work. Like all Close's colossal paintings, the portrait begins to break down and reveals how it is constructed. Seen from afar, it forms a face that seems bewitchingly real; the closer the viewer gets, however, the more it disappears from view.

Self-Portrait, 1997, oil on canvas, 259.1 x 213.4 cm, Museum of Modern Art, New York

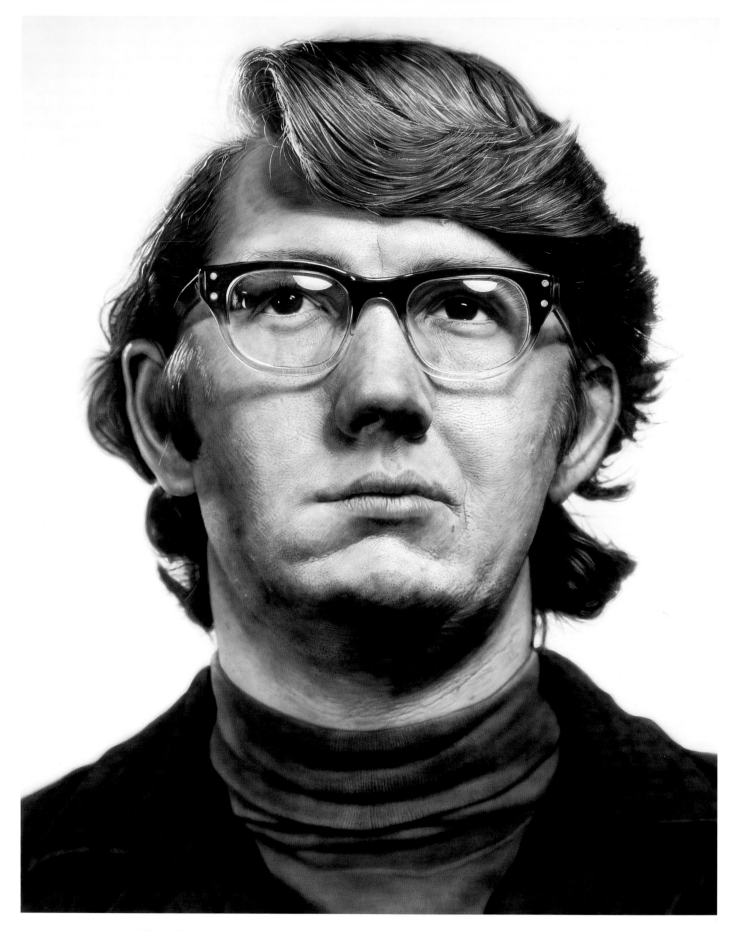

Keith, 1970, acrylic on canvas, 275 x 213.4 cm, Saint Louis Art Museum, Saint Louis

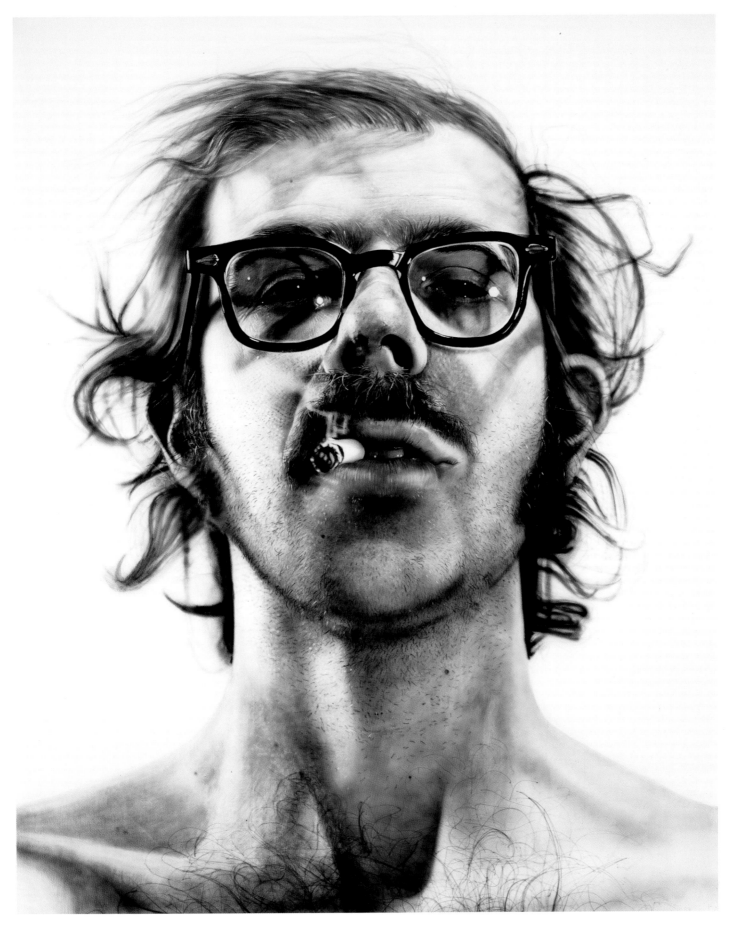

Big Self-Portrait, 1967–1968, acrylic on canvas, 273.1 x 212.1 cm, Walker Art Center collection, Minneapolis

GEORGES ROUSSE

1947–

Georges Rousse creates what he calls "immaterial sculptures" by photographic site-specific work that combines architecture and painting. These pieces blur the distinctions between art forms and upset our normal perception of things.

Georges Rousse was an architectural photographer before he developed his own particular art form, which is influenced by abstract art and Land Art and brings together painting and the environment in a new way. His work takes place in stages and starts with disused buildings. Rousse scours the world for suitable sites. When he has found one—an old rail station or disused abattoir, for instance—he sets up his photographic equipment, complete with lens, bellows, and frosted glass. He begins by drawing a design on glass and the lines of this are then transferred to the building by an assistant. Sometimes he prepares designs in advance and uses slides to project these onto the space instead. The space is then painted following the transferred or projected design. Once this is done, Rousse photographs the installation from a single fixed viewpoint. His work is the opposite of traditional kinds of trompe l'oeil: it gives an illusion not of depth but of flatness. In direct contrast to the great masters of illusionist painting in the Renaissance, Rousse collapses three-dimensional architectural space into a two-dimensional image. The installation is only a means to an end: once photographed, all trace of it is removed. The large-format prints made from the photographs represent the last in a succession of transformations and are the only surviving evidence of Rousse's process.

In Rousse's work, architecture, painting and photography come together to create a new type of image and conjure up the illusion of an imaginary space. His site-specific installations, or rather the photographs of them, make it seem as if the shapes, colors, and fragments of text that they feature are somehow generated by the space itself. The colored shapes seem to assume a sculptural form distinct from the architectural space, while matching its contours perfectly. The photographs are strangely unsettling because they appear to bring together three mutually exclusive spaces: the physical building in its original state, the painted installation, and another, fictitious, space that combines the other two and is generated by the photograph.

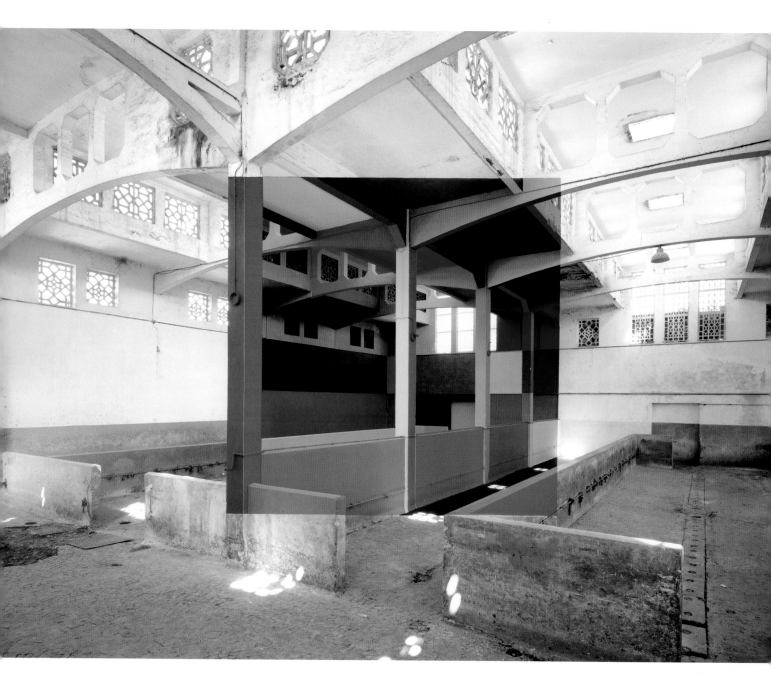

Casablanca, 2003

Blanc-Mesnil, 2006

Meisenthal, 2002

FELICE VARINI

1952–

Felice Varini's installations reveal a coherent set of geometric shapes only when seen from a single point of view. They have enormous richness, however, because the number of shapes viewers can find within them is infinite.

Felice Varini's installations require viewers to walk around: they invite them to survey the area just as Varini does before he begins an installation. Whether he operates in an architectural space or an urban landscape, Varini works with existing forms, complementing them with painted elements to change the way people perceive them. His painting seems to set the space in motion and forces viewers to move around to try to find the artist's starting point, the unique viewpoint that allows the geometric pieces to fall into shape. This viewpoint is determined by Varini's own height and is always at his eye level, precisely 1.62 meters from the ground: he tailors the world to his dimensions and makes us see it literally from his perspective. His installations articulate his way of seeing and give it a material reality, thus allowing us to see the environment as he sees it, as a set of lines and curves in an infinite number of patterns.

Varini begins by projecting a design onto the space he has chosen as his backdrop. He traces the outlines of the shapes and then fixes pieces of painted paper onto them. He uses simple geometric shapes that he paints with primary colors, black, or white: this is not about painting in trompe l'oeil, but about prompting a new view of the space on which the shapes are painted. Each painted piece points to a hitherto unnoticed architectural detail and the work as a whole is designed to prompt a fresh response to the city and architecture. Varini catches our eye by introducing an anomalous element into our field of vision: his paintings are like frameless pictures that give the illusion of a single plane in three-dimensional space. In his hands, painting works like photography: it flattens a space while revealing it. The link between the two does not stop there. Varini's works have only a brief existence in three-dimensional space; photography gives them a second life. In this sense photography sustains painting while showing it to be a trick. It is an optical trick that viewers have to let themselves be drawn into if they want to understand Varini's works. Finding the precise viewpoint that allows the design to fall into place is exhilarating because it makes viewers feel as if they have put together what was previously a disjointed jumble and made it into a coherent whole. But the search is ultimately only a way of allowing viewers to discover countless other viewpoints of their own: each new perspective enriches the work, and the scope is endless.

Rettangoli Gialli Concentrici Senza Angoli al Suolo, 1997, acrylic, private collection, Suglio, Switzerland

Archi e Corone, 2004, acrylic, Antico monastero delle Agostiniane i sotterranei dell'arte, Monte Carasso, Switzerland

Archi e Corone (not aligned with viewpoint), 2004, acrylic, Antico monastero delle Agostiniane i sotterranei dell'arte, Monte Carasso, Switzerland

MICHAEL KALISH
1973–

Close to, *reALIze* looks like nothing more than a mass of leather punch bags hanging in the air. This sculpture by Michael Kalish needs to be seen as a two-dimensional work, from a distance and at a particular angle to make sense.

Devised by the artist Michael Kalish, *reALIze* took three years and the help of the architect Oyler Wu to construct. The sculpture is over 20 meters high and took kilometers of steel cable to support the black-and-white leather punch bags and tons of aluminum tubing to form the framework. A portrait of the famous boxer Muhammad Ali, it was set up temporarily in a square in Los Angeles in 2011 and was made at the request of the Ali family. For several years Kalish has been exploring American identity by making portraits of American icons very much in the tradition of Pop Art. He adopts a similar style to artists such as Andy Warhol and Roy Lichtenstein, whom he openly pastiches. His portraits are three-dimensional, however, and they are mainly made out of metal American car license plates. The names of the same states crop up again and again, crossing over from one work to another, making America seem ingrained in his subjects' skin.

Generally speaking, the power of a sculpture relies on our being able to walk around it. This is certainly the case with *reALIze*, although the face the sculpture contains becomes visible only when looked at head-on from the front and from a distance. What then appears is a black-and-white photorealist treatment of a face. It is an image of an image, at one remove from reality, and to some extent constitutes a reflection on the nature of representation. By combining the two-dimensional quality of a photograph with the three-dimensionality of a sculpture, however, Michael Kalish transforms a simple portrait into a veritable homage. A photograph of Muhammad Ali, of a comparable size, could have communicated his heroic stature. But Kalish wanted to convey what media images conceal and to portray him through the work, endurance, and suffering that made him the man he was. Kalish deliberately used common boxing apparatus as his medium: the sculpture includes over a thousand punch bags, a token of the number of hours of training Ali put in. Kalish's design allows us to go behind the image, to see what its two-dimensional face conceals.

reALIze, 2004, installed from 25 March to 9 April 2011 in Los Angeles

YAYOI KUSAMA

1929–

Yakoi Kusama's works allow viewers to visualize and so enter into her hallucinations. She gives material form to images that are intensely private and normally hidden, and turns them into disturbing and enveloping spaces.

Since the 1960s a large part of Yakoi Kusama's work has been based on an image from a childhood memory. Sitting with her family at a table one day, she suddenly saw the patterns on the tablecloth multiply and cover the whole room as well as her body. The experience had a traumatic impact on her and became an obsession: "I am just another dot, among countless others in the world," Kusama said in 1960. She has continued to suffer from hallucinations in which she sees her body covered with dots. Her response has been to confront the experience through her art, staging performances in which she and the set become covered in dots, and creating monumental installations in which dots seem to proliferate endlessly. She uses mirrors in her installations to accentuate the sense of repetition: the effect is to make viewers lose their bearings when they are inside them, as if they were assailed by a kind of vertigo. Viewers catch sight of their own reflection surrounded by countless dots, and are compelled to experience for themselves Kusama's obsessive sense of being just one dot among many. Kusama's works are both invasive and absorbing at the same time.

She makes sculptures out of textiles, for instance, in the shape of carnivorous flowers that seem to devour her. The same soft forms feature repeatedly in her work: helium balloons, phallic, tentacle-like, amorphous shapes populate worlds of dots. Although the universe she creates as an artist derives from a private and internal world, it is charged with a powerful desire for freedom in more public—feminist and political—terms. In the 1960s her work focused on sexual liberation and on the brutality of consumer society. After a long period of self-imposed exile in New York, Kusama returned to Japan in 1973, where she chose to live in a psychiatric hospital that she leaves only to go to her studio. She continues to take a stand against not just the emptiness that threatens to overwhelm her but also what she calls the "homogenized culture," "polluted nature," and "imagery of hell" of our information-laden society.

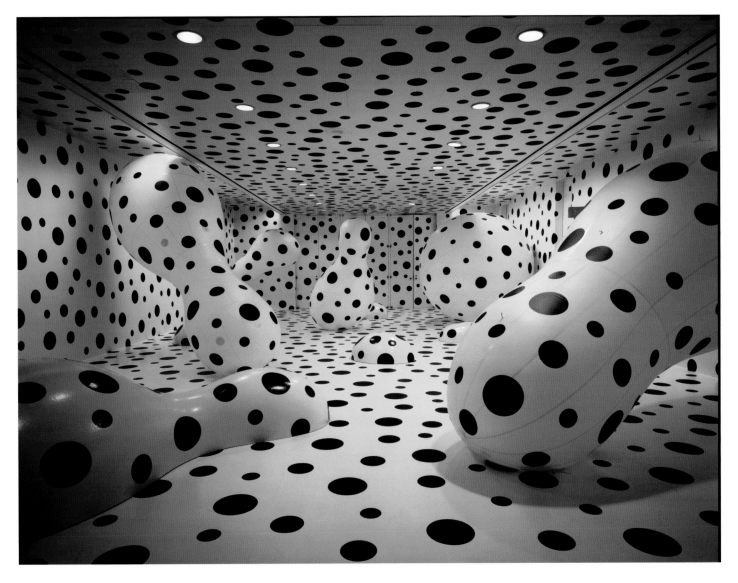

Dots Obsession – Day, 2008, installation, mixed media,
view of the *JAPAN! CULTURE + HYPER CULTURE* exhibition at the Kennedy Center, Washington, DC

Following pages: **Dots Obsession – Night,** 2008, installation, mixed media,
view of the *JAPAN! CULTURE + HYPER CULTURE* exhibition at the Kennedy Center, Washington, DC

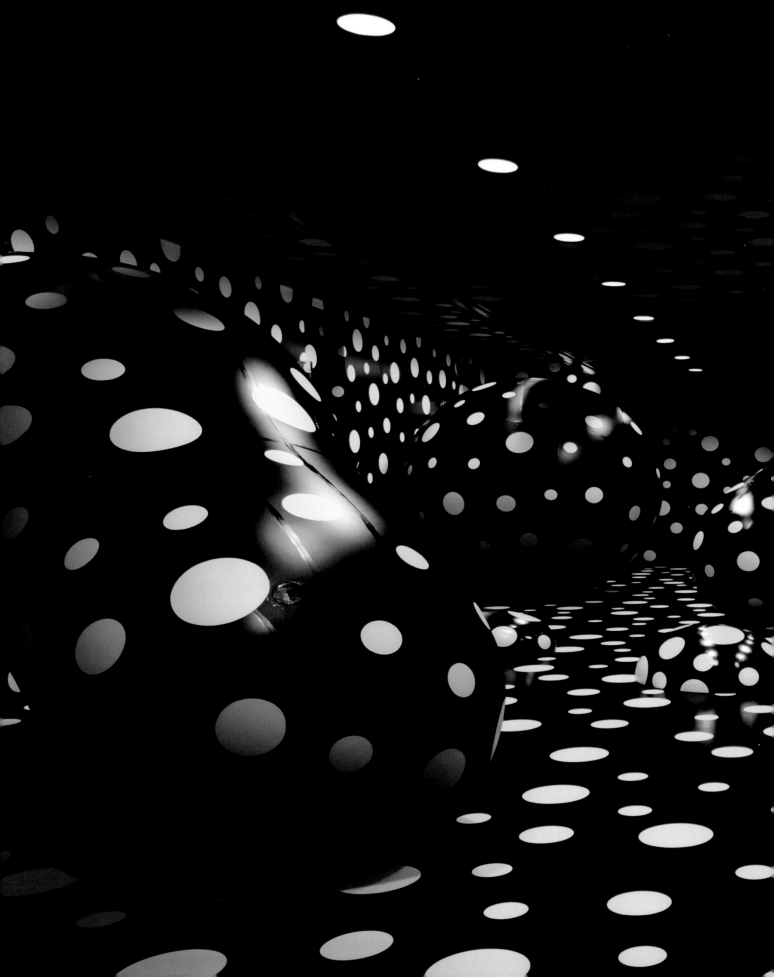

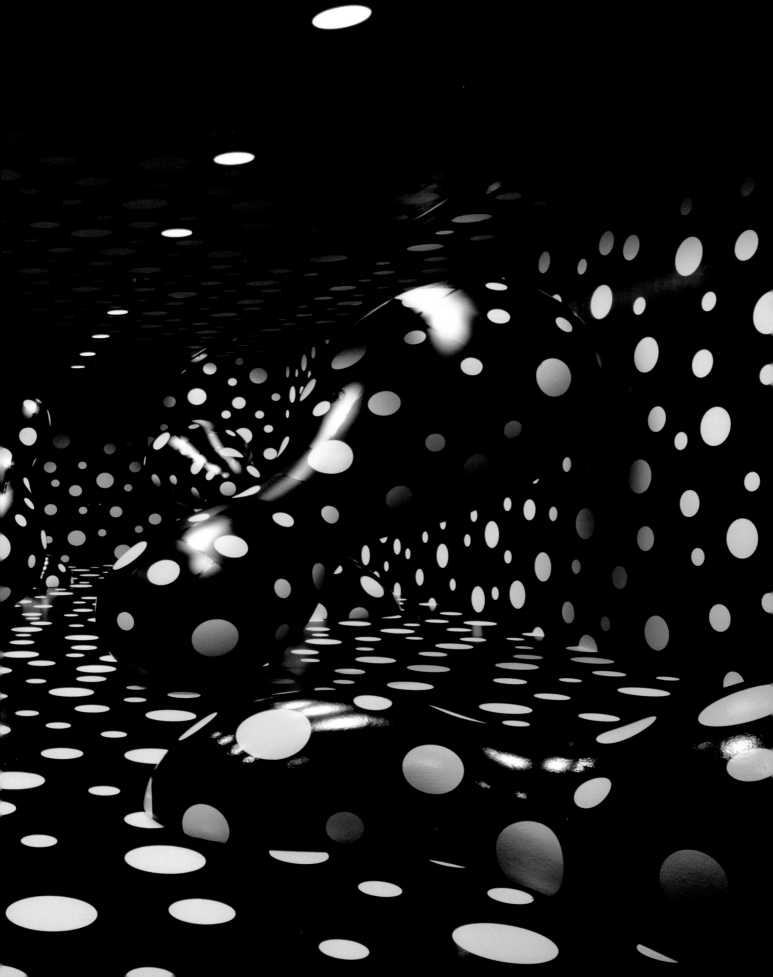

ANISH KAPOOR
1954–

The contemporary artist Anish Kapoor has created a series of mirror sculptures that reflect the sky, the space around them, and the people looking at them. These monumental pieces give an illusion of disappearing into the world that surrounds them while in fact offering only a distorted reflection of it.

In 2001 Anish Kapoor was commissioned by the city of Nottingham in England to make a sculpture to go outside the Playhouse. He designed a gigantic concave mirror of stainless steel, a version of the sky mirror he exhibited at the Rockefeller Centre in New York in 2006. With their perfectly smooth forms both these enormous sculptures give a distorted reflection of the spaces around them and the bodies of anyone who comes up to them. Unlike artists in the Renaissance and Baroque, who painted ceilings to look as if they opened onto the sky, Kapoor brings the clouds down to the ground. In a breathtaking feat of illusion, *Sky Mirror* makes it look as if the earth has turned into the sky and become weightless.

Kapoor works with space and emptiness, playing on them in his sculpture so that the stainless steel surface merges into the environment and seems to create a window in it, as in a painting by René Magritte. The images that are reflected in it make us lose sight of the sculpture itself: for Anish Kapoor these mirror works are "non-objects." Although they are monumental and made of tons of steel, they appear light and evanescent. As a result, everything is inverted and everything becomes fluid: inert and abstract forms become animated with mobile forms, sky-scrapers nudge us with their tips, clouds touch the ground, and images of reality change cease-lessly as people pass by. Kapoor's *Sky Mirrors* seem to swallow the world in which they exist and make it part of themselves. We see ourselves reflected in the sculptures and at the same time we seem to see ourselves inside them. Visitors could actually get inside the gigantic *Leviathan* that Kappor designed for Monumenta at the Grand Palais in Paris in 2011. When they did so, they found their expectations challenged: it was like being enveloped in the throbbing belly of a monstrous beast. Kapoor's mirror sculptures similarly lead us to explore the way we perceive the world and so to experience it differently. Sight is generally taken to be a "cold," disembodied, sense when compared to touch, which is more obviously sensual. Kapoor's work sparks a physical sensation as we look at it, as if our eyes were suddenly rediscovering their lost connection with the rest of the body.

Sky Mirror, 2006, stainless steel installation, exhibited from 19 September to 27 October 2006 at the Rockefeller Center, New York

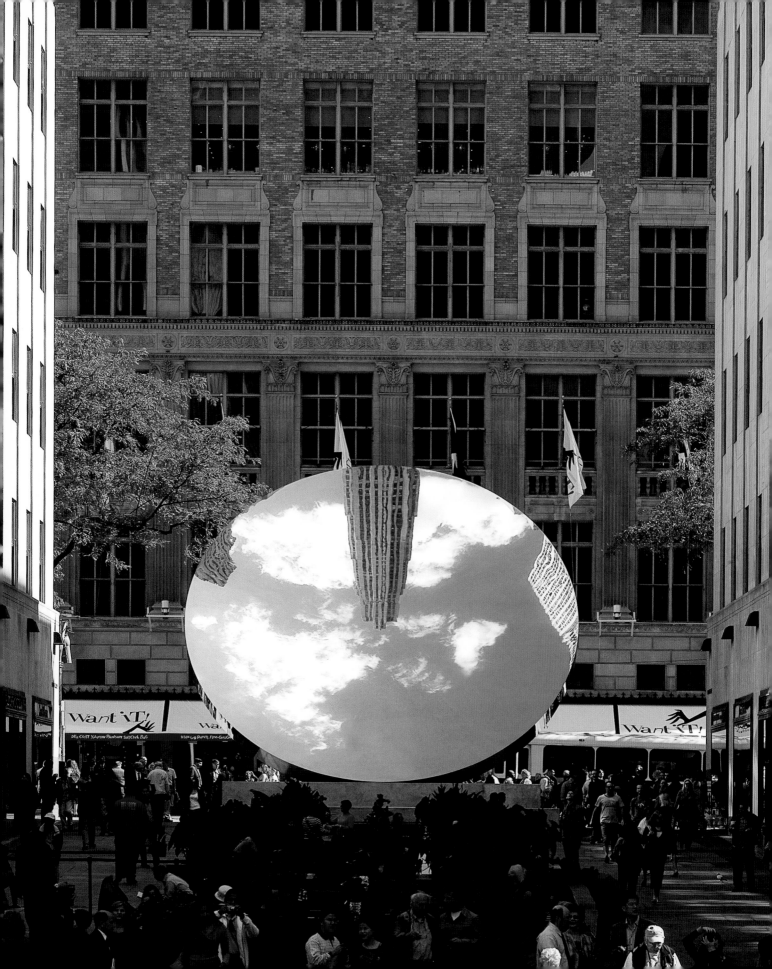

BEYOND REALITY

RENÉ MAGRITTE

1898–1967

René Magritte's paintings are puzzles whose titles render them more impenetrable still. The point is not to solve the puzzles, but to confront them as impossible images that reveal a mystery that remains forever latent.

René Magritte was initially influenced by Futurism and Cubism, but in 1927 his work became synonymous with Surrealism. But though there is an obvious affinity between Magritte's work and Surrealism, there is nothing symbolic or allegorical about his paintings: they do not call for interpretations of the kind that Surrealist works do with their links to dreams; instead, they encourage us to accept the mystery inherent in the most mundane reality. The ingredients in Magritte's paintings are always the same and are quintessentially ordinary: bowler hats, apples, windows, doors, skies, clouds. Using these simple elements, Magritte demonstrates the impossibility of there being any correspondence between an object and its representation: "Everything suggests there is little connection between an object and what it represents." Words do not solve the problem, they complicate it: "An object is not so attached to its name that one cannot find another for it which is more suitable." This idea is perfectly encapsulated in Magritte's famous picture of a pipe that is entitled *This is Not a Pipe*. The point of art, for Magritte, is not to represent reality; art can do far more than create an illusion of reality. If his paintings have the appearance of realistic representations, it is in order better to question the visible world. The objects in Magritte's pictures are painted with such faultless smoothness that it is easy to forget that they are in fact painted, and they always suggest that there is a hidden part beyond what is visible. In the real world where logic applies, a mirror reflects the face of a man standing in front of it. In Magritte's universe, however, this seemingly obvious logical truth is undermined: the visible is interesting only for the invisible that it implies. Our habitual ways of seeing are disrupted, to remind us that everything we see is pregnant with unseen meaning. In many of Magritte's pictures, like the one that has a train coming though a fireplace into a sitting room, there is no distinction between inside and outside. Such impossible situations are puzzles that are not meant to be solved: they bring us face to face with mystery that, for Magritte, is a new way of understanding reality.

Forbidden Reproduction (Portrait of Edward James), 1937,
oil on canvas, 82 x 65 cm, Museum Boijmans Van Beuningen,
Rotterdam, The Netherlands

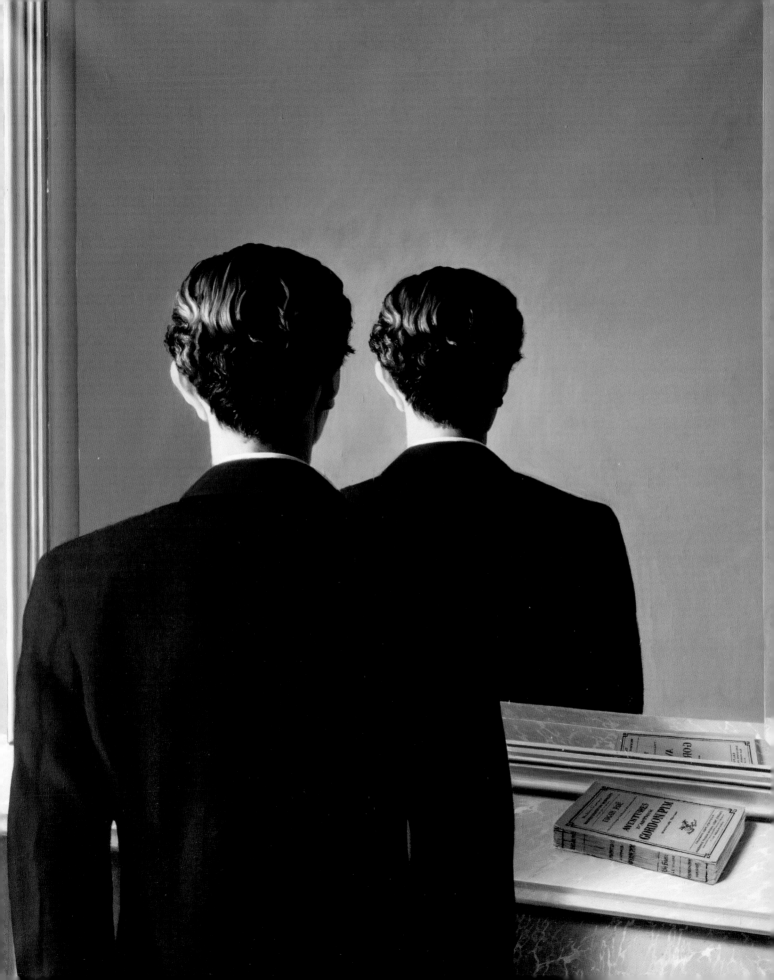

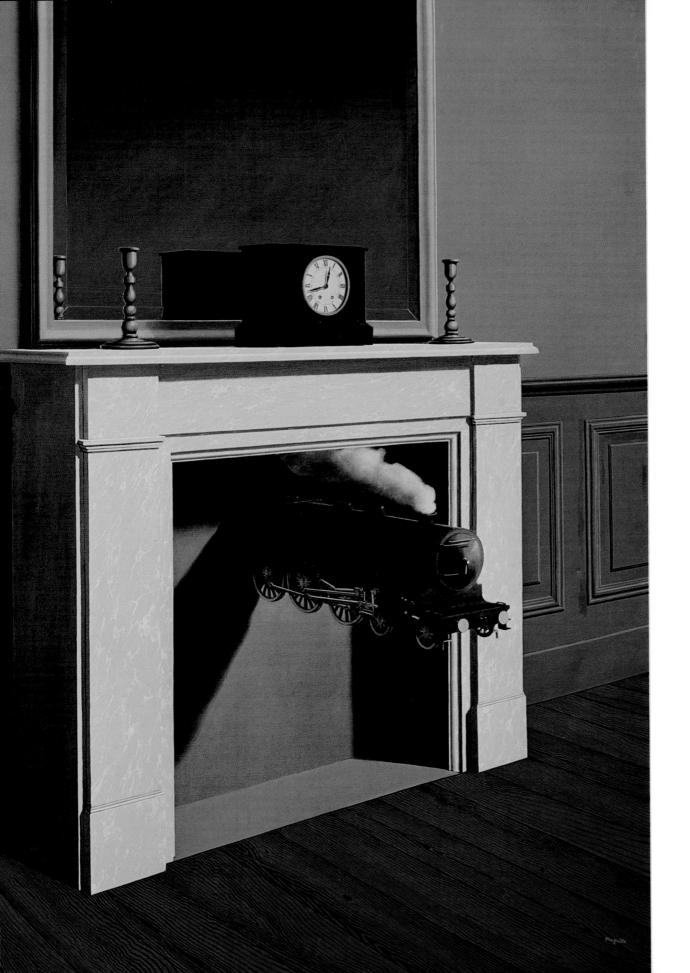

Castle in the Pyrenees, 1959, oil on canvas, 200 x 145 cm,
The Israel Museum, Jerusalem

Time Transfixed, 1938, oil on canvas,
147 x 98,7 cm, The Art Institute, Chicago

PHILIPPE HALSMAN

1906–1979

Philippe Halsman became famous both for his fashion photography and for his portraits of famous people. Early in his career, in the 1930s, he mixed in Surrealist circles and this almost certainly influenced his photographs, which try to penetrate his subjects' inner being.

Philippe Halsman set up his first photography studio in Paris in 1932. He mixed with artists and photographers, and particularly with members of the Surrealist movement. His photographs reflect their influence: details are out of place, undermining the realism of the pictures and bringing incongruous elements together in the way the Surrealists loved because it prompts a free association of ideas and so gives access to another reality. Halsman never lost his desire to reveal the mystery in the subjects he photographed. He compared his practice to that of a psychologist seeking to get to a genuine internal truth by capturing an unconscious manifestation of it.

In 1940 Halsman fled occupied Paris and emigrated to the United States with the help of Albert Einstein, of whom he took one of the most famous photographs. Two years later, he began working for *Life*. The magazine commissioned dozens of portraits of celebrities from him, of subjects as disparate as Marilyn Monroe, Alfred Hitchcock, and Winston Churchill. For nearly thirty years, up to 1972, Halsman's photographs regularly made the front cover of the magazine. In 1941 Halsman met Salvador Dalí and the two began a long collaboration. In 1948 Halsman produced a series of photographs that are reminiscent of paintings by Dalí. "Dalí Anatomicus" is an extraordinary picture that captures Dalí, his canvas, easel, three cats, and a bucket of water all in mid air. There was no trick photography involved and the picture took hours to produce. The following year Halsman produced a portrait of Jean Cocteau that showed him as a non-stop, super-energetic writer, filmmaker, designer, and debonair man of fashion rolled into one. Throughout his career, Halsman tried to encourage his subjects to drop the masks they normally wore: he wanted to "get at the psychological truth of the subject and present it in a valid form, a graphic form, but would always sacrifice design for content." In the end he developed an original method that he called "jumpology": he got his models to jump in the air and captured them at a moment when they were not thinking about controlling their expressions. He even managed to convince people as famous as Richard Nixon and the Duchess of Windsor to try it.

Jean Cocteau, New York, 1949

MAURITS CORNELIS ESCHER

1898–1972

At first sight the scenes in Maurits Cornelis Escher's prints look as though they are governed by strict rules of perspective, even entirely built on rules. After a minute or two, however, viewers realize that they are looking at a world that is absolutely impossible.

In Italy in the late eighteenth century, Giovanni Battista Piranesi had already exploited his perfect mastery of technique to subvert the normal rules of perspective and to use alternating true and false perspectives in his famous series of etchings *Carceri* (Prisons) to accentuate the sense of oppression he wanted to create. It was in Italy that the Dutch artist Maurits Cornelis Escher was to learn engraving. There he focused on landscape, particularly in the south of the country, and was already fascinated by the structure of houses, stairs, and walls. In 1936 he visited the Alhambra Palace in Grenada, his discovery of its Moorish architecture playing a crucial part in shaping his thinking of space in terms of contrasts of black and white. Back in the Netherlands, he became interested in geometry and crystallography and as a result of his study of these developed the rigorously precise methods that allowed him to produce in the prints that have made him world famous. These rely on the same principle of false perspectives as Piranesi's etchings. Since the Renaissance artists have schooled us to look at the world in terms of one-point perspective, even if it does not entirely conform to the laws of science. We have become so used to looking at the world this way that we lose our bearings as soon as there is any departure from a single perspective. Escher's prints incorporate other ways of representing three-dimensional space, each internally logical but completely impossible when used together. Escher combines different points of view in a single two-dimensional picture space with the result that any illusion of perspective gives way to a dizzying feeling of vertigo. Escher also has a liking for impossible objects, two-dimensional images of structures that could not exist in three-dimensional reality. *Cascade*, for example, locks us into a perpetual circuit, like a labyrinth without an exit. Escher did not think of his prints as finished works, but saw them as provisional solutions to complex technical problems. Metaphorically, his unsettling images illustrate a reality in which different truths co-exist.

Cascade, 1961, lithograph, The Granger Collection, New York

JOAN FONTCUBERTA
1955–

Joan Fontcuberta is a mischievous artist and consummate hoaxer who explores the relationship between photography and truth and takes advantage of our credulousness. In his hands photography is not about representing reality but about falsifying it.

The Catalan artist Joan Fontcuberta started out in the late 1970s making photomontages directly inspired by the Surrealists, following in the tradition of the likes of Luis Buñuel and Man Ray. He continues to display a taste for displacing elements, and to repudiate objectivity, but his montages have changed scale. No longer content to work within the limitations of individual photographic images, he now creates entire exhibitions that demonstrate the power photography has to act as a substitute for direct experience of the world.

In 1985 Fontcuberta put together *Fauna*, a traveling exhibition that introduced the general public to the work of a little-known German scholar called Peter Ameisenhaufen, who in the course of his travels in the mid-twentieth century discovered a number of strange creatures that had issued from rare species long thought extinct. *Fauna* took the form of a huge installation in which yellowing documents, drawings and photographs of stuffed animals were displayed in dusty, old-fashioned glass cases. Labels with Latin names described the behavior, diet, and habitat of the species on display, such as the *Cercopithecus icarocornu*, a mutation of the mythical unicorn, a little nocturnal creature with wings to allow it to escape the humans who tracked it for its supposed magical powers. Not only visitors, but critics and journalists alike fell for the hoax. Fontcuberta maintained his anonymity, but planted clues throughout: the fictitious scholar Ameisenhaufen's research assistant, for instance, was called Hans von Kubert, the German equivalent of Fontcuberta. Fontcuberta has exhibited these astonishing archives in various places, meticulously observing the display conventions of scientific institutions and museums. In reality, everything is invented, everything is fabricated: the archives and photographs are artificially aged; a taxidermist was hired to concoct the fake species out of a mishmash of bits of stuffed animals. *Fauna* is no mere artistic hoax, however: fictions such as this demonstrate that photography is not just a medium for recording. Today, it is capable of challenging the very fields that give it legitimacy: art and science.

Cercopithecus icarocornu, Fauna, 1987

166

JEFF WALL

1946–

Jeff Wall's huge photographs continue a naturalist pictorial tradition but offer a particular critical take on it. Wall explores the question of representation by creating not illusion but fiction.

In the late 1970s the Canadian artist Jeff Wall traveled to Europe, where he became interested in the great Realist paintings of the nineteenth-century and the ideas they embodied about the nature of representation. He looked at the work of Édouard Manet among others. Not only did Manet use color and light in a new way, which corresponded with Impressionist painting, he was also one of the first artists in the history of Western art to leave visible the canvas on which he painted, making obvious the properties and material limits of the medium that the illusionist tradition had thitherto sought hard to conceal. Jeff Wall began to use photography to re-explore some of the issues that had preoccupied nineteenth-century naturalist painters. He set about creating modern transpositions of major pictures with figures such as *The Death of Sardanapalus* by Eugène Delacroix or *A Bar at the Folies-Bergère* by Manet. Like many nineteenth-century painters before him, he works in his studio, getting actors to pose for him and recreate the compositions. He then makes large-scale transparencies that he lays on white fabric to accentuate their luminosity before displaying them in a backlit case. At a time when black and white is something of a norm in art photography, Wall bucks the trend by using color which is generally associated with advertising. Wall calls his photographs "cinematographs": they are spectacular and certainly do evoke both painting and the cinema. With them Wall recaptures the presence and influence painting once had. In 1993 Wall worked from a woodcut by Hokusai that had inspired the Impressionists before him. Unlike the Impressionist painters who sought to do justice to the sublime aspect of the landscape by capturing it like a photograph, however,

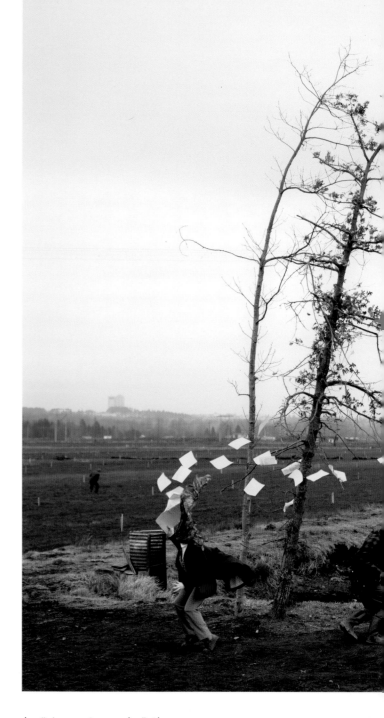

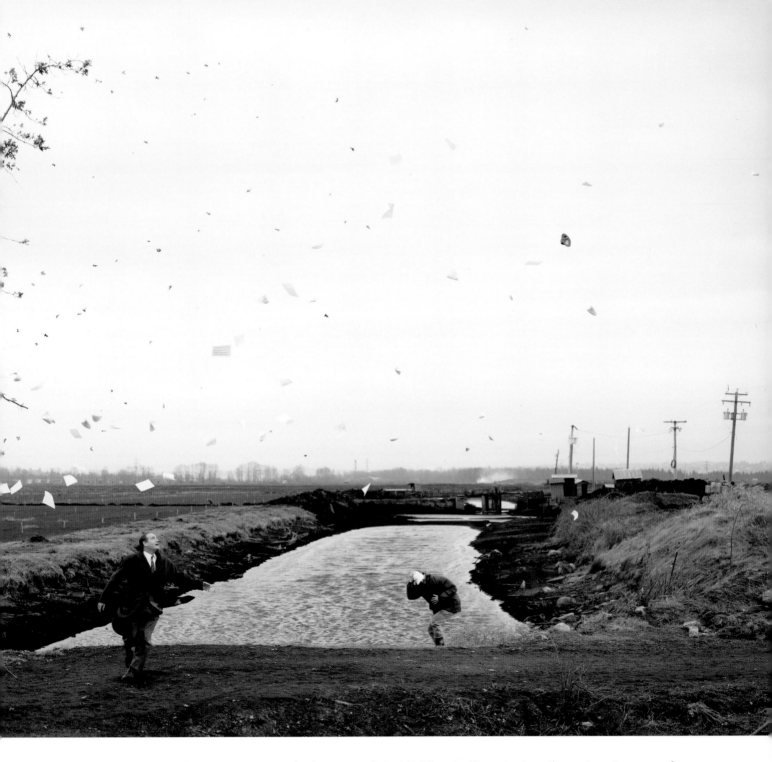

Wall imitated the beauty of the composition the better to distort it. The strolling nineteenth-century Japanese figures are turned into twentieth-century workers and the natural event takes on a comic twist. The staging and the retouching of the photograph emphasize the improbability of this incongruous fiction. Although he chooses not to exploit the documentary properties of photography, Jeff Wall nevertheless offers a new view of the society we live in, and has always called himself (in an allusion to the nineteenth-century French poet Charles Baudelaire) a "painter of modern life."

A Sudden Gust of Wind (after Hokusai), 1993, ektachrome, illuminated case, 229 x 377 cm, Tate Modern, London

MAURIZIO CATTELAN
1960–

In Maurizio Cattelan's hands, illusion becomes an instrument of irreverence and subversion. His works are like a new type of vanitas and ridicule all forms of power, institutionalization, and sanctification.

Maurizio Cattelan sets up stuffed animals or hyperrealist sculptures in unusual or shocking positions in order to snap us back into consciousness. His pieces lay bare the mechanics of alienating systems and modes of being to which we are no longer aware that we subscribe. Adolf Hitler kneeling asking for pardon, Pope John Paul II struck down by a meteorite, Cattelan himself, his head emerging from a hole in the floor in a museum gallery: his figures are satirical, but they also represent desperate attacks on authority of every kind, be it historical, political, religious, or cultural.

In a calculatedly sadistic gesture at the opening of a show in 1999, Cattelan stuck his Milan dealer, Massimo de Carlo, to the wall of his own gallery with large strips of gaffer tape. The dealer thus found himself in the same position as the objects he sold, in a reversal of roles that exposed the exploitative nature of the relationship dealers have with the artists they represent. Cattelan had already "martyrized" his Paris dealer, Emmanuel Perrotin, at the Venice Biennale in 1995, by disguising him as a pink rabbit, clearly phallic in appearance, and making him walk around the exhibition space dressed like that. The contemporary art world is one of Cattelan's main targets: the money and power at stake in it exemplify every kind of vanity. In 1992 Cattelan created the Oblomov Foundation, a fictitious institution that awarded a prize to an artist who undertook not to produce anything for a year. In 1998 he got an actor dressed up as Pablo Picasso with a ridiculous papier mâché head to stand outside and greet visitors as they went into the Museum of Modern Art in New York. The following year, he organized the Sixth International Caribbean Biennale, an event at which the artists invited had nothing to do or show, but had to take a paid holiday at the exhibition's expense. All of these absurd and brazen stunts add up to a kind of comic parody of the reality of the contemporary art and media worlds. When he puts a stuffed horse in a gallery high up in the air, its head stuck into the wall, Cattelan reverses the whole convention of displaying hunting trophies. It is not just the vanity man displays by killing and seeking to dominate which Cattelan is mocking, however, but a whole artistic tradition.

Untitled, 2007, stuffed horse, 300 x 170 x 80 cm, view of the exhibition
at the Museum für Moderne Kunst, Frankfurt am Main, 2007, photograph by Axel Schneider

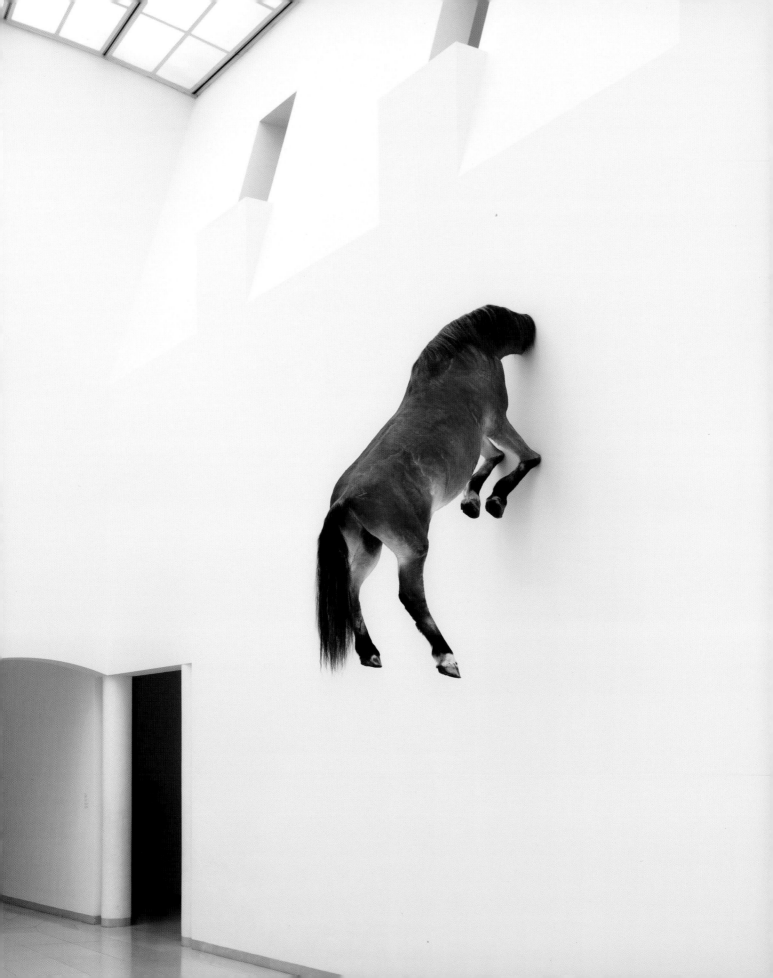

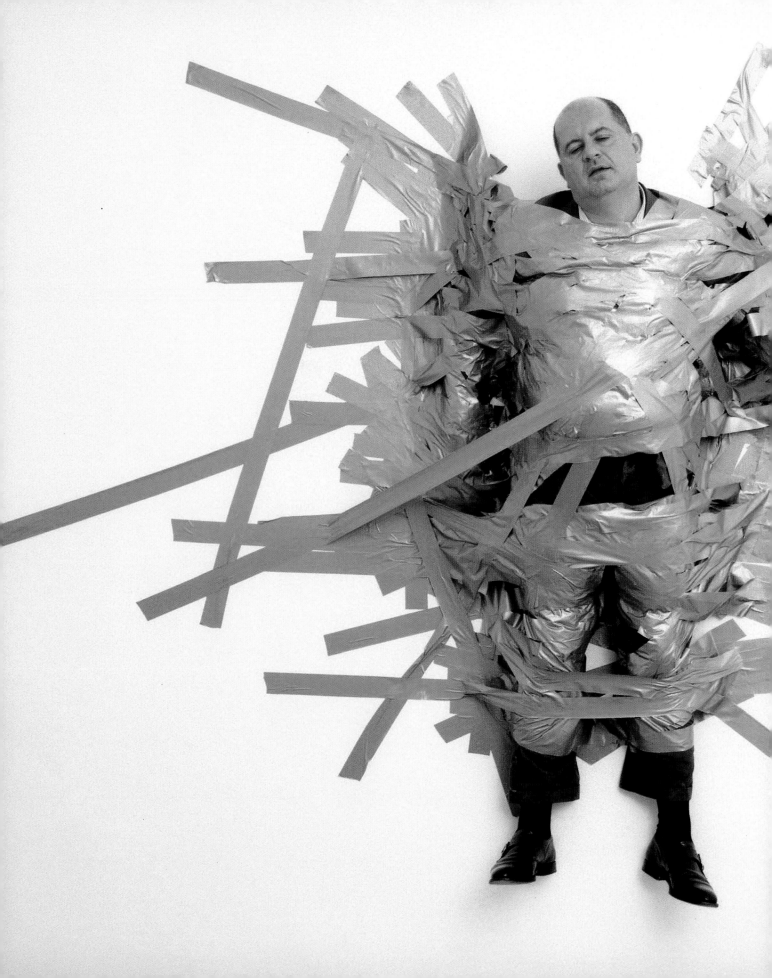

A Perfect Day, 1999, color photograph, Plexiglas, aluminum, 258 x 192 cm, photograph by Attilio Maranzano, Massimo de Carlo gallery, Milan

EIJA-LIISA AHTILA
1959 –

"Illusion has become material to work with," states Eija-Liisa Ahtila. The Finnish video artist certainly exploits the magical powers of cinematographic images to take us through the looking-glass.

Presented for the first time at documenta in 2002, *The House* shows a woman's psychological deterioration into a nervous breakdown. The film conjures up a sense of loss of all spatial and temporal bearings, of breakdown of all coherent meaning in the world, all logical perception of things. The house serves as a metaphor for the human mind: a cow suddenly bursts into the sitting room and cars move about on the walls. "With the use of fantasy elements made with special effects I try to run side by side the realistic settings and logic, and the unfamiliar or the imaginary," the video artist explains. Viewers can neither take refuge in a simple identification with the character, nor stand back to analyze her. Instead, they are confronted with the immediacy of the emotions she is going through, made to witness the innermost unconscious of another being, to look head-on at images to which in reality they could never have access.

Eija-Liisa Ahtila has been considered a major figure in video art since the start of her career in the 1990s, not least because she uses and combines all the cinematographic registers and all the digital technology at her disposal. Real places merge with scenes from dreams or hallucinations as the narrative is constantly broken up by disjointed images, voice-overs and subtitles, juxtapositions of scenes on multiple screens, and the use of special effects. Her filmed narratives blend documentary, fiction, and fantasy to conjure up intense or painful psychological states, the successive emotions felt in moments of grief, anger, or erotic desire. Her films are performed by professional actors, but are based on documentary research. Ahtila uses fiction to get to the truth of an inner state that she explores from all sides. She constructs subtle visual narratives that constantly oscillate between reality and imagination. The images Ahtila creates always have something more to tell than they show.

The House, 2002, DVD installation for 3 projectors with sound, 14 min.

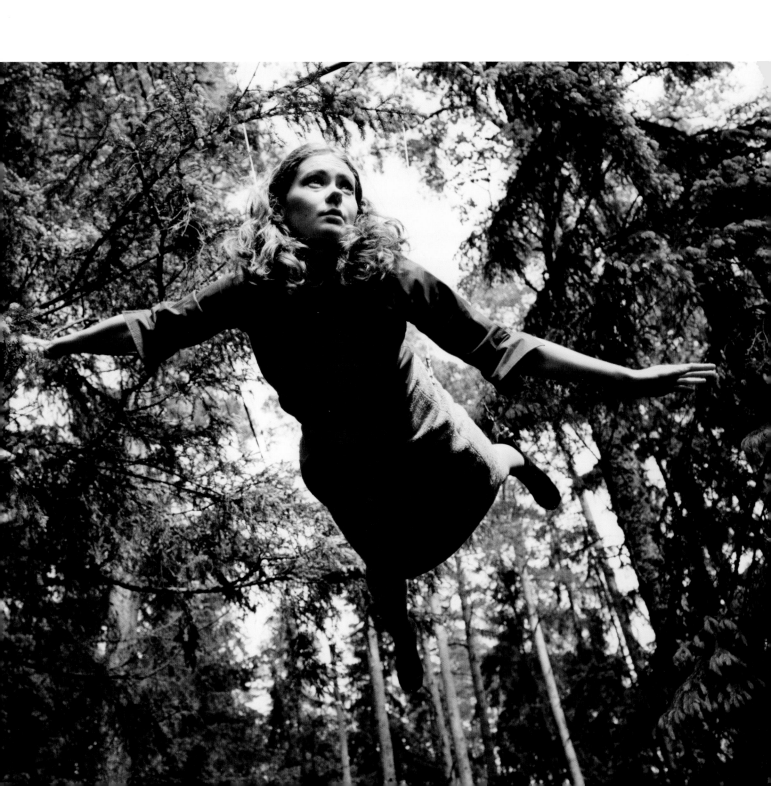

GILLES BARBIER
1965 –

Nurtured by the world of strip-cartoons and science fiction, Gilles Barbier's work takes ever-changing forms. It is often darkly humorous and parodies, in strings of fictitious installations, the difficult relationship we have with the world.

Gilles Barbier starts by writing, then he makes drawings on paper, and only then does he embark on a sculpture. He sets figures in the center of installations that look like enormous strip cartoons in three dimensions. From 1998 to 2008 he was the recurring character in his own work. Like a mad scientist, he produced an endless series of clones of himself. He made hyperrealist sculptures of himself out of wax that he placed in provocative or moving situations. Inventing a perfect twin harks back to childhood and the imaginary friends and opponents children dream up as playmates: it is a universal fantasy. There is more than just playful fun to Barbier's use of himself, however: it suggests an obsession with identity to which a world threatened by standardization reduces us. As he says himself, Barbier seeks to "give more space to me." He describes his work as a huge "mental design" to which he is slowly giving form by "applying to the physical a process which to start with is intellectual." For him, this process of materialization is integral to his art and also acts as a means of transmitting it. In this way, *The Drunk,* one of his clones, can seem like a metaphor for his art practice. Although the figure is clearly weighed own, his memories and fantasies burst out of him and proliferate in space, asserting his uninhibited individuality, let loose by drunkenness: his identity reclaims its place in the world. In another work in the *Clones* series, Barbier imagines a band of decrepit superheroes congregated in a nursing home. Does this mean Superman too can die, now that he has found refuge in a nursing home? Or is Barbier making a point about the destiny that awaits elderly people in contemporary society, a destiny that strips them of their heroism?

Barbier's fictitious little creations are also metaphors for the human mind, which mixes together images, obsessions, and fictional characters. Thought is not linear; it is like a set of teeming networks that connect or short circuit in turn. This is how Barbier's works operate both independently and together. His is a self-generating, constantly expanding universe full of echoes and interactions.

In this sense, fiction can give reality a new meaning and give us a greater hold over it. Gilles Barbier patiently and playfully creates endless new scenarios in order to conjure up whole new possible worlds, ones that are sharply critical of our own.

The Drunk, 1999–2004, installation, mixed media, 700 x 100 x 90 cm, GP & N Vallois gallery, Paris
Following pages: *The Nursing Home,* 2002, installation, six wax figures, assorted objects, variable dimensions, GP & N Vallois Gallery, Paris

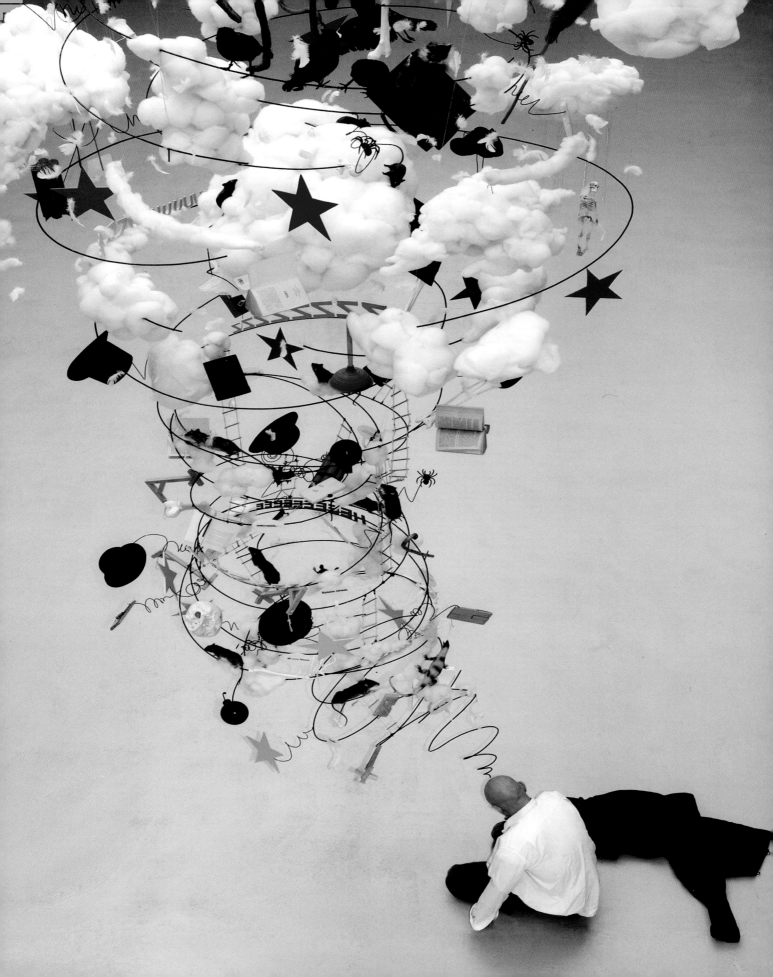

PHILIPPE RAMETTE

1961–

For Philippe Ramette, "a work should always be driven by a story or by the possibility of a story." To this end, he stages absurd and impossible situations and places himself in the middle of them, even when this puts him in danger. More than the sculptural objects he makes, it is the set-ups he and the viewer imagine that are the works of art.

Philippe Ramette starts off by making drawings, each with a story to tell: they come about as "the result of a story I was telling myself." He realized that he was more interested in the material nature of objects than their representation. He began therefore to make sculptures out of wood, creating objects that were for the most part totally anomalous, such as "plinths for reflection," "crutches for the newborn," and even a "preventative gallows for potential dictators."

Ramette cannot devise a sculpture without immediately thinking of the context in which it could be used. For him, objects on their own are not evocative enough, so he came up with the idea of adding himself to the scene and getting himself photographed as part of the work. By doing so, he is entering into exactly the spirit of one of his pieces entitled *Object for Becoming the Hero of One's Own Life Story*. He is making his life into a fiction—a fiction that is liberating. All of these works free the body from the physical constraints to which it is subject in a rational world. Ramette defies the laws of gravity by suspending himself from helium balloons, submerging himself in water, hanging from a cliff with the aid of prostheses ... These positions require real physical effort on the artist's part: the photographs do not rely on trickery. For the underwater photographs in particular, Ramette really did put himself in danger. There are films of these shots being taken: they show Ramette on one occasion plummeting down into water with his sculpture under the horrified gaze of his sponsors. Ramette takes inspiration from visual contradictions of the kind that happen when we channel hop from one television channel to another: the successions of images we generate conjure up situations that cannot possibly occur in reality. At a time when every sort and kind of manipulation is possible through information technology, Ramette deliberately eschews all trickery. With a seriousness that borders on the comic, and dressed in a smart but somewhat dated suit, he moves about in a world of his imagination that disturbs and disorientates us, but nevertheless also compels us to follow his fictional path.

Gravity Inversion, 2003, color photograph,
150 x 120 cm, Xippas Gallery, Paris

RON MUECK

1958–

In some ways, Ron Mueck's works are akin to the hyperrealist sculpture of the likes of John De Andrea and Duane Hanson, but his manipulation of scale engenders very different emotions and thoughts. The likeness he achieves is both perfect and impossible at the same time.

Ron Mueck started out working in special effects and devising puppets for television, and is a past master at creating illusions and trompe l'oeil. In 1996 he began producing hyperrealist sculptures. Although his figures are made out of fiberglass and silicone, touched up with oil paint, the skin, pores, hair, furrows, and wrinkles on them make them look uncannily like real human bodies. They are monstrous beings, however, and their inhuman scale shatters the illusion and determines the very particular way viewers inevitably interact with them. Most of them are huge, and at first their monumentality makes us recoil. But they are so perfectly made that we cannot help but look at them more closely. Mueck's huge head, *Mask II*, exemplifies all the paradoxes inherent in his work. It has a face too big to be human, but hair, a mouth and wrinkles that are more real than the real thing. The expression on the face is that of a man asleep, but this reading is immediately contradicted by the fact that the head is detached from its body, like an anatomical part preserved after the death of its owner. Mueck also creates very small sculptures that make us feel as though we are looking at them through a microscope, giving us an unpleasant sensation of being compelled to become voyeurs observing something private. There is never anything inviting in the expressions of these figures: they do not encourage us to look at them or approach them. Instead, they manifest apprehension, fear, anxiety, and distress. These very ordinary men and women evoke situations and conditions that are fundamental to all of us: birth, death, loneliness, old age, relationships. Alternately minute and huge in comparison to these sculptures, viewers are forced into an awareness of their own bodies in a space that the deliberate changes of scale make difficult to apprehend. The expressions on these figures are so realistic that it is impossible not to imagine that they were once alive, even though we know that they could not have been. By setting up an illusion only to shatter it, and provoking a mixture of attraction and repulsion as a result, Mueck's work draws viewers into an emotional experience that they are powerless to resist.

Mask II, 2001–2002, mixed media, 77.2 x 118.1 x 85.1 cm, the Art Supporting Foundation collection, Museum of Modern Art, San Francisco

Following pages: *In Bed,* 2005, mixed media, 161.9 x 649.9 x 395 cm, private collection

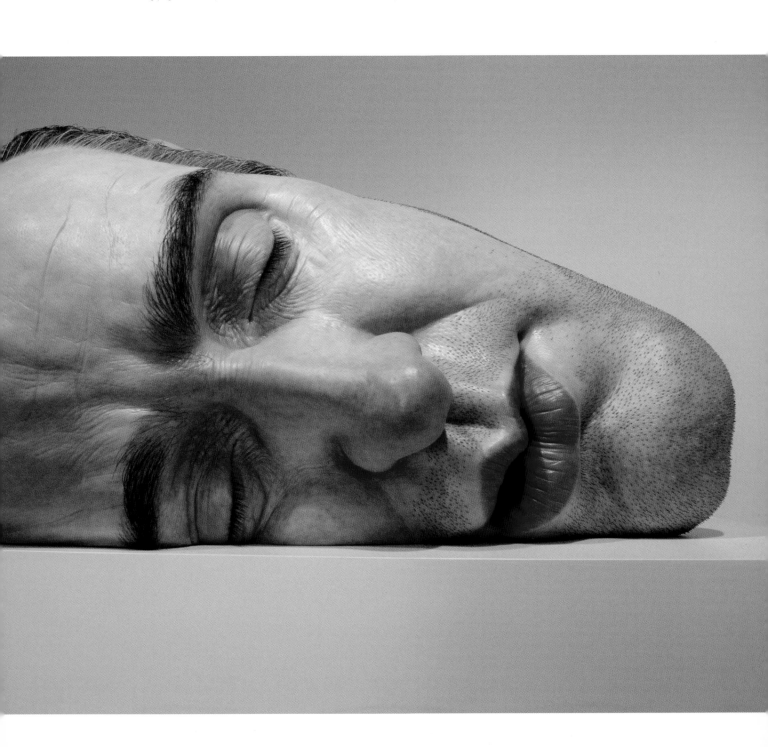

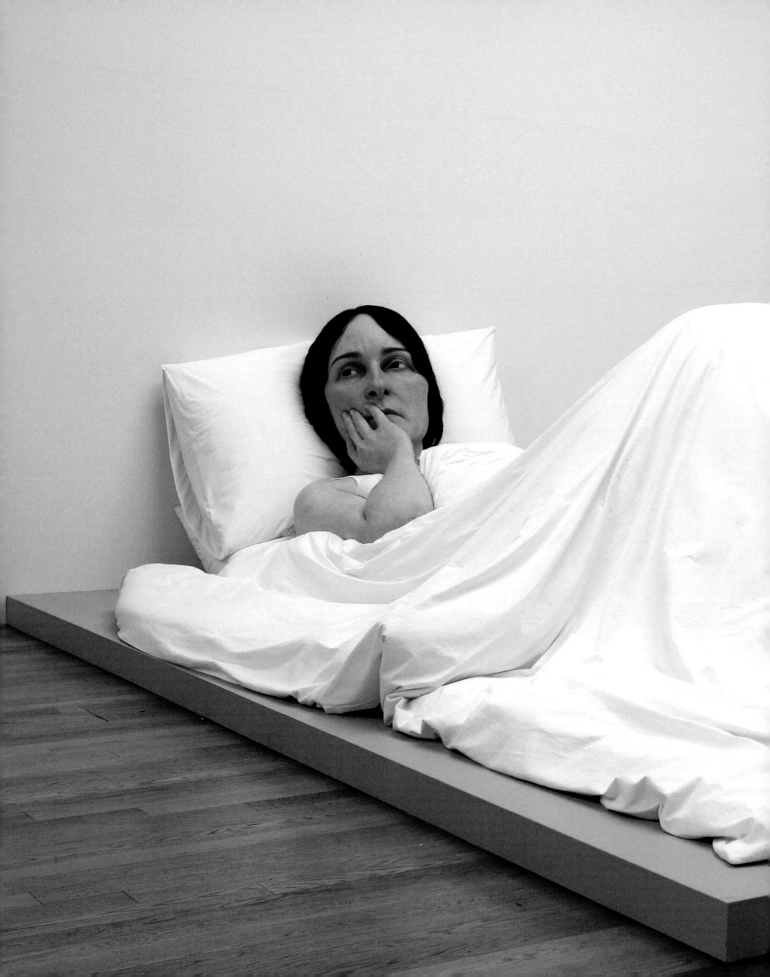

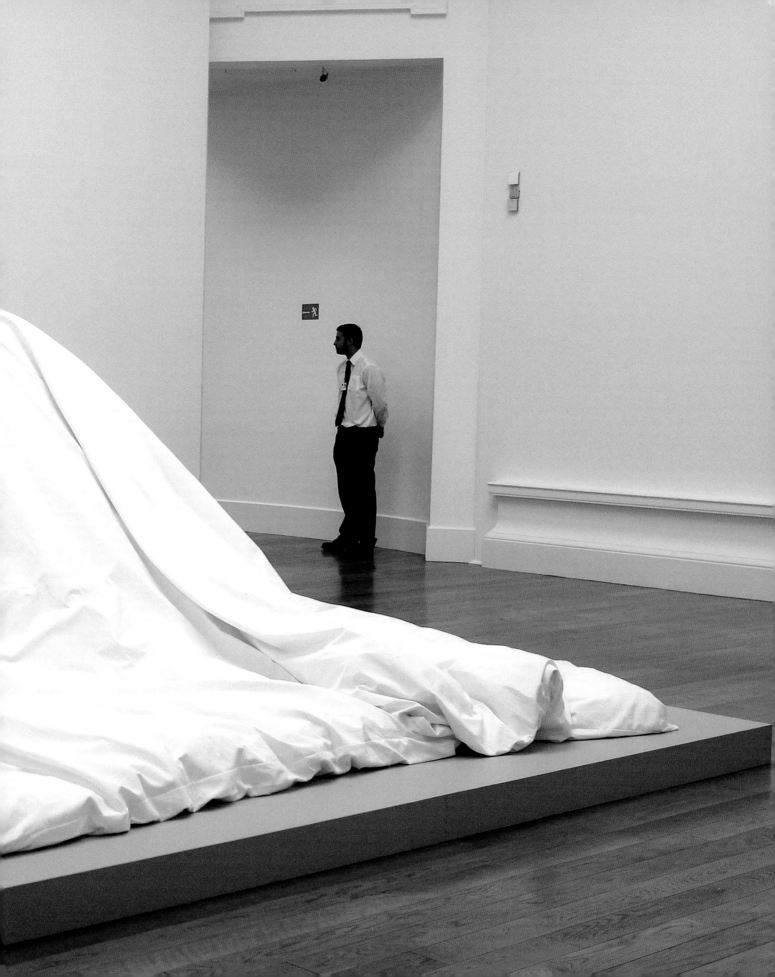

LI WEI

1970–

The Chinese artist Li Wei combines photography and performance to show himself in positions that defy the laws of gravity. His photographs look impossible but are not rigged and suggest a violent world in which we struggle absurdly.

A mirror with a stunned face sticking through it, a body with a head embedded in the ground, a group of young people flying through the air tied to a convertible driving over the roofs of Beijing, such are the spectacular scenes captured in Li Wei's photographs. To create these impossible situations and positions, the photographer/performer sets up clever arrangements of cranes, scaffolding, and metal cables, which all disappear in the final prints. The physical acrobatics and the dangers involved are real, however; there is no trickery or montage.

Wei's illusionist work presents us with fantastical images of what city life could be to human beings. He produces thematic series in which his body falls, rises of its own accord, becomes dismembered, or buries itself. The figure hurling himself out of a window of a skyscraper could be an overworked employee. Sometimes the photographs depict obvious conflict: Wei is pushed into the void by another man, or thrown into the air by a woman who has him by the ankle. These photographs conjure up an imaginary reality, a frightening scenario of the world gone mad. At the same time, the incredible positions and poses they include suggest a form of revolt and a body freed of its natural constraints. The sudden ability to defy the laws of gravity that Wei's figures display can be seen as a metaphor for their desire to tear themselves away from a human condition that has become unbearable. The photographs are always shown in huge format and are both very oppressive and funny at the same time. Working within the economic and political context of his country, Wei invites us to question the way society is evolving and the struggles for power between men and women. Wei declares that he is looking for "a universal artistic language" by creating "symbols that can be understood by anyone in the world."

Li Wei's work also prompts us to think about the role of art and artists in contemporary society. His practice is informed by a provocative philosophy of the absurd and perhaps inevitably calls to mind both the image and the spirit of Yves Klein's famous photomontage *Leap into the Void*, produced in 1960. In his own way, Li Wei subverts the illusionist tradition of art by showing that today illusion requires a physical investment on the artist's part that involves real risk.

Li Wei at the High Place, 2008, photograph, 176 x 176 cm, Beijing, China

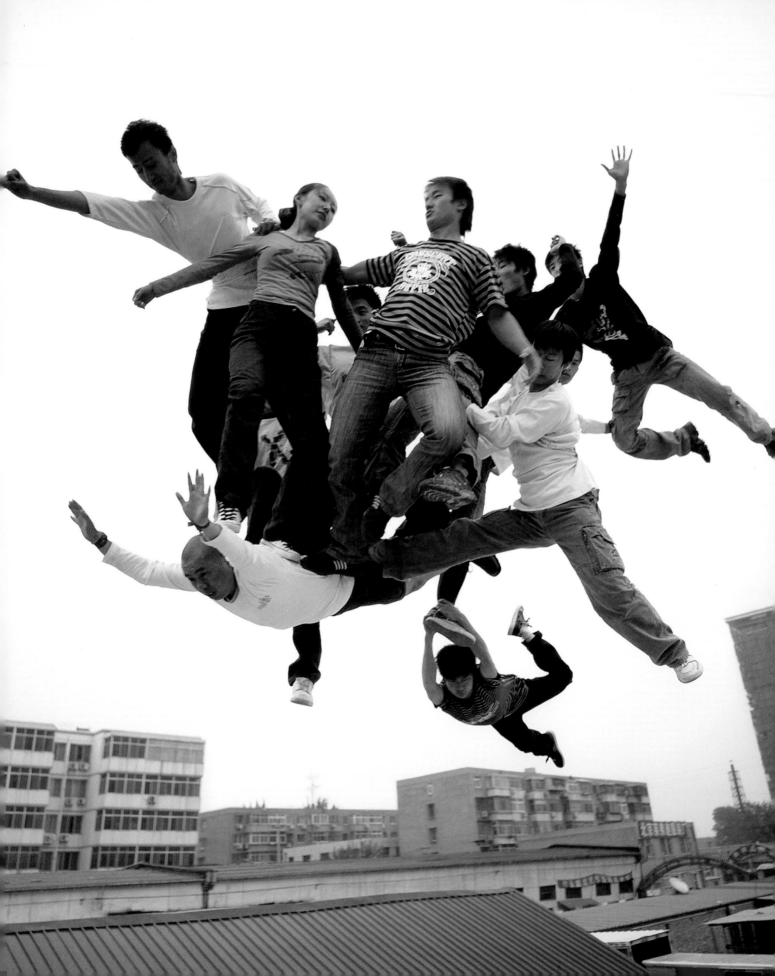

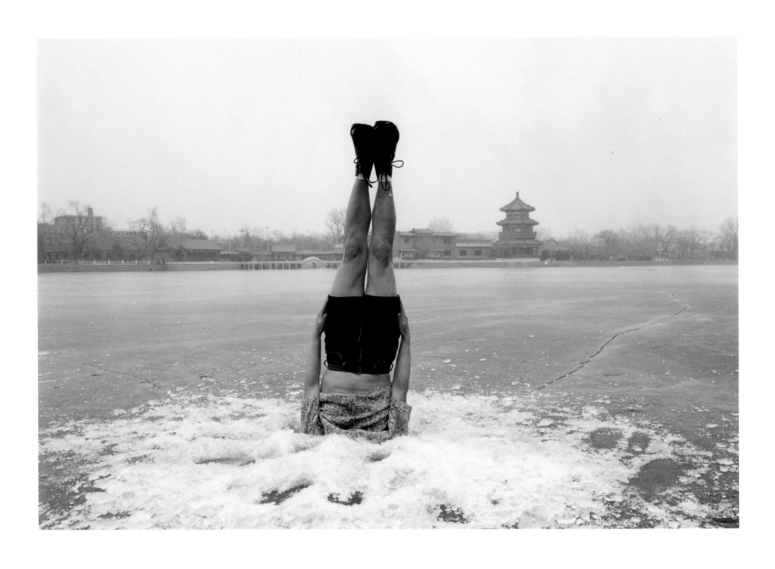

Li Wei Falls to the Ice Hole, 2004, photograph, 120 x 170 cm, Beijing, China

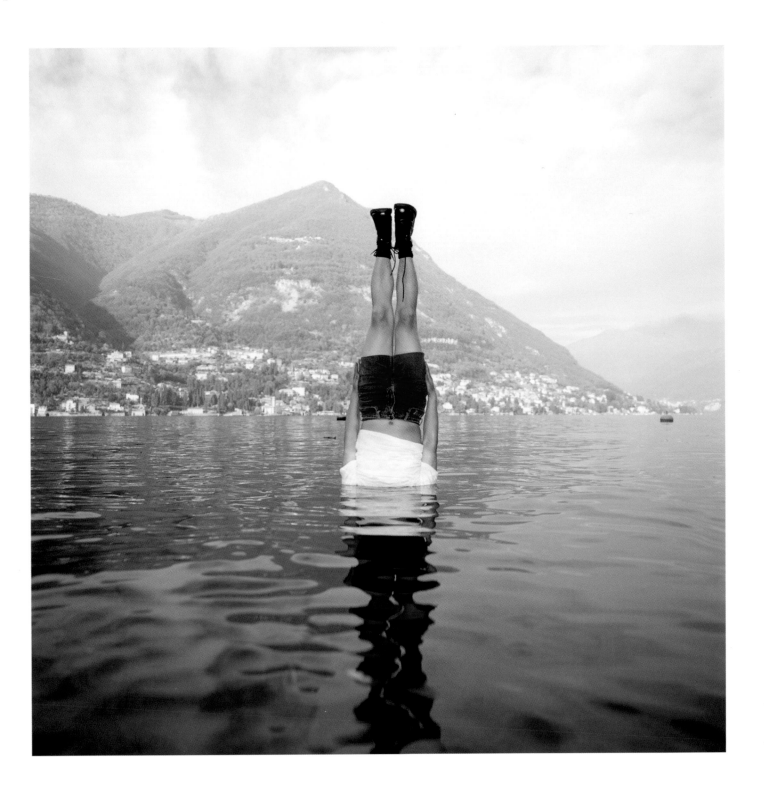

Li Wei Falls to the Como Lake, Italy, 2004, photograph, 150 x 150 cm, Como, Italy

INDEX OF ARTISTS

Ahtila, Eija-Liisa 174–175

Andrea (de), John 30–31

Anonymous

 Frescoes from Pompeii 12–14

 Venus of Milandes 62–63

Arcimboldo, Giuseppe 92–95

Balla, Giacomo 126–127

Banksy 54–57

Barbier, Gilles 176–179

Bolin, Liu 118–119

Bruegel the Elder, Pieter 122–123

Cattelan, Maurizio 170–173

Caso (del), Pere Borrell 24–25

Close, Chuck 136–139

Cragg, Tony 84–85

Dalí, Salvador 78–81

Estes, Richard 26–29

Escher, Maurits Cornelis 164–165

Ferrer, Cayetano 58–59

Fontcuberta, Joan 166–167

Gijsbrechts, Cornelis Norbertus 22–23

Hack, Emma 114–115

Halsman, Philippe 162–163

Hanson, Duane 32–35

Hill, William 76–77

Holbein the Younger, Hans 68–69

Jenkins, Mark 112–113

Kalish, Michael 148–149

Kapoor, Anish 154–155

Koons, Jeff 40–41

Kuniyoshi, Utagawa 74–75

Kusama, Yayoi 150–153

Magritte, René 158–161

Mantegna, Andrea 64–65

Merian, Matthäus 96–97

Michelangelo 20–21

Mueck, Ron 182–185

Mughal School 72–73

Müller, Edgar 50–53

Muniz, Vik 100–103

Noble, Tim, and Webster, Sue

 86–89

Oursler, Tony 110–111

Penny, Evan 108–109

Pras, Bernard 104–107

Raetz, Markus 82–83

Ramette, Philippe 180–181

Richter, Gerhard 36–39

Riley, Bridget 132–135

Rousse, Georges 140–143

Schön, Erhard 66–67

Scrots, William 70–71

Seurat, Georges 124–125

Sherman, Cindy 98–99

Van Eyck, Jan 16–19

Varini, Felice 144–147

Vasarely, Victor 128–131

Wall, Jeff 168–169

Wei, Li 186–189

Wirths, René 42–45

Witz, Dan 46–49

Yoshida, Kimiko 116–117

PHOTO CREDITS

tl; top left | **bl;** bottom left | **tr;** top right | **br;** bottom right

Cover: René Magritte with © VG Bild-Kunst, Bonn 2012 / Artothek

© **ADAGP, Banque d'Images, Paris 2012 for all the works by its members: Duane Hanson** pp.6 (32), 33, 34, 35; **Salvador Dalí** pp.7 (78), 78–79, 80–81; **Markus Raetz** pp.7 (82), 82; **Tony Cragg** pp.7 (84), 60 (hd), 84, 85; **Vik Muniz** pp.8 (100), 101, 102, 103; **Bernard Pras** pp.8 (104), 105, 106, 107; **Kimiko Yoshida** pp.8 (116), 116, 117; **Giacomo Balla** pp.8 (126), 127; **Victor Vasarely** pp.9 (128), 128, 130–131; **Georges Rousse** pp.8 (140), 141, 142, 143; **Felice Varini** pp.9 (144), 145, 146, 147; **Anish Kapoor** pp.8 (154), 155; **Joan Fontcuberta** pp.9 (166), 167; **Eija-Liisa Ahtila** pp.9 (174), 174, 175; **Gilles Barbier** pp.9 (176), 177, 178–179; **Philippe Ramette** pp.9 (180), 181

René Magritte, p.159: © Photothèque R. Magritte – ADAGP, Paris 2012, and pp.9 (158), 160, 161: © ADAGP, Banque d'Images, Paris 2012

pp.6–7 © Photo Scala, Florence–courtesy of the Ministero Beni e Att. Culturali (12); © Photo Josse/Leemage (16); © Vatican Museums and Galleries, Vatican/The Bridgeman Art Library (20); © SMK Photo (22); © collection Banco de España, Madrid (24); © Richard Estes, courtesy of Marlborough Gallery, New York (26); © Louis K. Meisel Gallery (30); © akg-images (32); © Gerhard Richter 2012 (36); © Jeff Koons (40); © René Wirths (42); © Dan Witz (46); © Edgar Müller/www.metanamorph.com (50); © Banksy (54); © Cayetano Ferrer (58); © MNP, Les Eyzies, Dist. RMN/Philippe Jugie (62); © Raffael/Leemage (64); © BPK, Berlin, Dist. RMN/Jörg P. Anders (66); © Musée des Beaux-Arts, Rouen/Giraudon/The Bridgeman Art Library (68); © National Portrait Gallery, London (70); © BnF (72); © DR (74); © DR (76); © Luisa Ricciarini/Leemage (78); © courtesy of galerie Farideh Cadot (82); © Frac Bourgogne (84); © Tim Noble & Sue Webster. Courtesy of the artists (86); **8–9** © Pixl Icono (92); © IAM/AKG Images (96); © Courtesy of the artist and Metro Pictures (98); © Evan Penny (108); © Tony Oursler, collection Centre Pompidou, Dist. RMN/Jean-Claude Planchet (110); © Mark Jenkins (112); © Emma Hack (114); © Liu Bolin and Eli Klein Fine Art (118); © Hessisches Landesmuseum, Darmstadt/The Bridgeman Art Library (122); © The Art Institute of Chicago/The Bridgeman Art Library (124); © Albright-Knox Art Gallery, Buffalo/The Bridgeman Art Library (126); © akg-images (128); © Bridget Riley 2012. All rights reserved, courtesy Karsten Schubert, London (132); © 2012. Digital image, The Museum of Modern Art, New York/Scala, Florence (136); © www.jondavisphoto.com (148); © Yayoi Kusama (150); © Seong Kwon Photography (154); © Private Collection/ Peter Willi/The Bridgeman Art Library (158); © Philippe Halsman/Magnum Photos (162); © The Granger Collection NYC/Rue des Archives (164); © Joan Fontcuberta & Pere Formiguera (166); © Courtesy of the artist (168); © photo; Attilio Maranzano. Courtesy of Massimo de Carlo, Milan (170); © Crystal Eye Ltd, Helsinki. Courtesy of Marian Goodman Gallery, New York and Paris (174); © Courtesy of galerie GP & N Vallois, Paris (176); © photo; Marc Domage – Courtesy of galerie Xippas (180); © Jeff J. Mitchell – AFP (182); © Li Wei (186); **10** © collection Banco de España, Madrid (tl); © Dan Witz (tr); © Richard Estes, courtesy of Marlborough Gallery, New York (bl); © René Wirths (br); **13** © Luisa Ricciarini/Leemage; **14, 15** © Photo Scala, Florence–courtesy of the Ministero Beni e Att. Culturali; © PrismaArchivo/Leemage SMA; **17** © Photo Josse/Leemage; **18–19** © AKG Album/Oronoz; **21** © Vatican Museums and Galleries, Vatican/The Bridgeman Art Library; **22–23** © SMK Photo; **25** © collection Banco de España, Madrid; **26, 28–29** © Richard Estes, courtesy of Marlborough Gallery, New York; **31** © Louis K. Meisel Gallery; **33, 34, 35** © akg-images; **37, 38–39** © Gerhard Richter 2012; **41** © Jeff Koons; **43, 44–45** © René Wirths; **47, 48, 49** © Dan Witz; **51, 52, 53** © Edgar Müller/www.metanamorph.com; **55** © Banksy; **56–57** © Banksy/Getty Images; **59** © Cayetano Ferrer; **60** © MNP, Les Eyzies, Dist. RMN/Philippe Jugie (tl); © Frac Bourgogne (tr); © DR (bl); © Tim Noble & Sue Webster. Images courtesy of the artists (br); **63** © MNP, Les Eyzies, Dist. RMN/Philippe Jugie; **65** © Raffael/Leemage; **67** © BPK, Berlin, Dist. RMN/Jörg P. Anders; **69** © Musée des Beaux-Arts, Rouen/Giraudon/The Bridgeman Art Library (top), © 2011 and © The National Gallery, London/Scala, Florence (bottom); **70–71** © National Portrait Gallery, London; **73** © BnF; **75** © DR; **77** © DR; **78–79** © Salvador Dalí Museum, Saint Petersburg/The Bridgeman Art Library; **80–81** ©Luisa Ricciarini/Leemage; © courtesy of galerie Farideh Cadot; **84** © Frac Bourgogne; **87, 88–89** © Tim Noble & Sue Webster. Courtesy of the artists; **90** © Pixl Icono (tl); © Emma Hack (tr); © Tony Oursler, Collection Centre Pompidou, Dist. RMN/Jean-Claude Planchet (bl); © Mark Jenkins (br); **93** © Getty Images; **94, 95** © Pixl Icono; **97** © IAM/AKG Images; **99** © Courtesy of the artist and Metro Pictures; **100** © Crédit photographique de l'artiste; **101, 102** © Crédit photographique de l'artiste, Courtesy of galerie Xippas; **109** © Evan Penny; **111** © Tony Oursler, collection Centre Pompidou, Dist. RMN/Jean-Claude Planchet; **112** © Mark Jenkins; **115** © Emma Hack; **116, 117** © Kimiko Yoshida; **119** © Liu Bolin and Eli Klein Fine Art; **120** © Bridget Riley 2012. All rights reserved, courtesy Karsten Schubert, London. akg-images (tl); © Hessisches Landesmuseum, Darmstadt, Germany/The Bridgeman Art Library (tr); © The Art Institute of Chicago/ The Bridgeman Art Library (bl); © Yayoi Kusama (br); **123** © Hessisches Landesmuseum, Darmstadt/The Bridgeman Art Library; **125** © The Art Institute of Chicago/The Bridgeman Art Library; **127** © Albright-Knox Art Gallery, Buffalo/The Bridgeman Art Library; **128** © akg-images; **130–131** © Centre Pompidou, MNAM–CCI, Dist. RMN/Jacqueline Hyde; **133** © Bridget Riley 2012. All rights reserved, courtesy of Karsten Schubert, London; **134–135** © Bridget Riley 2012. All rights reserved, courtesy of Karsten Schubert, London. akg-images; **136** © 2012. Digital image, The Museum of Modern Art, New York/Scala, Florence; **138** © Saint Louis Art Museum, Funds given by the Shoenberg Foundation, Inc.; **139** © Collection Walker Art Center, Minneapolis; **149** © www. jondavisphoto.com; **151, 152–153** © Yayoi Kusama; **155** © Seong Kwon Photography; **156** © Courtesy of Jeff Wall (tl); © AFP Photo/Robyn Beck (tr); © photo; Axel Schneider. Courtesy of the artist & galerie Perrotin, Paris (bl); © Li Wei (br); **159** adapg; **160** © Art Institute of Chicago/The Bridgeman Art Library; **161** © Private Collection/Peter Willi/The Bridgeman Art Library; **163** © Philippe Halsman/Magnum Photos; **165** © The Granger Collection NYC/Rue des Archives; **167** © Joan Fontcuberta & Pere Formiguera; **168–169** © Courtesy of the artist; **171** © photo; Axel Schneider. Courtesy of the artist & galerie Perrotin, Paris; **172–173** © photo; Attilio Maranzano. Courtesy of Massimo de Carlo, Milan; **174–175** © Crystal Eye Ltd, Helsinki. Courtesy of Marian Goodman Gallery, New York et Paris; **177, 178–179** © Courtesy of galerie GP & N Vallois, Paris; **181** © photo; Marc Domage – Courtesy of galerie Xippas; **182–183** © AFP Photo/Robyn Beck; **184–185** © Jeff J. Mitchell – AFP; **187, 188, 189** © Li Wei